D1232013

THE LIGHTED WINDOW

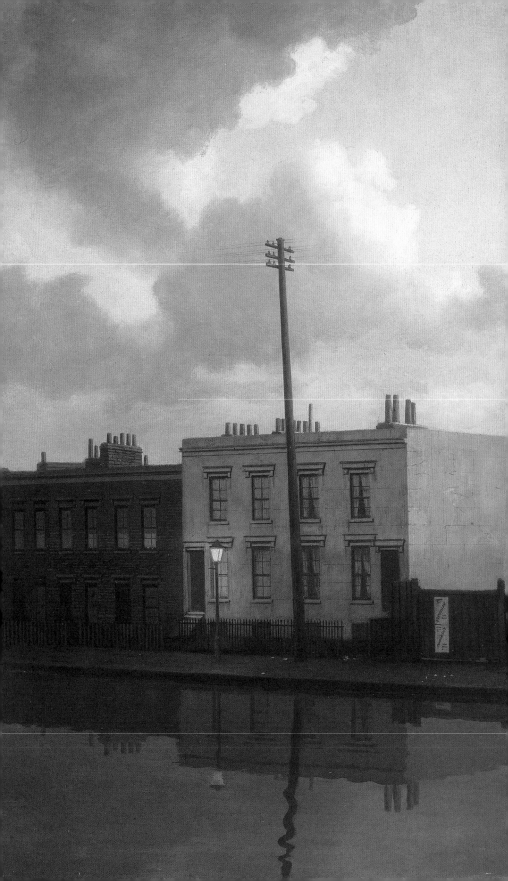

THE LIGHTED WINDOW

EVENING WALKS REMEMBERED

PETER DAVIDSON

BODLEIAN
LIBRARY
PUBLISHING

First published in 2021 by the Bodleian Library
Broad Street, Oxford OX1 3BG
www.bodleianshop.co.uk

ISBN 978 1 85124 514 7

Text © Peter Davidson, 2021
All images, unless specified on p. 208,
© Bodleian Library, University of Oxford, 2021

Peter Davidson has asserted his right to be identified as the author of this Work.

Quotation on p. vii from Alexander Nemerov, *To Make a World: George Ault
and 1940s America* (New Haven and London: Yale University Press
in association with the Smithsonian American Art Museum, 2011)
reproduced with permission of The Licensor through PLSclear

All rights reserved.

No part of this book may be reproduced, stored in a retrieval system, or
transmitted in any form or by any means, electronic, mechanical, photocopying,
recording, or otherwise, without the written permission of the Bodleian Library,
except for the purpose of research or private study, or criticism or review.

Publisher: Samuel Fanous
Managing Editor: Deborah Susman
Editor: Janet Phillips
Picture Editor: Leanda Shrimpton
Production Editor: Susie Foster
Cover design by Dot Little at the Bodleian Library
Designed and typeset by Lucy Morton of illuminati in 12½ on 15 Perpetua
Printed and bound in China by C&C Offset Printing Co. Ltd
on 140 gsm Chinese Golden Sun woodfree paper

British Library Catalogue in Publishing Data
A CIP record of this publication is available from the British Library

CONTENTS

For Alan Powers and Mark Gibson

The gift-giver, made of light, envies the darkness,
wishing that he too could be the night and receive
'gifts of light' instead of only bestowing them.

ALEXANDER NEMEROV

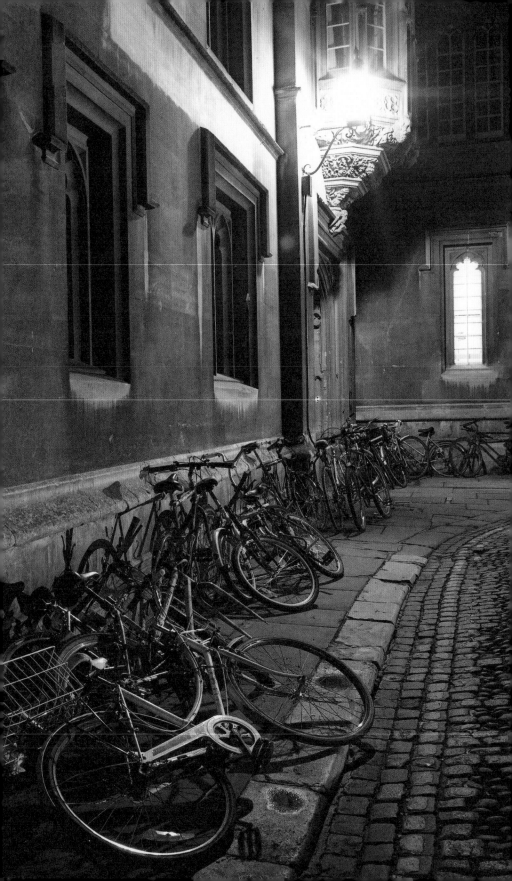

INTRODUCTION

OXFORD AT NIGHTFALL

It is evening now and I should walk home soon. When I reach the library door it is dark and the windows are lighted on the other side of the street. The air touches my skin with a chill like water, and bicycles whisper swiftly through the dusk. Opposite are the golden-stone theatre and museum, the stone piers which support the railings crowned by giant carved heads, stirring in the shadows between the street lamps. Beside them is the stark grandeur of Hawksmoor's Clarendon Building, which is tough and melancholy and belligerent all at once. Sparse lights, reflecting upwards in deep window embrasures. Lead statues of the Muses patrol the dark roofline: pitiless executives of success and memory, genius and fame.

I start to walk along Broad Street, past the closed gates and the concert posters, over wet leaves on slicked pavements. I glance across to Trinity College, sitting far back behind its screen of railings, beyond lawns and trees, like a country house in its autumnal park. There is a glimmer of wavering light at the bottom of the chapel windows although their keystones are in shadow – light striking upwards from the music desks. I turn south into Turl Street – the first customers are eating an early supper by candlelight in the panelled front room

Lighted window, gate lantern, cobbles, stone. Norman McBeath's photograph of bicycles outside Pembroke College, Oxford, 2006.

of the Turl Street Kitchen. How different the pale yellow of these wavering flames are from the steady white of the bulkhead lights which illuminate the bicycle racks behind the wall of Jesus College on the corner, from the bluish overhead strip lights in the porters' lodge on the other side of the street.

Reflections from street lamps and college windows glimmer dimly on damp flagstones, brighter on wet tarmac and cobble. Now the smart shops pass: jeweller, dandies' tailor, wine merchant, the whisky shop with its window full of names from the cold uplands along the Spey. Light strikes upwards, glimmering on the unlit brass chandeliers and the high stucco ceiling of the church-turned-library on the corner. The windows of the Mitre glow red from shaded lights on the panelled walls.

I cross the High Street at the lights. Then down bricky Albert Street, and round the corner by The Bear, where lamplight is glowing on the polished wood of the bar. Out into St Aldates and threading through the crowds at the bus stops – the bright buses for Wantage and Abingdon, setting off into the damp night towards the lighted constellations of the villages and towns. I walk down the hill past the front of Christ Church, Wren's Gothick tower shadowy above me, through the breath of wood smoke and refracted fire from the pizza van at the college gate, and across the wide road.

Brewer Street is dim, sheltered by the bulwark of the old city wall, lit by lanterns fixed high on the outer wall of Pembroke College, dim light only behind the coloured glass of the chapel windows. The sound and brightness of the main road fades with every step, more removed still as I push open the outer door of Campion Hall, a deep doorway in a lightless wall, and slide the tab against my name to IN. I think that only in this college are there three choices: IN or OUT or AWAY. Given the early history of the Jesuits in Britain it is hard not to associate AWAY with phrases like 'gone beyond the seas', or 'fled to his kinsfolk in the North'.

A smell of polish and flowers and careful cooking. Past the great Spanish polychrome carving of Ignatius and his companions, through

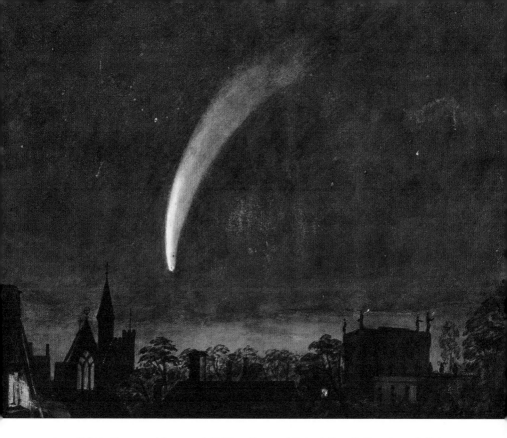

Lamplight in the year of the comet. William Turner of Oxford, *Donati's Comet over Balliol,* 1858.

the unlit dining room with a glance at Augustus John's nervous, brilliant portrait of Fr Martin D'Arcy. Through the lobby with its paintings from Flanders and Peru, and into the library. Panelling above the broad stone fireplace, books from floor to ceiling, pools of lamplight on polished parquet. The big room is still as this quiet house grows quieter at evening. It is almost as though it grew more secluded and further away, when these lamps are lit in the library and the fire is lit in the common room. It becomes like a manor house, silent at nightfall, remote and westerly and enfolded by wooded hills. The buds of the birch tree outside the window rustle in the dark like rain, the windows in Pembroke's new building seem as far away as the lights of hill farms, dimming in memory on the slopes of the Pennines.

★

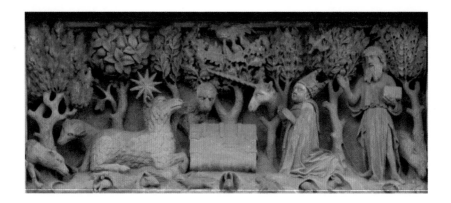

A frozen paradise in stone. The fifteenth-century carved panel set over the main gate of Merton College, Oxford.

A star is tangled in the branches of a stone forest, one of whose trees is laden with miraculous apples. There is a unicorn under the apple tree, a lion and a lamb on the floor of the grove. A bishop is kneeling with a great book closed before him. There are hounds or wolves in the shadows. All the unknown poetry and strangeness of England seem to inhabit that one carved stone, and I can barely decipher its details by the sparse lanterns on the walls, by the dim light spilled from Gothic windows. November night-fog stirs around the lighted archway, blots the light from the porters' lodge. It is bitterly cold, damp striking up from the cobbles, frozen mist advancing across the water meadows. I have only just arrived, forty years ago and more, and it is my first evening in Oxford, indeed my first evening in England. I am with a group of musicians, one an ex-schoolfriend with whom I am staying, and we are gathering at the gateway of Merton College to go to evensong at Christ Church.

I have never before seen anything like this narrow street, the gate towers and postern gates, the cusped Gothic of the window heads, now silhouetted against the deep yellow electric lamplight of the third quarter of the last century. It is wholly unlike the honeyed baroque lanes of Salamanca, the towering limewashed closes of the

Old Town of Edinburgh. Light spills from the triumphal arch which is half-disclosed by the curve of the street. We pass through the lit gates and into Christ Church, and I am stopped in my tracks by the magnificence of the plaster ceiling of the lighted upper library, by the virtuosity and extravagance of the geometric foliage, and that this whole snowy expanse is moulded, not painted as it would be almost anywhere else in Europe. Desk lamps glimmer behind crown glass in the tall windows of Peckwater and then we dive into another tunnel of fog and stone, another tower with a lantern in the arch and dim carved images half out of sight above, and make our way into the cold waste of Tom Quad where the fog fills the sunken basin of lawns and fountain, stirring and flowing like an otherworldly lake, casting up filaments of vapour towards the lamps on the walls of the canonries, hiding the gate tower and choking the bells. When we turn under the porch of the cathedral, the flames of the choir's candles are blurred into ghost-suns by the watery cold in the air.

All that I remember clearly from that visit is music, fog and darkness. I know that we must have walked around the city during the short days: I can remember waking in the half-light and going into breakfast in a dark-panelled Hall full of noisy young men in track suits and white sweaters. Smells of sweat and fatty bacon, a barked greeting of 'good morning, men'. I can half-remember walking along a riverbank in failing afternoon light, visiting bookshops and music shops as the sky faded once more into fog and chill at the shadowy end of afternoon.

Gate lanterns and gate lodges were islands of lamplight in the ocean of winter night. Music every evening, men's voices in cold chapels: services and concerts, some choirs still singing three-part alto–tenor–bass in a town which seemed as desolate as it was wonderful, being almost bereft of women. My mind kept worrying back to the panel over the gate: suppose the blazing star was rather the sun come down to earth, the winter sun trapped in boughs borne down by miraculous fruits, trees with pelicans and phoenixes nesting in their branches. Suppose it was the blood red, horizon-riding of the north. The wounded sun which recalls the unconsoled devotion of the verse:

Now goeth sun under wode,
I pity Mary thy sweet rode,
Now goeth sun under tree,
I pity, Mary, thy Son and thee.

Which recalls to me now the valley of the Hodder in the trough of
winter: gritstone, oaks and holly groves; the blinding whiteness of
hoar frost on the flank of Pendle, walking to early Mass in the dead
of the year.

★

It took the whole of a winter day to travel from Scotland to Oxford in
those years: although my father had seen me onto the train at 8.30 in
the morning, the light was already weakening when I changed trains
at Birmingham. It was somewhere in the southern suburbs of that
city, on a bleak winter afternoon, that the train of 1970s' slam-door
carriages, halted at a signal. The embankment was above a bomb site,
a triangle of land sloping to the railway, small red-brick terraces along
the crest of the hill showing the first lights in their windows. There
was a fire of debris on the rubbly waste ground, a few young men
in bomber jackets standing around the fire, a boy kicking a football
through rusty willowherb. All of this caught and held my attention:
the waste ground and the flames, and the cold cloud gathering in the
sky. I thought at once how urgently I wanted to record this thing barely
worth recording, and how powerless I was to do so.

That moment was for me the beginning of all subsequent attempts
to write about place and season, particularly about obscure and
disregarded places. For many years, when we lived in the north, I
gave my attention to the view out, to the weather outside the window
glass, to migrating geese and bare hills on the western horizon. Now I
think increasingly of long town walks at twilight, of looking up at the
lighted windows, at constellations of unknowable lives. There are so
many lights in the darkening, remembered towns: church and chapel
windows in Oxford, flickering coloured-bright below and dark above.
There are arc lights and floodlights in Edinburgh – railway yards and

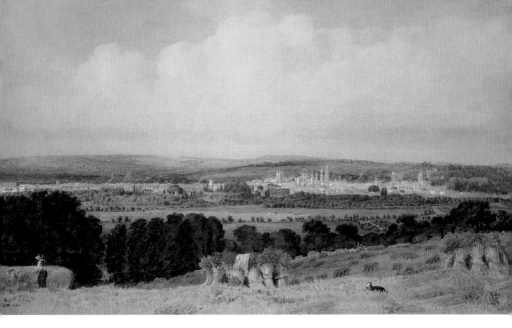

'Distant cries of reapers in the corn.' William Turner of Oxford (1789–1862), *View of Oxford from Hinksey Hill.*

football fields. There are lighted squash courts and fives courts at night, their cold geometries, their cubes of hard white light. There are the yellow-glowing windows of the corner restaurants in Flanders, rain falling, the illuminated tramcars passing softly over the cobbles outside.

One of the concerts which I heard in a chill Oxford chapel that November consisted of only an overture and then a cantata-with-reciter, unlike anything else I had heard before: Vaughan Williams's *An Oxford Elegy*. Desolate, rich-textured, profoundly sad music, lamenting for a lost friend, evoking long-past student days idling amidst the little hills and tributary streams of the upper Thames. It introduced me for the first time to that overwhelming English regret for the past simply because it is over. It sets words from two poems by Matthew Arnold, *The Scholar-Gipsy* and *Thyrsis*. The organization of the piece is strange: the choir is mostly wordless, their voices part of the texture of the orchestra accompanying text declaimed by a speaker. On the few occasions when the choir sing out Arnold's words it is to give voice to the regretted past or to an imagined future: those moments when lamentation gives way to recollection, or to a flicker of qualified hope. I felt that I was learning a new imaginative landscape: at first

summery – 'distant cries of reapers in the corn' – a line which evoked the already-familiar harvest scenes of Samuel Palmer (1805–1881), but latterly wintery and strange.

The names of the midsummer garden flowers seemed sad as they were sung, belonging to the realm of things already gone, lost as the poet's lost friend. The rectory garden, the scented July night, the candle in the upstairs window answering the evening star – these all exist in a place which the poet can only visit alone:

> Soon will the high Midsummer pomps come on,
> Soon will the musk carnations break and swell,
> Soon shall we have gold-dusted snapdragon,
> Sweet-William with his homely cottage-smell,
> And stocks in fragrant blow;
> Roses that down the alleys shine afar,
> And open, jasmine-muffled lattices,
> And groups under the dreaming garden-trees,
> And the full moon, and the white evening-star.

All of this was sadder for being sung on a freezing night to an audience of young men who wore overcoats and scarves over their jackets for warmth. The summer does not last in the piece, and its dominant tone is a winter melancholy. The image which lingers longest in the mind is that of the scholar-gipsy climbing the hill at nightfall, moving away from the city and from the life he had once lived there, the solitary wanderer taking one last look at the lighted windows below.

> And thou hast climb'd the hill
> And gain'd the white brow of the Cumnor range;
> Turn'd once to watch, while thick the snowflakes fall,
> The line of festal light in Christ Church hall
> Then sought thy straw in some sequester'd grange.

For many years, this image haunted me as a distillation of the crepuscular poetic of the English nineteenth century: the solitary figure on the snowy hill, the distant lighted windows. The realization came

gradually of how many other thoughts and recollections were gathered about the image of the solitary figure and the lighted building, or of the lighted window in the landscape or townscape: this is a motif with many moods and contexts. It occurs again and again in visual art and literature from the Romantic period to the present day, in Europe and beyond, and has a remarkable variety of moods and articulations.

In England, with Arnold or with the painter Atkinson Grimshaw (1836–1893), it can express the melancholy of the long nineteenth century in a new perception of a poetic townscape: gaslight or lamplight glimmering on rain-wet cobbles. This appears often in painting and fiction, culminating in the beauty, power, nostalgia and desire expressed by Alan Hollinghurst's *The Sparsholt Affair*, a novel which moves sure-footedly through history, tracing the fortunes of the handsome athlete first glimpsed in a lighted room in wartime Oxford.

The lighted window in a quiet street, or in an isolated villa, is often associated with stories of the supernatural; the unexpected glimpse of a painted room or ceiling from the past, often seen in old towns in the Netherlands, is also a kind of haunting. The window lighted, or the lamplight moving, in an empty dwelling is a clichéd rumour about any haunted house. Lighted windows can articulate many perceptions of the European city, beginning with the moonlight and firelight, images of Dresden painted by Dahl and Carus at the turn of the nineteenth century. This grows more complex in the twentieth century, with the extreme contrast between the rainy gravity of the photographs of Josef Sudek, and the mannered elegance, the windows open to pale-flowered gardens, painted by Henri Le Sidaner (1862–1939).

There is a kind of fascination associated with the lighted windows of great cities, particularly in the fictions of detection and adventure which shape the imagination of the modern metropolis. The approach of the London evening brings forth a kind of alienated poetry, first observed by Whistler, and then captured in the paintings of George Clausen and Algernon Newton, in the poetry of Guillaume Apollinaire. Paradoxically, excitement and sadness alike are called forth by lighted trains or ships which move through the dark and relentlessly

Windows glimpsed through mist at nightfall. James Whistler, *Nocturne in Grey and Gold: Chelsea Snow*, 1876.

away from the observer, as with Eric Ravilious's haunting *Train Going over a Bridge at Night*, his paintings of ferries and piers between the wars.

But the image of the lighted window has also an unequivocally positive aspect, an opposite mood by which it represents the security of home, a promise of domestic happiness towards which the traveller hastens at nightfall, especially the traveller returning after a long absence. Perhaps one of the most distinguished artists in this mode is the nineteenth-century ruralist Samuel Palmer, who conveys a blessed and exceptional security in his images of lighted cottage windows folded about by small hills and orchard trees bowed down with fruit. There is a moment in a letter from the young Cyril Connolly to a friend where he describes lighting lamps in December so that he may contemplate his home shining out through the winter dusk:

I … turn on one light, or all the lights when my father has gone
to bed and go out to the end of the garden to see the golden shafts
shining through latticed windows and stretching over the grass to
where I stand by the dark yew hedge listening to the soft splashing
of our stream, my feet in the dead leaves.[1]

The image of yellow, welcoming light in the vast blue dark of winter is
a repeated motif of Scandinavian romantic painting, the sheer scale of
the northern landscape emphasized by the sparse lights of the dwellings
scattered across its hills and islands. In a different mood, the single
lighted window, or the lonely street lights in rural or urban darkness,
became a defining motif of American art in the years during and after
the Second World War, and remains so to this day, particularly in
the work of contemporary American photographers. From the turn
of the twentieth century, the lighted window is also a motif repeated
with infinite subtle variation in Japanese prints. These nocturnes are
beautifully rendered in superimposed blocks of cobalt, turquoise and
shadow, in points of brilliant yellow and white.

The motif of the lighted window also appears in those optical devices
and models in which painters have delighted since the eighteenth
century: transparencies and glass paintings, like Gainsborough's
Showbox, with its reverse-lit slide of a lamplit cottage by a moonlit
pond. This technique continues with the varnished transparencies,
often depicting lit buildings at night and designed to be viewed with
a lamp or candle behind the paper, which were a passing fashion of
romantic Germany and England. This fashion manifests itself later in
small devices of wonder: toy theatres and Christmas lanterns, innocent
lights and diversions for the depths of the winter.

★

My mind circles back to the *Oxford Elegy*, to Arnold's wanderer on
the snowy hill as an image expressing belatedness and regret for the
life abandoned or relinquished, belated arrivals, chances not taken.
Variations of this scene became for me a talisman of nineteenth-century
English poetry and experience. So much so that I set out from Oxford

on a mild, dim afternoon last winter, over the causeway through the flood meadows, through South Hinksey, across the ring road and up into the hills on the muddy footpath by Chilswell Farm, only to abandon the enterprise as the early dark came down, and I found that the rain-blackened branches of scrub trees and neglected hedgerows seemed to block all views down into the valley.

It was only in spring, when a radiant afternoon on Easter Sunday drew a group of my friends to stroll onto the same hills above the city, that I realized that if I had pressed onwards on that midwinter afternoon, through the wooden gate in the grove by a stream, and up across a little road, I would have emerged onto spacious grassland with the old city in its bowl of hills at my feet, with the towers and pinnacles of Christ Church in the foreground.

The precision with which Arnold identified one particular row of windows as visible even at distance and on a foul night, remained as a puzzle in my mind. I bothered a generous colleague there about the precise date of the installation of gaslight at Christ Church, thinking briefly that I had found the answer to my puzzle in an imagination of white gaslight shining out bravely from a city of dim yellow candle flames. But the fact, as she reported it, was that gaslight was still a decade in the future when Arnold wrote the verse, so that we must imagine the light in the valley below the scholar-gipsy to be nothing more brilliant than candlelight after all, flickering behind the long windows like the flickering flakes of blizzard on the hill. It reminds the modern reader just how little light a town would have shown from a distance, even as late as the mid-nineteenth century; how scant the light which would have appeared at a window or on a street, until candles were widely replaced by oil lamps and later by electricity, until gas or mercury-vapour street lights replaced torches and candle lanterns over doors. How dim and vague a city would have seemed from a distance in fading winter light.

This can be seen in John Baptist Malchair's (1730–1812) haunting *Oxford from Shotover Hill, from Recollection*. This image is dated precisely to 10 January 1791, almost as though it was an urgent record of a dream,

Oxford in a winter dream. John Baptist Malchair, *Oxford from Shotover Hill, from Recollection*, 10 January 1791.

a memory or vision of a darkened city seen in bleak winter weather. A sombrely dressed wagoner has halted his cart in the foreground, where another man is seated by the side of the road, perhaps sketching the view. The middle ground is occupied by featureless tableland, green fading grey, with the straight line of the road cutting across it like a stream. In the distance, down in the sombre valley, is a monochrome dream-Oxford, wound round in shadow and shrouded in river mist. The darkening hills beyond the river seem higher than they are in reality. It is as though the recollected city is lifeless, abandoned, lost in memory.

The city is seen from the west, and while its landmarks are present they are flattened and changed – Magdalen Tower and Bridge, the spire of the University Church, the dome of the Radcliffe Camera are all there, but Christ Church towers have transformed themselves in dream-memory into the paired west towers of some great continental cathedral. The washes of river mist and sluggish water are everywhere: a silvery fog fills the whole valley beyond the city, swallowing bushes and trees, rising to lap at the city walls. No light catches dome or

vane or spire, everything is sombre and remote, and there is no hint of light in any house or college. That is perhaps the single element which renders the image most disquieting. The bleak absence of lighted windows, even in such dull weather, makes the city seem abandoned, recoverable only in the memory of the artist who has sat for a moment on the hill to take a last dream-sight of the misted towers in the valley. It is also a sombre anticipation of the blacked-out Oxford of the Second World War, the lightless city in which Alan Hollinghurst's mysterious and beautiful novel *The Sparsholt Affair* begins.

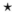

Although Malchair's watercolour hints at the location of the artist within the painting, many of the most memorable evening townscapes show unpeopled streets, many nocturnal landscapes are deserted. This presence and absence can imply mood, choice of viewpoint can encode a narrative. The considerations which Joseph Leo Koerner has applied memorably to the landscape paintings of Caspar David Friedrich (1774–1840)[2] are equally relevant to any attempt to understand English night paintings of the nineteenth and twentieth centuries. An unpeopled landscape or townscape can state a mood, or even imply a narrative, simply by choice of viewpoint. This is inevitably governed by the society for which the painting was made: few people habitually walked at night for pleasure in early-modern Europe, even in summer. From the Romantic era onwards, however, a summer evening landscape is likely to imply a walk taken for reasons of aesthetic pleasure, in a society whose landscape guidebooks had begun to recommend moon viewing as an element of the appreciation and enjoyment of place.[3]

This mood is embodied in Abraham Pether's (1756–1812) *Evening Scene with Full Moon and Persons* from 1801, which could well show a Cumbrian landscape, the upland Britain loved by travellers and connoisseurs of the picturesque at the turn of the nineteenth century. The viewpoint is a small hill above an extensive lake; a villa on a promontary, one room lit, is reflected in its waters. The flooding moonlight catches the smoke from its chimney, the window panes of

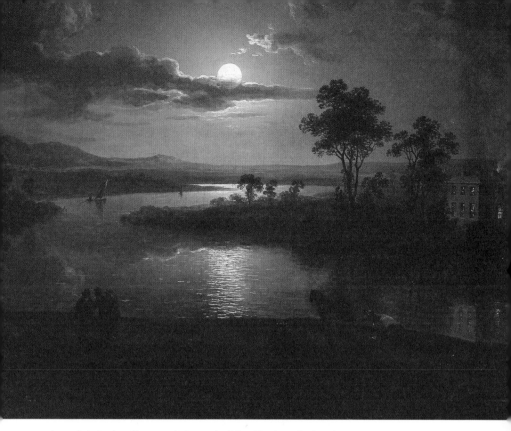

Lamplight in the villa, moonlight on the lake: Abraham Pether, *Evening Scene with Full Moon and Figures*, 1801.

its unlit rooms, and shines brilliantly on waters which stretch away to the mountains in the background. The reflection is so bright that a sociable group of figures on the shore are seen in near-silhouette. Everything about the composition conveys pleasure and repose: the summer trees are in full leaf, the villa offers a hospitable refuge, with its bright drawing-room window just glimmering in calm water, water milky with moonlight.

The same delighted juxaposition of urbane elegance with night in wild country is seen in Humphrey Repton's summer night nocturne, showing a couple in an octagonal pavilion, surveying a prospect of moonlight on the Menai Strait and the mountains of Snowdonia beyond. There are yachts on the water, their folded sails silvered in moonlight. This 'Pavilion and Greenhouse for a Gothic Mansion,' was published in 1803 in Repton's beguilingly illustrated *Observations*

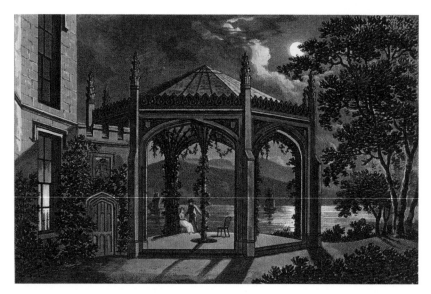

Picturesque landscape by night with candlelight in the window: Humphrey Repton, *Pavilion and Greenhouse for a Gothic Mansion (Plas Newydd, Anglesey)*, 1803.

on the Theory and Practise of Landscape Gardening (1803), and represents part of his 1799 scheme of improvements for the Georgian Gothick Plas Newydd on Anglesey. Ingeniously, the pavilion is furnished with removable windows so that it can serve as a greenhouse in winter, but in this colour plate silvery monochrome represents the moon-haze of the high summer night. The only area of colour is the pinkish-buff light of one candle placed in a ground-floor window, a small light exactly represented, the candlestick just visible behind the panes of glass, and candlelight and moonshine, jasmine and honeysuckle, all combining in an evocation of cultured recreation in the era of the picturesque.

This contrasts with night landscapes and townscapes shown in adverse weather. Such a view of water and mountains would take on a different emotional aspect in winter, one relating to a darker romanticism. While a lighted window seen on a winter night can imply a comfortable homecoming (this is a trope so well established that it has become a cliché of photographs advertising houses for sale), a figure outside a lighted window in winter weather implies disjunction or alienation: loneliness in the dark as opposed to sociability in the

lighted room. In such circumstances, the lighted window can imply mystery, even the uncanny, can hint at social or personal barriers between the lighted room and the figure outside. In twentieth-century European visual art the unpeopled townscape of lighted windows is often melancholy, an expression of loneliness in crowded places. In modern North American painting and photography it seems almost always to speak of alienation, of the unknowable nature of self, place and neighbour, of the lonely vastness of the American night.

The figure of the rejected lover or of the unfortunate outsider, contemplating the lighted house from which they are excluded, recurs often in Victorian poetry and painting. To Arnold's scholar-gypsy could be added Tennyson's rejected protagonists in *Maud* or *Locksley Hall*. The lonely figure in the cold or rainy street, the lighted windows of substantial villas or mansions behind garden walls, bare trees and evening sadness are the chief subjects of the coarsely executed, emotionally powerful paintings of Atkinson Grimshaw. While Grimshaw's compositions of buildings and figures should perhaps not be over-interpreted, they certainly yield readily the kinds of implied narrative which Koerner finds in the viewpoints of German landscape painting. In these paintings of affluent suburbs by night, the first implication is that the viewer is an intruder. These expensive streets are meant to be unpeopled after dark, especially in winter (the shadows of bare branches always underline the season), and this feeling is only reinforced by Grimshaw's frequent *staffage* figure of a maidservant hurrying home with a basket, as though emphasizing that it is the proper condition of these streets to be empty. Where is the viewer positioned in Grimshaw's *November, 1879*? You have just rounded a curve in the cobbled suburban street. This street is high on the slope of a hill, light ahead to the left reflects up into the moonlit sky, hinting at more populous roads, an industrial town in the valley below. The maidservant is walking away, perhaps quickening her step hearing another step on the cobbles behind her. The air is cold and raw: damp snow is still thawing on the pavement, the cobbles are awash with meltwater. The eye is inevitably drawn to the one lighted window

in the substantial villa behind the wall on the right. It is well into the evening now, the moon is high in the sky, and the drawing room is lit after dinner. This is no hour to pay a call, and the viewer's presence in that place becomes uneasy, an intrusion. Why are you out so late, and how do you place yourself in relation to the lighted window, which presents itself so insistently as the goal of your journey?

Grimshaw's *Under the Moonbeams* (1887) implies a variant of this narrative of intrusion: the viewer has just turned a corner in a hillside street of substantial houses where railings on the right-hand side again imply a town in the valley. Again, it is a winter night and the moon is high in the sky. Behind a wall and trees to the left what looks like an older house, a gritstone manor of the north country behind its boundary wall, shows a scatter of lights in ground-floor windows and one upstairs light in a stair-tower or porch room. But there is someone already there, halted, half-turned and looking intensely at the lights. Rather than a hurrying maidservant, this is a woman in what would then have been called walking dress, and she is fixed in her place, unaware that she is observed. Once more, the viewer becomes a disquieted intruder, the unwilling spectator of a narrative of betrayal or exclusion. All the situations of family melodrama come to mind, all the nineteenth-century narratives of disappointed love, of love thwarted by disparity in social station. Or has the viewer come upon a lesser sadness, a lonely governess dreaming of a moment of comfort, permanence, security. The doubly intruding viewer also becomes a protagonist in a double narrative: what has brought you here? Do the gritstone streets hold memories for you as well? Or are your memories of an earlier time, not so very long ago, when these slopes above the foundry were bluebell woods and the garlanded gate-piers of the Old Hall stood alone on a country road? Everything has changed, the place has grown so fast: streets of villas have spread over the wooded hills, the lights of the mills flare up from the valley. Why is there always this sense of belatedness, of returning too late to this northern city, after

Nightfall in a northern city. John Atkinson Grimshaw, *Under the Moonbeams*, 1887.

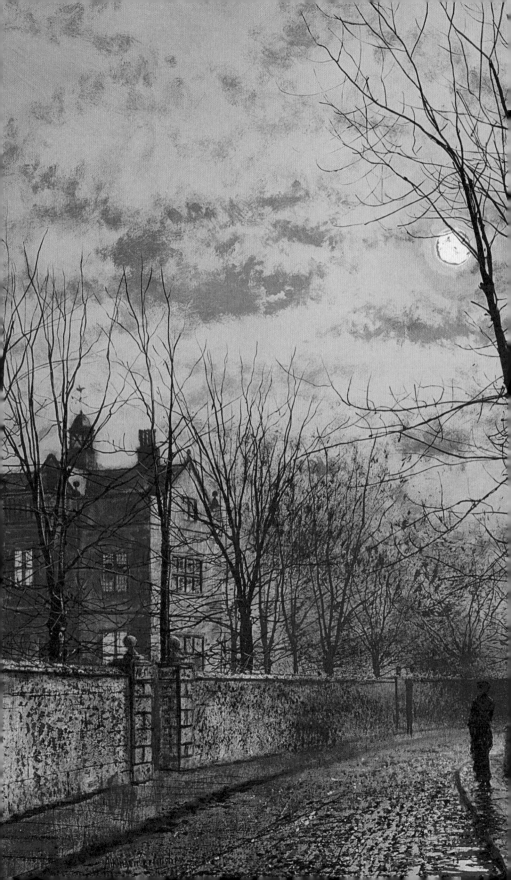

the frosty railheads, the evening trains, the gaslit hotels? Why this unbearable evening longing, and the present which is already slipping into the past as you stand on the rain-slicked cobbles?

<p style="text-align:center">★</p>

Alan Hollinghurst's novel *The Sparsholt Affair* (2017) begins with an exceptional act of impersonation, a nostalgic conjuration of evenings and war and lost time. It assembles its opening out of twilight, evoking a city darkened by the blackout regulations of the Second World War. We are reading an unpublished memoir by a literary man long dead, which has for its subject a ruthless, beautiful athlete, first glimpsed at twilight in a lighted window, on the other side of a quadrangle.

> Tall panes which had reflected the sky all day now glowed companionably here and there, and figures were revealed at work or moving around behind the lit grid of the sashes ... beneath the dark horizontal of the cornice, a single window was alight, a lamp on the desk projecting a brilliant arc across the wall and ceiling ... Now a rhythmical shadow had started to leap and shrink across the distant ceiling ... the source of the shadow moved slowly into view, a figure in a gleaming singlet, steadily lifting and lowering a pair of hand-weights ... he showed, in his square of light, as massive and abstracted, as if shaped from light himself.[4]

This moment brings the first of the haunted lit windows of Alan Hollinghurst's astonishing novel into view, a moment bracketed by history and the night, as the blackout darkens all the windows – 'By dinner time the great stone buildings would be lightless as ruins',[5] and the scout comes into the room to put up the blackout screens.

Later, in the same recollected wartime evening, the narrator walks a friend home along Merton Street, rendered strange by the very absence of lighted windows:

> Now the lane was a little black canyon, its gabled and chimneyed rim just visible to us against the deep charcoal of the sky. Clouds, in peacetime, carried and dispersed the colours of the lights below, but in the blackout an unmediated darkness reigned. I

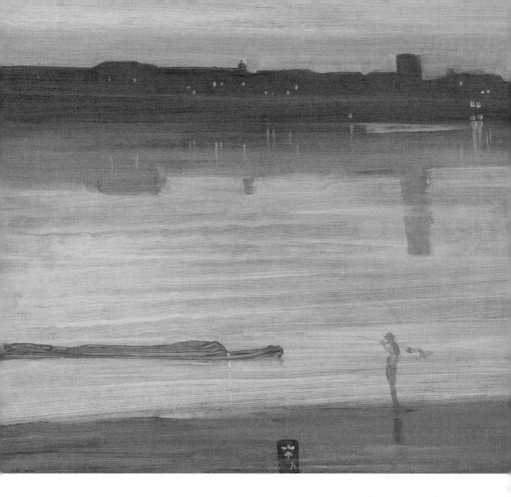

Distant lights across the Thames. James Whistler, *Nocturne: Blue and Silver – Chelsea*, 1871.

thought I knew this street I'd walked along a hundred times, but memory seemed not quite to match the dim evidence of doorways, windows, railings that we passed.[6]

And so the fiction moves onward, haunted by lighted windows and by scenes observed through windows: after an unexpected night together, one of the wartime undergraduates looks out from his window to see the unconcerned Sparsholt running out into the meadows with his fellow rowers; Sparsholt's later disgrace, in a political and sexual scandal, is conveyed by the image of a moving Venetian blind, publicly documented by photographs taken through a window. Other windows and lights haunt that later part of the book which traces the career of

Sparsholt's son: a lamplit workshop during the three-day week, 'the whole crisis was a nuisance and potentially a disaster, but it had these accidental beauties, winter evenings out of the past.'[7] Pictures and windows alternate and change places: young Sparsholt first sees a man reflected in picture glass in the National Portrait Gallery; he returns from a suburban auction laden with a lot of picture frames; he looks deep into the 'small miracles of observation' in a Whistler *Nocturne*; a street lamp casts 'autumnal gleams' in through the open curtains of his London room.[8]

All of this is most subtly prepared by the opening wartime memoir: more lighted windows attend the last glimpse of Sparsholt in Oxford High Street – 'the glowing windows of the Schools across the way looking almost friendly in the bitter December morning'.[9] 'Alarming as well as splendid',[10] the undergraduate Sparsholt vanishes from memory, and thus this pitch-perfect, exquisite memoir fades out with the image of Sparsholt running in the cloud of his own breath. (The attentive reader guesses by the end of the novel that Freddy Green never published anything as fine as this memoir, written for a memoir club of friends but never read to them, found among his papers.) The perfectly voiced record of moments of light in wartime Oxford acquires a distanced yet urgent status: witnesses to Sparsholt's youthful beauty are dead and dying. These recollections were found unpublished after their author's death; the student artist who drew him naked was killed in the war. The last flickering apparition of Sparsholt is on the other side of the wartime traffic, in the winter light of lost years: the handsome runner is 'first here, then there, then no longer there, as if swallowed up by his own momentum'.[11]

Floodlit sports fields in the urban night seem nostalgic today, larger versions of lighted windows, the dead-whiteness of the light heavy with pastness, like a photograph from the last century: white-lit, white-lined fields cut out from the dark with their inhabitants running or passing a ball in a territory as distanced as the screen of a cinema.

Mist-drifts or scuds of rain moving grey-silver under the light towers, passing through territories of monochrome. Pavilion lights on winter afternoons (or the window lights around playing fields) brightening as the light fades, then beginning to spill just-perceptible paths of light onto the grass, so that the weary players have ghost-shadows for the last few minutes of the game.

Or suburban fives courts, thirty years ago, boxes of white light and smoky breath in the night, blazing out cold among the soft yellow windows of the Gothic villas on winter evenings after the clock had gone back. On those nights, frosts iced the mash of fallen leaves on the pavements so that I slithered as I jogged home, high on exhaustion, moving through an evening townscape of lighted drawing rooms, like a memory of Grimshaw's paintings, turning a corner into moonlight and sprinting for home on the silvery pavement. Even today, a sense of pastness attends the University running track in Oxford on autumn and winter nights, floodlights and rain silvering the white singlets of the runners into old film, so that the lights of the Victorian terrace at the top of the slope lose their colour, like the flames of the first autumn fire in the hearth turned white by low sunlight.

Other Oxford winter evenings bring their lighted windows to mind. Lincoln College Chapel: cedar panelling, stillness, candlelight. The proportions of the walls and windows are quietly beautiful in themselves, a gentle Laudian simulacrum of the Temple of Solomon. Shadows cluster up under the ceiling. Above the heads of the congregation, the windows in the north and south walls show as blank, dark as the night behind them; their geometries of stone frame only darkness. Where I am sitting, I can only see the dark, but that temporary blindness is a trick of daylight and lamplight having changed places at nightfall.

In pursuit of this thought, I imagine being in the quadrangle outside. Light moves both ways, as we are reminded every nightfall. Anybody standing outside at this moment would not be seeing darkened glass, as we see it, but coloured windows shining with the figures of the Prophets, our lamps and candles behind them, giving them visibility

and life. The figures would appear glorious, lit from behind by that same light which falls on prayer books and music books within. In the centuries when the chapel was lit by candlelight alone, the robes of the figures in the glass would have seemed to stir as the air, the breath of the singers, played with the flames inside. I try to imagine what it would be like to stand outside while the Magnificat was being sung. Such a moment would offer the kind of vision of light in darkness, transfiguration and music which has been associated through the centuries with the anticipation or imagination of heaven. At such moments, such lighted windows of coloured glass can act almost as thresholds or doors, glimpses of light beyond the candlelight.

I think of other lights which shine in more than one dimension. In the undecided days between the end of term and Christmas, my friend Gerard arrived from Krakow, where he is Professor of English Literature, and we talked for a long time after dinner. It was a mild, foggy night, wholly unlike the freezing river mists of forty years ago, so he offered to walk halfway home with me, as far as the river. Still talking, we diverted into the Head of the River pub, crowded out in summer, empty save for us on this winter night. We took our drinks to the window, looking out on mist coming and going on the water; mist visible for moments in the light from the windows, in the street light spilling down from the bridge. The flats above the boathouse opposite showed lamps in their windows, and they trailed their reflections in the water.

It offered an almost perfect visual rhyme to a woodblock print by one of the twentieth-century masters of that technique, Kawase Hasui (1883–1957), an artist wonderfully skilled in the deployment of those blue pigments which had entered Japanese printmaking in the nineteenth century. In many iterations, one of his favourite themes is a street or village at nightfall, dusk and lighted windows. His 1930 print of Omori Beach is set at late twilight, so late that the tone of the sky and its reflection in the water is turquoise rather than cobalt. Clouds are lifting and clearing over the modest houses with little wooden piers which line the beach. The composition is governed by the three perfect

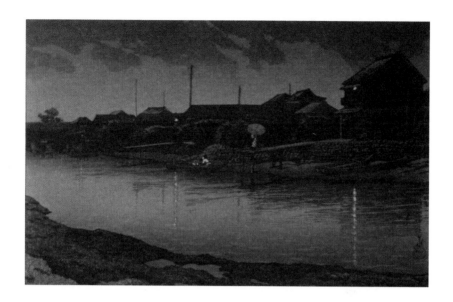

Still blue evening, yellow lamplight by the water. Kawase Hasui, *Evening at Omori Beach*, 1930.

vertical yellow lines which represent the threads of reflected light from three lamplit windows. These verticals are counterpointed by the posts or telegraph poles which break the skyline. Children are playing by the water, a woman with an umbrella stands on one of the piers. A restricted palette has been used with great skill to suggest gradations of deep shadow over the differing textures of the rocky shore, wood and lumber in the yards behind the houses, a stone retaining wall. The mood is serene – stillness and quiet with no suggestion of regret, just a tremor of evening wind to shake the threads of reflected light.

Prompted by the scatter of lights across the Thames, by the occasional bicycle lamp approaching on the towpath and then vanishing behind the boathouse, Gerard told me how, a few weeks before, a young Jesuit friend had driven him halfway across Poland by night after the installation of the archbishop of Łodz, driving for hours on end through the early-fallen dark of All Souls' Day. As they travelled on the empty roads, Gerard had begun to notice scattered constellations

of lantern lights at the edge of every village, as though the lights from the darkened houses had migrated into the lights of the candle lanterns placed on graves all over the country. So it continued for hours, driving through great tracts of land with lights showing only in the houses of the dead.

We fell silent for a moment, as I tried to imagine those points of light, the cold roads which they had traversed, the November wind moving over such vastnesses of Europe. Outside the window, the mist had lifted a little and the reflections of the lamps in the rooms opposite cast ladders of light almost across the river. We reached for our coats and moved out through the deserted beer garden.

When we said our goodnights at the end of the bridge, the lamps in the boathouse windows had gone out, the mist had thickened again, and the damp in the air made blurred golden circles around the street lights. Gerard started off back into town, I began to walk home over the little footbridge beside the Folly, thinking of the mild damp night and how cold winter weather has retreated far into the north now, to the Pennines and beyond. Gone are the glittering city pavements, the bright winter light over frosted furrows, the skies under which my past winters come to mind.

I thought of a visit, the December before, to the northernmost slopes of the Pennines. The beautiful house sits withdrawn amidst its trees, on the edge of a village which lies remote in the bare, snow-mottled fells. The house is a wonder: master mason's baroque, rough felicities of carving and panelling everywhere. On the freezing midwinter day of our visit, after our long drive over the uplands, the garden was grey with cold, shadow and frost. Everything within the house is of great beauty, and comes out of the cosmopolitan shadow-world of the English Catholics: portraits of priests, of clerical savants, Italian buildings painted in grisaille. There were fires burning in the bright grates of library, drawing room, dining room. There were silver cups from Lancashire race meetings down the centre of the table. On that dark day, it displayed its own hybrid perfection, an outpost of the south in the north.

A friend, a curator from London, was sitting at my right, at the end of the long table, with the dining-room window behind her and the lawns and yews outside. We had been talking about candlelight, and how small flames draw moonlight flares from silver on a table, as the candles before us were doing as the light began to dim outside the windows, and the talk ran on to the lost beauties of glimmering stuffs in the centuries of candlelight. We talked of the strangeness of our own time, which has achieved great authenticity in the performance of baroque music, but which rarely looks at works of art or textiles in the lights for which they were made. We talked then about the candlelit viewings of the Soane Museum, of the pub in Cambridge which has firelight and candlelight on winter evenings, of Shakepeare's lovely phrase in *Cymbeline* for the polished metal of the andirons, the 'winking Cupids / Of silver' which glimmer in the firelight.[12]

Then she told me about a summer evening when the light of the past had been remade in the present. In Spitalfields in London, that enclave of surviving eighteenth-century streets, when the late Dennis Severs was still the curator of his own candlelit Georgian house in Folgate Street, he had contrived a festive gathering in one of the narrower roads. So Elder Street was lit from end to end by candles placed in ground-floor windows, by the occasional lantern at a door. Drink and talk, and people rustling to and fro in the warm air and the soft, unfamiliar light. She said that it was one of the most extraordinary things she'd ever seen. Once eyes had adjusted to the dark, to candlelight falling momentarily on a passing human face, faces were transformed and beautified, being caught for a moment by the subtle light seeping from the windows. Masks and countenances moving in and out of the dark, and the soft transforming glow coming and going the length of the street.

The northern winter day was fading behind her as she spoke, and snow was falling hesitantly, sparsely, on the darkening yews beyond the window. On maculate lawns, on the fast upland stream at the foot of the garden, on the treeless Pennine hills beyond.

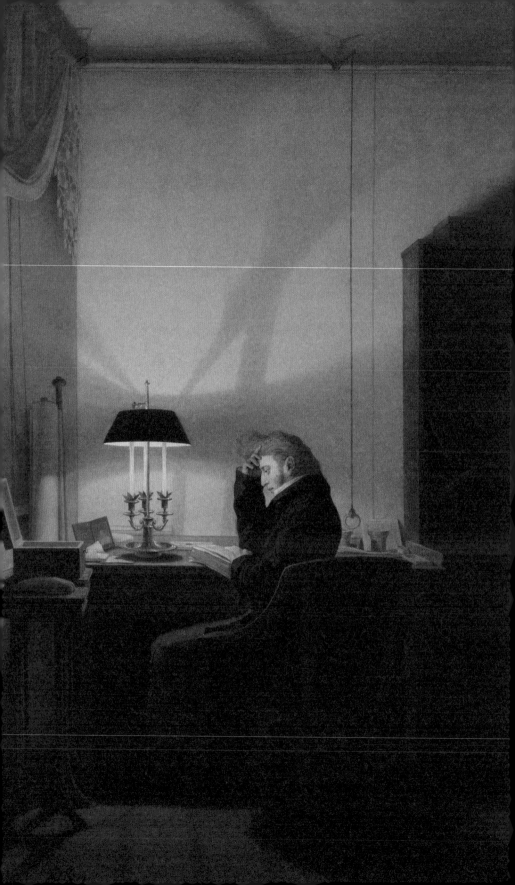

ONE

WINTER CITIES

The Augustijnenkaai in Ghent was silent except for the faint stir of the willows along the water. The street lights had come on early on a winter evening: lights trailed in the canal, glowed behind sparse leaves, glimmered over wet cobbles. Elegant, substantial houses of all eras from the late Middle Ages to the nineteenth century lined the quay, and all were unlit in this early evening, dark as the apparently deserted villages seen from the train from Brussels at dusk the day before. Stepped gables, a palace front with a central carriage entrance, the long blank wall of a convent.

We walked to the bridge at the corner and turned back down through the cobbled square on the other side, its houses lightless also – handsome renaissance houses with stepped and carved gables. Then a light kindled between the willow leaves, reflected in the dark canal, and yellow lamplight shone out from a ground-floor window in the only small house on the quay. Then the gap between hanging branches gave us a glimpse into a comfortable room, the corbelled beams of the ceiling painted yellow, a standard lamp beside a green sofa. A fair-haired young man was standing by the lamp, reading the newspaper. The moment was both haunted and haunting, seeing the

The lamp by the window. Georg Friedrich Kersting, *Lesender bei Lampenlicht* (*Reader by Lamplight*), 1814, detail.

one lit room and its watery reflection amongst so many vast, dark town-palaces, in a city which seemed all but deserted at that hour of the evening.

We recrossed the canal and pressed on to the restaurant called De Lieve on the next corner, its lights spilling across the crossroads where the lit trams passed, crossed and returned all through our quiet dinner, their lights doubled dimly on the wet surface of the empty streets, reversed in the mirrors behind the bar, so that if two trams passed each other at the corner the movement of their lights in the mirrors became for a moment kaleidoscopic. We wandered back through quiet streets, down alleys and along the quays, the houses now showing a few lights, some ground-floor rooms still with uncurtained windows, as was the old custom of the Low Countries. This custom is peaceful and reassuring – the succession of quiet domestic interiors glimpsed from the corner of the eye in passing; the small pools of light spilled from them onto the pavements of those strangely quiet streets, those streets with their sparse lights and watery reflections evoked so completely in Alan Hollinghurst's *The Folding Star*, in Rodenbach's *Bruges-la-Morte*, in Magritte's series of paintings which share the title *L'empire des lumières*. These versions of *The Empire of Lights*, painted between the 1940s and 1960s, all show variants of the same irreconcilable reality: a finely rendered night-time street, with street lamps and lighted windows, lies below a radiant daytime sky. In the version from 1954 in the Royal Museums of Fine Art in Brussels, the street is unequivocally Flemish, a canalside or riverside, with nineteenth- or early-twentieth-century brick and stucco houses. It is late, at least at ground level, and the quay is deserted. An exceptionally tall tree – a forest tree, not an urban tree – is planted on the quay, and its branches are as dark in the upper part of the picture as it is in the lower. Disquietingly, it seems to have (or lack) its own light source. The waters of the canal mirror the night street with no reflection of the radiant sky. The shutters of the stuccoed house are closed, and the lit windows in the brick house are those of

Houses of dreams by the still canal. René Magritte, *L'empire des lumières* (*The Empire of Lights*), 1954.

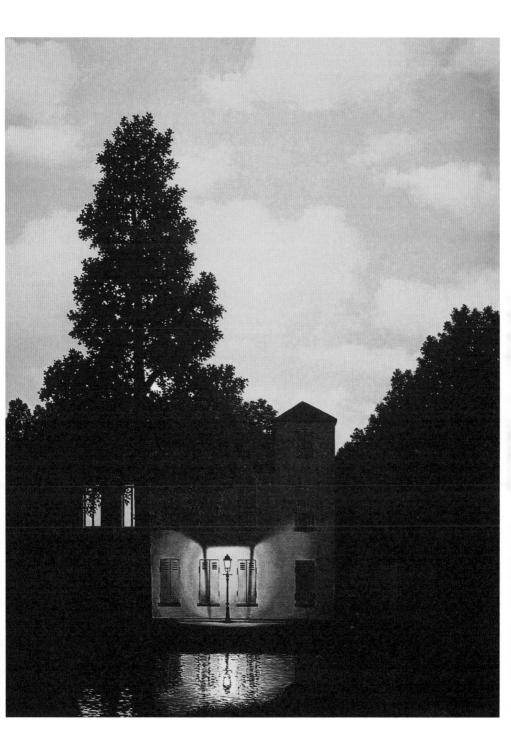

an upstairs bedroom. Some versions of the picture bear the alternative title *The House of Dreams*. One house is dreaming already; the other is near to sleep. The park beyond the railings and the radiant sky are as mysterious as if they formed part of the scenography of the dream: dark below and day above.

The disordered climate presented us with a simulacrum of Magritte's painting in Oxford on Christmas afternoon, clear and chill at dusk after clammy months of unrelenting rain. As I walked along the towpath with my friend Catriona and our dogs, all the football pitches to the south lay under a sheet of water: Brasenose Field flooded, Queen's Field drowned. An angry orange-turquoise sunset flared behind the houses in the Abingdon Road, which were already showing a few lights in their windows. The groundwater lay perfectly still, so that buildings, sky and lights were all reflected, with a strip of darkness along the fold where reality and reflection met. Sitting on this line, in the shadows of the hedges, were the cold white lights of Brasenose Pavilion, mirrored in the flood, disturbing the apparently flat screen of houses and their inverted doubles, their drowned lighted rooms. The flood, cloud shadows and fermenting sky, composed an extraordinary, sad simulacrum of Magritte's painting: dark below and day above. The rain began again, with sorrowing persistence, soon after nightfall.

More than any simple painting of Low Countries streets, *L'empire des lumières* evokes for me the long series of afternoon walks which I took thirty years ago with my art-historian friend David Mees, through Leiden, Amsterdam, the Hague. The contrasts of dark and bright in Magritte's picture evoke realities as much as dreams: towards the end of clear autumn afternoons, the narrower streets would already be dark with their lamps coming on, while it was still possible to glimpse the late bright yellow in the sky beyond gables, roof tiles and spires. We walked endlessly, tirelessly, while he taught me the vernacular of Dutch brick architecture, the shaping of the water towns of the northern Netherlands. At that time, the custom of leaving windows uncurtained was almost universal, and as a result he was able to talk me through the interior architecture of the seventeenth and eighteenth

centuries as we walked along the patrician canal, the Rapenburg, over the brick paving of the narrow lane to St Peter's Church, passing on the corner the ancient bookshop called the Templum Salomonis, into the Herensteeg, over the bridge and down into the quiet side canal of the Vliet, with its regular trees along the water and the yellowing rose briars growing up the neat brick walls of the houses. What an extraordinary succession of rooms presented themselves to us in the lighted windows of early evening: perhaps the most surprising came very near the beginning of the Rapenburg, just past the antique shop with polychrome statues in the window, a mysterious shop which was never open.

Through long windows, the ground-floor saloon could be seen, painted around the walls with a continuous view of a formal garden, as though the room itself were a shaved lawn or bowling green, a place where the shadowy alleys of clipped trees converged below an evening sky. There were plain modern desks with lamps in the room, but its strange apartness remained intact, so that the modern furniture looked uncomfortable and transient. The quality of the painting was very high, so that, looking in from the street as the light failed outside, the eye was led down fictive hedged walks, coming to rest by a fountain or half-seen statue. The sporadic illusion created by painted rooms can be disquieting in itself, in this room painted with a maze-like garden especially, multiplying paths and perspectives, feigning shadowy places. I came upon another of the same kind, wandering one spring evening in the streets around Falkner Square in Liverpool, a lighted ground-floor window showing a continuous painted panorama above the dado of what must have been a fairly small sitting room: dark trees with a hint of a valley falling away beyond to a river, completely unexpected, wonderful, and strangely in accord with the geography of the real city sloping to the Mersey.

We moved onwards through the old streets in Leiden and past the lighted windows: painted beams lit from below; a ceiling with an oval of dusk-yellowed clouds and swallows in flight; a curving rococo chimney breast with a panel of doves and flowers. A raised ground

floor, up a few steps with a curving balustrade, and a glimpse of verdure tapestry and silver sconces.

Almost always these lighted, beautiful ground-floor rooms were empty, as the streets outside were also almost empty at nightfall. Sparse footsteps on brick paving, the rustle of chestnut leaves, leaves turning in the street light as they fell to the canal, their yellow stars floating on the black water. Perhaps, in truth, the inhabitants of streets and rooms were simply gathered around tables at the backs of their houses, perhaps there would be more people in the streets later on, but the feeling and illusion of that hour were ghostly, as though these fine, lit, unpeopled rooms were anchored insecurely in time. (I felt this if anything more acutely more recently, walking on an autumn evening along the canals around the Prinsenhof in Delft: a feeling of obtrusive hauntedness caused by the sheer emptiness of the streets, the consistent vacancy of the lighted ground-floor rooms.)

This same emptiness characterizes Gerard Reve's desolate novel of the Netherlands immediately after the war, *The Evenings*, with its young protagonist driven out from the family home by devouring boredom, evening after evening. Much of the alienation of Frits van Egters is conveyed by the very absence of lighted windows, of domestic lives offered to public view, in the anonymous winter city where the novel takes place. He hurries, head down, through freezing streets to meet with half-indifferent old school friends, inhabitants of underheated rented rooms. The war is barely mentioned, but their jokes are all narratives of disaster; there are endless small acts of violence against insects and animals; the horror and tedium of war and occupation are clearly only just over. Everybody in the novel is damaged; nobody in the novel talks about the recent past. At one point, on New Year's Eve, when neither family nor civic community offers Frits any kind of light or comfort, he finally formulates a wartime image for his own loneliness:

> 'So here I am standing in this darkened doorway,' he thought, 'like a spy. What else am I if not a spy? ... Peering out from darkened rooms into lighted streets. And so it is.'[1]

His image inverts the customary affirmation of community offered by the uncurtained, trusting windows open to the view of the Dutch streets. He hurries to his joyless home, traversing a city emptied by his own misery.

This emptiness is as disquieting as the illusions with which Magritte conjures in another of his transformations of a quiet street in the Low Countries, *La bonne aventure* from 1937, in which a night sky and sickle moon have invaded the foreground shadows, while the lighted windows have become holes in the facade, looking through to a sunset sky and bare trees: the facade of the houses subtly displaced in space, season and time.

There was a pair of windows in Forth Street at the eastern end of the New Town of Edinburgh which also seemed to be loosely anchored in time, offering a momentary glimpse of a different reality beyond. I noticed it particularly not long before nightfall, one evening just before Easter five or six years ago. I was walking towards the junction with Union Street; the lengthening day had just moved into twilight and there were a few lights in the windows – sparse lights on the eve of a holiday in a street of classical stone houses and tenements, which are mostly offices. Then I saw a pair of upstairs drawing-room windows which showed a reddish, flickering light – the steep angle looking up from the street disclosed only a triangle of the fireplace wall, but I could see that there were six candles lit on the mantelpiece of what seemed otherwise an empty room – no pictures and no curtains, shutters open, the panes of glass in the window very clean. The effect was oddly memorable – another instance of the unknowability of upstairs city windows – as if that apartment were occupying a different epoch from the rest of the darkening street.

Two years later, after dinner in Oxford, on a rainy night at the ragged end of winter, I fell into conversation with a postgraduate philosopher from India who had studied in Edinburgh – I think he said that he was the sixth generation of his family to go to school and university in Britain. It emerged that he had lodged as a student towards the eastern end of the New Town, and that he had walked much about

the city by day and night, so I asked him if he had ever noticed anything in Forth Street. He said that he had often thought how strange it must be to be one of the few residents in a street of offices – 'and then there were those windows with the flickering light'. He too had noticed them on many occasions, had tried various narratives over in his mind to account for them, had even once thought of trying the main door and going up to ring the doorbell of the flat, but had decided in the end that he preferred not to know. This minor mystery added to the enchantment of a city of regular, even monumental, facades concealing fine, fantastical rooms, like the delicate *trompe l'œil* rococo panelling in the ground-floor drawing room where Nelson Street doglegs into Northumberland Street, visible only at twilight in the ten minutes before the shutters are closed against the night and the north wind off the Forth.

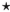

In the ghost story *Number 13*, by Edwardian master of the genre M.R. James, the supernatural shows itself literally in a shadow cast by such a light from the past shining through a window of a later time. A scholarly English traveller lodges in a Danish provincial city, staying at an inn once a city mansion owned by the last Catholic bishop, and investigating the town archives for papers relating to the reformation. The building is changed at night, so that its room divisions seem to shift, and a room numbered 13 forms itself in the hours of darkness out of parts of the rooms on either side. The first glimpse of the revenant or demon inhabiting it is a silhouette seen by the protagonist as he smokes at the window of the neighbouring room:

> The light was behind him, and he could see his own shadow
> cast on the wall opposite ... also the shadow of the occupant of
> Number 13 on the right. Number 13 was, like himself, leaning
> on his elbows in the window-sill looking out into the street. He
> seemed to be a tall thin man – or was it by any chance a woman? –
> at least it was someone who covered his or her head with some sort
> of drapery before going to bed, and, he thought, must be possessed

of a red lamp-shade – and the lamp must be flickering very much. There was a distinct playing up and down of a dull red light on the opposite wall.[2]

It is a frequent motif of supernatural narratives – the house that alters, even appears or disappears, in hours of darkness, but seldom is it more economically handled than here. The traveller's researches produce little: only that the last Catholic bishop was protecting an individual said to be a sorcerer who lived in a substantial house in the old town until he died a sudden death. (So often, in English tales of terror, it is Catholicism which is associated with the diabolical: renegade or lax clerics, demonic practices or actual demons which return with a young traveller from a tour in the South. It is as if the Old Religion is a phantom still haunting the temperate Edwardian closes and lawns inhabited by James and his contemporary John Meade Falkner.)

As the inhabitants of the inn begin to investigate the phenomenon of Number 13 – of which the landlord had only received hints before – whatever is in the room begins to sing and to laugh and, when they are waiting to break down the door, a hand emerges, like the hand of a shrouded corpse, clawing rather than striking. (Many of James's horrors have this quality of fumbling or clumsiness, as though they are blind or only just awakening in the world of humans.) Perhaps the intended victim is protected by his having instinctively uttered the apotropaic final verse of Psalm 150: the creature retreats, and the room vanishes with the first cockcrow. An illegible manuscript is found under the floorboards, and once it is taken out of the inn the visitations cease, so that the unnatural lighted window is never seen again.

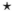

Magritte's *L'heureux donateur* (1966) feels intensely haunted, a picture which suggests a narrative of memory or revenance. It is proverbially futile to attempt any concrete or narrative reading of Magritte's works: it is better to approach them with a sequence of associations and possibilities. In *L'heureux donateur* there is a hole in reality in the shape of a conventionally dressed man. Within his outline is a landscape of

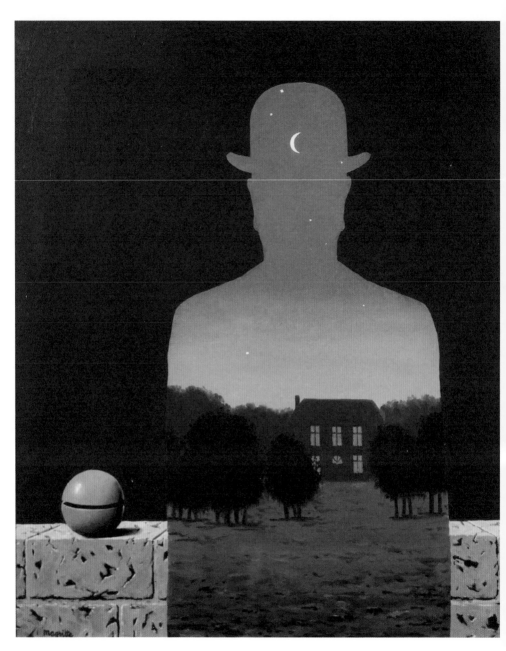

A shadow with a haunted house for a heart. René Magritte, *L'heureux donateur* (*The Happy Giver*), 1966.

grass and trees on a cold winter night, almost a park landscape, but the grass is rough, uncropped, ungrazed. The ground is white with frost, and a sickle moon and the evening star are rising in the distant sky. Yet the frosty grass appears to be drenched by moonlight from high above. Light rising amidst the cold clouds on the horizon hints paradoxically at moonrise, although there are (the painting implies) already two moons in the sky. Some way off there is a house with all its windows alight, lit with a deep flame-coloured light like firelight, so that the structure of the house itself is indistinct in shadow and feebly lit by the dream-moonlight. It seems to be a brick suburban villa rather than a country house, a house quietly discordant, out of place. There is no visible door – although bright light glows in a fanlight – and certainly there is no path or drive leading to the house, which rises abruptly out of the frozen grass.

The outline *Rückenfigur* is poetically ambiguous, standing as it does in the relation to the lit house of a traveller returning homewards. But the figure's sheer otherness, the fact that its outline has been cut out of another reality and a different sky, also suggests that the figure menaces the house which he approaches. It is an image which seems to want to speak about memory so devouring as to cut the one who remembers loose from time. It speaks obliquely about present and the past as represented by the two realities which coexist in the painting. It seems to carry also a fragment of narrative about revenants and unwelcome visitors, about the dream-condition of standing behind the hollow, dimensionless figure who approaches, or even menaces, the dream house. Or perhaps, as in dreams, the figure cannot advance over the frozen grass and the viewer who stands behind his transparency is rooted also. However we read the picture, we are left with the initial image of a man with a haunted mansion where his heart should be.

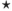

Perhaps the first perception of a new kind of urban poetry, dependent on darkness and artificial light, came in early-nineteenth-century Dresden, in the works of Johan Christian Dahl (1788–1857) and Carl

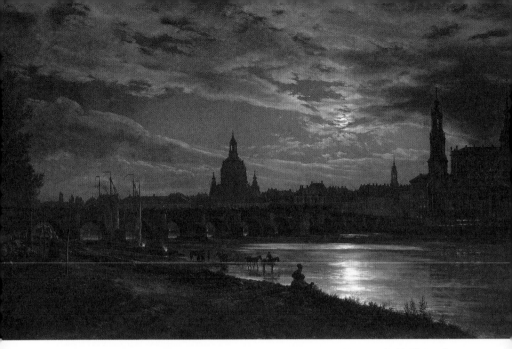

The moonlit and candlelit world of Romantic Germany. Johan Christian Dahl, *Blick auf Dresden bei Mondschein* (*View of Dresden by Moonlight*), 1839.

Gustav Carus (1789–1869). As with so many developments in the visual arts at the turn of the nineteenth century, restrictions on travel during the Napoleonic Wars combined with a new focus on the romantic potential of northern Europe, to turn the attention of artists to the towns and landscapes in which they spent their lives. It is also highly likely that the bright-burning, round-wicked lamp, invented in 1780 by Aimé Argand, played a part in popularizing paintings with a sombre, nocturnal tonality, since they could now be appreciated by artificial light. Indeed the brighter window light which these lamps generated, and even the lamps themselves, appear in the work of several painters of the Romantic period in Dresden.

Johan Christian Dahl's 1839 *View of Dresden by Moonlight* offers a meticulous depiction of a combination of natural and artificial night lights. This painting is of a piece with Dahl's other innovations in the precisely observed depiction of northern European season, light and weather. Here he paints a summer night of full moon, with a light breeze lifting the pennons on the masts of the boats, ruffling the moonlit water of the Elbe, moon and water perfectly observed. There

are little tar-melting fires on boats; fires along the foreshore; women are hanging out clothes to dry in the moonlight. There are almost no lights showing in the town, although there are brilliantly illuminated windows in the riverside building, which was originally the lodging of Italian craftsmen working on the *Residenz*. These lights are warm in tone, like lamps on tables: the bright lights of a place of entertainment. In contrast there are only glimmers of pale light in the Palace quarter: a few candles in a first-floor saloon, and in an upstairs room. These contrive to be evocative, even mysterious, touching on the fantastical world of the writer and musician E.T.A. Hoffmann (1776–1822), who was himself with a travelling opera company in Dresden in the catastrophic time of the Napoleonic Wars. These sparse lights bring to mind the strange figures who flit from princely court to princely court in the Germany of his imagination: haunted musicians, bizarre savants with more than a hint of necromancer about them. It is easy to imagine that the candles in the palace half-light a mirrored room in which there is a reading of curious narratives set in just such princely capitals on nights of full moon. After which the inventor, the violinist, the ghost-seer disappears back to his lodgings through the moony streets, and his courtly audience retire to a restless sleep, broken by the moonlight through the high windows.

Moonlight and little fishermen's fires are also the lights of Caspar David Friedrich's summer nocturne *Lonely House by the Pinewood*, which he painted in the 1830s, when he too was living in Dresden, at the stage in his career when he was solitary and withdrawn, his work already falling out of fashion. It is an image of lonely serenity: governed by the profound purple-blue of the night sky, which is reflected in the marshy waters in the foreground. The dim crescent moon is rising, diffusing misted light on the wooded slopes in the distance. The composition is shaped by the two small, human lights of a lamp in the cottage and a fire outside it. Both are precisely reflected in the sluggish waters, lapping gently into the reflected moonlight and starshine which glimmer on their surface. For all its serenity, the image is a lonely one: the finely rendered glimmers of human light only emphasize the

extent of the surrounding solitude. And the viewpoint, and thus the implied position of the viewer, is a strange and ambiguous one on the watery land in the foreground. There appears to be no secure way of approaching the cottage by land: the light is too dim and the marshy land too uncertain. But with a boat the whole landscape could be traversed and enjoyed with dreamlike ease: everything ambiguous would become serene.

It is extraordinary how closely the mood and setting of this picture accord with one of Schubert's most atmospheric songs, 'Des Fischers Liebesglück' (The Fisherman Happy in Love), written in the November of 1827.[3]

As with several of his most compelling, most intensely felt songs, the vocal line of 'Des Fischers Liebesglück' moves at first in steps, in intervals of a tone or semitone, with occasional stark leaps and falls of a fifth or octave. Apart from these octave leaps, the vocal compass is notably restricted. In this, and in the step movement of the melody, there are resemblaces to two other strange songs: the 'ghost voice' of *Thekla* (1817) setting Schiller, and the deluded voice of a man suffering from exposure in 'Der Leiermann', the last song of *Winterreise* (1827), setting Wilhelm Müller's narrative of the outcast lover wandering in the snow. In 'Des Fischers Liebesglück', an infinitely happier song, there is a small element of tension between Karl Gottfried von Leitner's short-lined, close-rhymed, rapturous text and Schubert's mostly minor-key, half-voiced setting, which modulates gently into the major only at the midpoint and close of each stanza. It is as if Schubert's murmuring, minor-key music is eloquent of the starry night and of the secrecy of the lovers' meeting, whereas the major key at the half-close and the major key with a sighing turn at the full close convey the rapture of a reciprocated love, one that transcends the immediate surroundings of water and willows and the lighted window of the beloved's house, and offers the lovers at last an imagination of an apotheosis in the summer sky.

The lighted window of the beloved's room takes up the whole of the first three stanzas of von Leitner's poem – establishing a scene which

Blue dusk and lamplight on the waters. Caspar David Friedrich, *Einsames Haus am Kiefernwald* (*Lonely House by the Pinewood*), 1830s.

is very close indeed to Friedrich's painting: the light which shines out from the window of the beloved, flickering through the willow leaves and the reflecting waters, like an *ignis fatuus* through the blue world of the evening

> Dort blinket
> Durch Weiden,
> Und winket
> Ein Schimmer
> Blaßstrahlig
> Vom Zimmer
> Der Holden mir zu.

(Now it shines through the willows, a shimmering light shining out from the chamber of my beloved.)

And all of the waters and the mild breeze combine to bless the innocent lovers. The short lines are like the quiet ripples of inland waves, the light splash of the directing oar, under the blue night. And in the last stanza the stars seem to invite the lovers to rise in spirit into their sphere.

In context, the strophic repetition of the melody emphasizes the unity of feeling throughout the song, the contemplation of good fortune in love, in place, time and season. So much so that the last cadence of the final verse, with its little melisma seems to express an absolute and paradisal contentment, wholly in consonance with the profound calm of Friedrich's blue-purple sky and crescent moon shining on the waters.

Schubert's song 'Auf der Bruck' (1825), setting a poem by Ernst Schulze (1789–1817) from a decade earlier, offers a much stormier, more troubled, juxtaposition of a traveller and a distant light. The song drives forward, repeated notes in the pianist's right hand counting the rapid hoofbeats of a galloping horse, travelling on the wooded ridge near Göttingen called *der Bruck*. At first it seems as if masculine energy is happily matched by wild weather as the singer rides for home at a gallop through night and rain towards the distant light which (at least in anticipation) will shine up from the valley. The song develops, and reveals the subtlety of Schubert's reading of the poem, mostly in the way that the repeated figure in the accompaniment changes its meaning: what begins as the onomatopoeic thudding of hooves in wet woodland rides becomes by the end of the song a representation of the obsessions which drive and menace the poet.

At first the minor key which predominates seems to evoke the wild night and the responding energy of horse and rider: it feels by the end of the song as if it also represents the fixations which dominate him – hopeful excursions into the major key never last. The minor key always brings back reality and the rainy night, and self-delusion and the thudding hooves.

Frisch trabe sonder Ruh und Rast,
Mein gutes Roß, durch Nacht und Regen![4]
(My good horse, trot quickly, tirelessly
through the night and the rain.)

Only in the opening does the journey seem straightforward or
appealing, participating in the Romantic delight in night and storm.
Almost at once the simplicity of a homecoming at the journey's end is
expressed with reservation, only as a conditional in the future.

Dehnt auch der Wald sich tief und dicht,
Doch muß er endlich sich erschliessen;
Und freundlich wird ein fernes Licht
Uns aus dem dunkeln Tale grüßen.
(Although the wood is dense and deep, in the end it must thin out and
a distant, friendly light will shine out to greet us from the dark valley.)

More hoofbeats, more bluster and storm, precede the crucial admission
of the poem that the poet has not been strictly faithful even in a short
absence, and that he does not return to love but to his sorrow – or
that is how he phrases it.

Und dennoch eil ich ohne Ruh,
Zurück zu meinem Leide.
(And yet I hurry without rest, back to my grief.)

The poet is entirely focused on his own divided feelings about his love;
he says nothing about his beloved, nothing about external circum-
stances. The expert eye and ear of pianist and scholar Graham Johnson
expounds the way in which Schubert's music comments on this:

The stormy interlude between verses 3 and 4, different from the
others, struggles to take new directions, but governed by a fixation
stronger than its longing for freedom, it returns to the home key
for the final verse.[5]

The last stanza (as set by Schubert, who rearranged its lines) begins
with the assertion that love will find a way as surely as the migrating
birds, even as the singer dramatizes his night ride:

Drum trabe mutig durch die Nacht!
Und schwinden auch die dunkeln Bahnen,

(So trot on bravely through the night,
even though the tracks fade in the darkness.)

What might have seemed gallantry at the beginning of the song now
seems mere masculine folly, spurring the horse on through the dark
even though no longer sure of the track. And at once this is complicated
by the bland assertion that those dangerous personifications desire and
anticipation will be sure pathfinders through the night.

Der Sehnsucht helles Auge wacht,
Und sicher führt mich süßes Ahnen.

(The bright eye of longing is on watch,
and sweet anticipation is my reliable guide.)

Johnson reads the music which concludes the song as a negation of
any such ill-founded hope:

The optimistic note struck here, coming after such recent con-
fessions of despair, is unconvincing, but poet and singer are allowed
to persist in their belief that all will work out for the best. The
composer and pianist know better.[6]

The whole song lasts not much more than three minutes, but it
is extraordinary how much develops in the music in that time: a
young man and his life have been laid bare in the trapped circling of
key changes and the driving quavers which start as a brave echo of
hoofbeats and end by conveying that the forces which drive the singer
on and out of sight in the dark are sad obsession and self-delusion.
The lighted window in the valley was only the flickering creation of
a moment of hope, and the future towards which he rides will not be
a fortunate one.

★

The Romantic artists of Dresden were much concerned with windows:
as well as Friedrich and Dahl, the accomplished amateur painter and
physiologist Carl Gustav Carus (1789–1869) painted both views framed

by windows (most famously his picture of a window in Friedrich's studio) and lighted houses seen from outside. He even painted an unorthodox prospect of Rome, *Italienischer Mondschein*, now in the Goethe house in Frankfurt, where the whole foreground is occupied by a villa window with an elegant neoclassical lamp in it, and the dome of St Peter's is relegated to a detail in the distance. Closer to home, he painted a tender view of his own suburban house on a spring night: *Villa in Pillnitz* (dating from after 1852),[7] a picture which brings before us the world of those people who sang Schubert in the evenings in their sparse, elegant rooms, who sat up late by lamplight reading novellas of apparitions and unhappy love, stormy and yearning verses. The brightly lighted window shining through the spring dusk under the rising moon renders the elegant, but everyday, villa momentarily Romantic, linking it to Carus's view of a lit cottage built into his friend and teacher Friedrich's beloved monastery ruins at Eldena, away to the north on the Baltic coast. So much of the quiet verse set to music by the Romantic composers of the German-speaking countries is about such still evenings as the one which Carus captures, with the observant spectator momentarily enchanted by the daily manifestations of seasons and nature: the branch of the flowering linden brought indoors, the spring moonlight glimpsed through the tall windows.

Just such a reader is shown in the gentle interior painting with which this chapter opens, *Lesender Mann bei Lampenlicht* (1814) by another member of the Dresden circle of painters, G.F. Kersting (1785–1847). This small canvas, in the Kunst Museum Winterthur in Switzerland, evokes the same world, the night reader with a double oil lamp, completely absorbed in his book in his bare, practical room, with its rough shelves, its rolled charts and document cases. It looks as if evening has turned to night while he has been reading: the window with its muslin curtains would have cast light on his page, then his lamplight would have shone out from the window before he drew down the green blind against the dark. He has been reading for some time: it is a substantial book that he reads, in which he is absorbed and lost, where everything else on his desk, except a shadowy miniature of a

woman – sealed letters and dispatch boxes – suggests that this is a lawyer's office or the business room of a country house. His forehead has settled onto his right hand and his fingers have tangled themselves in his fair hair as he reads. The pale light of the twin flames reflects in the metal base of the lamp itself, spills gently over the scatter of papers. How beautifully the lamp's upward and downward casting of shadows is observed: the shadows of the bell pull and the blind cord on the green wall, which is paler where the lamplight falls. The ceiling of the high room is in shadow, the reader and his desk seem small in the pool of lamplight. The rest of the room lies out of sight, although the distance of the viewpoint from the figure at the desk suggests that it is of some size. How strongly the picture suggests the absence of sound or distraction as the reader reads on sunk in his book. It is an image which holds silence the same way that many of the Danish painter Vilhelm Hammershøi's paintings include silence. Silence spreads out from the lamplit room, this reader's depth of absorption is only possible if there is absolute silence below his window: in pleasure grounds with white lilacs under the waxing moon, in an empty cobbled street in a walled town.

The silence of an imagined medieval city muffled by snow is evoked in *Cathedral in Winter* (1821) by another Dresden painter, Ernst Ferdinand Oehme (1797–1855), a pupil of Dahl and associate of Caspar David Friedrich.

While his affinities with these painters are immediately apparent, the sense of quiet and solemn movement which he expresses here is completely his own. While it is easy to see the pictorial and compositional elements he shares with his Dresden contemporaries, the mood and purpose of his picture differ considerably from theirs. Framed by the shadowy arches of a cloister or gateway is the west front of a Gothic cathedral, its great door wide open to show the candlelit sanctuary within. It is late on a freezing afternoon: daylight is beginning to

An imagined mediaeval city in the snow. Ernst Ferdinand Oehme, *Dom im Winter* (*Cathedral in Winter*), 1819.

dissolve into a misty sky which promises more snow at nightfall. The figures of the black-clad monks are still, or are in the slowest movement away from the viewer, all turning towards the cathedral door. The one stir in the composition is an almost baroque treatment of arrested movement: dry snow slides off the slope of the buttress by the door and fans out into the cold air. The absolute stillness is deepened by the implied rustle of the powdery snow. In the distance are intricate pinnacles and towers, leafless trees; the old house on the left could have come from any Flemish winter picture. This is an entirely benign vision of the Gothic past: the focus of the picture, and of all the figures in it, is the light which radiates from the high altar of the cathedral; the converging figures have a sense of homecoming, of the timeless comfort of observing the liturgical hours.

Many elements of this composition – snow, bare trees in mist, the Gothic arch as frame and focus – are found in Friedrich's pictures of dolorous, apparitional processions of monks through ruined abbeys, of lonely burials on snowy afternoons. The little group of snowy bushes to the left of the central arch recalls Friedrich's meticulous, yet desolate, study of snowy thorns on the Dresden Heath.[8] The brightly lit building seen as nightfall approaches is a frequent theme in the work of both Carus and Dahl, but here it speaks only of consolation. There is a sense too of the natural world in easy consonance with the carved and fretted buildings: the filigree of bare branches matches the fine detailing of their tracery. This perception of the harmony of life and environment in the Gothic centuries is exactly poised in time between the nightmare imaginations of Romantic Gothick, and the stern advocacy of a return to mediaeval Gothic, founded in religious conviction, which would be expounded in Augustus Pugin's *Contrasts* of 1836.[9]

Another German late-Romantic image of the buildings of the past framed by the sensibility of the nineteenth century is found in a study of the 'Watchman's Tower' at Schwandorf, the *Blasturm in Schwandorf*

A living light in an ancient tower. Karl Spitzweg, *Blasturm in Schwandorf* (*The Trumpeter's Tower in Schwandorf*), 1870.

(1870) by Carl Spitzweg (1808–1885). This work is an oil sketch, broadly and confidently handled, of a night scene with a light showing in an old tower on the town walls. It contrasts with the majority of Spitzweg's works, which are highly finished genre paintings, often comic or grotesque in mood, showing a rather scruffy middle class inhabiting the elegant stone tenements and rococo libraries of minor ducal capitals which have declined to provincial backwaters in the wake of the Napoleonic Wars. Here, there is no narrative, only the inhabited tower in the moonlight, its surroundings dishevelled: the city wall dilapidated and a little garden roughly fenced out of the waste ground and rubble in its shadow. This, with the bright light of an oil lamp in the tower window, suggests a practical life being lived with some energy amidst the ruins of the past. Spitzweg's image resists all the moods and conventions of Dresden night painting: neither Romantic nor devout, it catches an everyday moment on a moonlit summer night in the third quarter of the nineteenth century, the fall of silvery light and the rising planet most economically conveyed by the rich textures of the paint. The Romantic sense of the hauntedness of the lighted window has given way to a consideration of the modern life going on in the ancient structure, so that the picture becomes a reflection on the picturesque quality of having a living, garden-tending town watchman lodged in the historic tower. It is an affirmation at least of the continuity of custom in an age when the historic fabric of the town is visibly crumbling. And the crucial element in the picture is that it is a modern lamp with its bright light which shines out from amongst the ancient stones.

The same quality of modern light blazing forth from ancient structures shapes the atmosphere of the twentieth-century nocturnes by the Czech photographer Josef Sudek (1896–1976). He was fascinated by the lighted window in a domestic context, and made many images of the garden window of his own Prague studio, but it is the rainy city nocturnes of the mid-century for which he is chiefly remembered. It is contrast of intensities of light which give these melancholy images their power: the great stone structures from the past are barely visible

in the light of street lamps, in light reflected in puddles or on wet, shining cobbles, but the few electric lights which show in the ancient window frames are, in context, dazzling. Many of these photographs are closely focused: the corner of a street framed by an arch, with a few intense lights showing in mullioned windows, one of the stone stairs which cross and recross the Castle Hill with its sparse electrified lanterns here and there. There are also haunting images of the riverside walks with receding lanterns along deserted paths amongst bare, rain-black trees. Always there is the sense that the viewpoint chosen by the photographer is one discovered after long, thoughtful and always solitary evening walks. The solitude, the location of the photographer in the cold damp streets, looking up at the bright windows, is what gives these images their power, their ability to evoke the uneasy, sad years in which they were created.

The many paintings of lighted windows made by the minor French painter of the turn of the twentieth century Henri Le Sidaner evoke the last years of amplitude before the wars and disasters which began in 1914. Le Sidaner is an artist who receives a number of rather qualified compliments in the course of Proust's *À la recherche du temps perdu* – being praised and collected by characters whose taste is neither flawless nor advanced.[10] He painted many lighted windows on summer evenings or at autumn twilight in accomplished depictions which are curiously neutral in emotion and atmosphere. There are many repetitions in his evening works: canals of Flanders, French village squares, and almost always a lighted window appears to articulate the composition, anchor the tonality. However, a few of his works have an unaccustomed immediacy: a sense of strangeness, of the capture of a moment where things have become uncertain, even transformed, at nightfall.

This quality is powerfully present in *Sweet Night* (1897), in the Kunsthalle in Hamburg, which shows a lucent summer night with hints of rising moonlight, at the stage of twilight when white things jump forwards in the picture plane. This visual phenomenon is deployed to great advantage here: two women in white dresses have come out into the garden or courtyard of an old town house and are

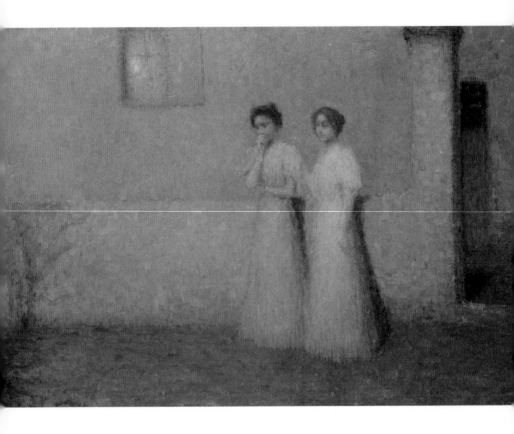

A summer evening of the *fin de siècle*. Henri Le Sidaner, *Nuit douce* (*Sweet Night*), 1897.

standing together in attitudes suggesting contemplation, attention. The ground at their feet is moon-washed from light shining straight into the composition; there is a sketched indication of a tree shadow; above all there is a sense of warmth and stillness, a pause induced by something undisclosed. The blanched wall behind the women shows one lighted window, apricot-yellow amidst so much moonlight: there is a lamp or candle burning on a wall bracket, but no further detail of the room can be seen. Is there music in the house, which can be heard in the garden? Are they held in thoughtful stillness by scent or by birdsong? The very restricted tonality places so much emphasis on

the window that it restores a considerable mystery to it, introducing an element of uncertainty, as well as of delight.

Throughout Proust's work, windows are always framers of meaning. Crucial revelations, exposition of elements of the narrative hitherto mysterious, are conveyed by incidents glimpsed through windows. The evening walk through the provincial city of Doncières in *Le côté de Guermantes* is an exceptional consideration of the motif. Intense poetic perception transforms the quotidian: many windows are seen at dusk by gaslight, lamplight or candlelight, and Proust's narrator's meditative walk is an epitome of potential responses to the phenomenon of the lighted window. We are presented with mysteries and transformations, glimpses that momentarily manifest a reality coming close to painting, a quasi-transformation visible only to those who have trained themselves to attend to the finest gradations of their surroundings.

In the course of this walk through the city where his friend Saint-Loup is stationed with the army, the narrator first emphasizes the everyday nature of his surroundings, the habitual nature of the walk from his own hotel to the one where Saint-Loup usually dines. He feels invigorated by the cold air of approaching winter, he sees the red and opaline lights of sunset and moonlight as refracted through the waters of successive fountains. Then he sees the gaslights of the barracks, as though for the first time:

> Next to the hotel, the old National Courts and the Louis XVI orangery, in which the savings bank and the Army Corps were now housed, were lit from within by the pale, golden globes of the gas already lighted, which, seen in the still clear daylight, suited these tall and vast eighteenth century windows from which the last reflection of the sunset had not departed … and persuaded me to go find my fire and my lamp, which, alone in the facade of the hotel I lived in, was fighting against the twilight.[11]

And the same heightened perceptions attend his return to his hotel room: the firelight, the last spillage of sunset onto the blue paper on the table, the table cover on the round table with its ream of paper.

When he sets forth into the now darkened, windy streets on his way to dinner with his friend, his attention is drawn to a series of lighted windows:

> The life led by the inhabitants of this unknown world seemed to
> me to be marvellous, and often the windows of a particular dwell-
> ing kept me motionless for a long time in the night, putting before
> me the true and mysterious scenes of existence into which I might
> not penetrate. Here the genie of fire showed me in ruddy colouring
> the tavern of a chestnut merchant where two sergeants, their belts
> slung over the backs of their chairs, were playing cards, without
> doubting that a magician was causing them to rise up out of the
> night, like a transparency on a stage...[12]

For that moment the little tavern is conjured up like a scene of flame and magic in the theatre, *Faust* at the Opéra. From the tavern window he passes on to the window of a junk shop where the soft lights of lamp and candle transform its jumbled contents into a *Vanitas* of the Dutch golden age:

> In a little junk shop, a half-spent candle, projecting its red glow
> onto an engraving, turned it into sanguine, while, struggling
> against the darkness, the light of the big lamp bronzed a piece
> of leather, inlaid a dagger with glittering spangles, deposited
> precious gilding like the patina of the past, or the varnish of a
> master, on pictures which were only bad copies, and finally made
> of this slum where there was only dross and rubbish, an invaluable
> Rembrandt.[13]

When he looks upwards to the windows of substantial apartments in the town palaces of the Gothic streets, he is struck by the otherness of the lives glimpsed in the lighted rooms, and wonders if the lamp-gilded atmosphere within which they move, golden and unctuous like oil, is really the same as the thin wintery air in the street outside.

> Sometimes I looked up to some large old apartment whose shutters
> were not closed in which amphibious men and women, readapting
> each night to live in another element than by day, swam slowly in

the oily liquid which, at nightfall, rose incessantly from the wells of the lamps to fill the rooms to the brim of their outer walls of stone and glass, and within which they caused, by the motion of their bodies, ripples of golden oil.[14]

These perceptions have something of the nature of hauntings: reality perceived through the fine-ground lenses of the narrator's sense of beauty and strangeness, the illusions of the stage, the arts of the past.

Philippe Delerm's *Paris l'instant*, published in 2002, is a record in words and nicely oblique photographs of a sequence of observant walks through Paris in the course of an extended summer from April to November. His lighted windows come late in the sequence, when the autumn is already well advanced and the dark arrives in late afternoon.[15] He contrasts the illuminated billboard for a cinema, whose lights are cold – 'lumières blanches et bleues du cinéma', and whose narratives are predicable, imported transatlantic banalities – with the warm reality and the mysterious humanity of the lighted windows of apartments on the upper floors. It is a fresh iteration of the contrasts of cold and warm light – the moonlight and candlelight of Le Sidaner – in the contrast of screen light and lamplight.

> Light calls us to look upwards. To the amber-lit apartments,
> glazing bars and high ceilings. A silhouette passes, momentarily,
> indifferent to the street. Indifferent? In the naturalness of its
> gestures is hidden an imperceptible affectation, the consciousness
> of belonging to the low lamps, to the saffron yellow of the sofa, to
> the creamy white of the bookshelves.[16]

Here are the reality and colour of ordinary days, as opposed to the snow-blue, snow-blind fictions of the cinema.

Julien Green (1900–1998), in the mid-twentieth century, was also a meticulous observer of Paris lights, as with this capture of a moment where mist and the density of the foliage turn the great chestnut trees of the quays and avenues into green lanterns:

> This evening a light mist covered Paris, and the chestnut trees, lit
> from within by the street lamps, were like huge Japanese lanterns.[17]

His whole book on Paris has the sense of threading a way in and out of fictions of the city, including one glancing moment of terror when he imagines himself to have stumbled into the transformed Paris of one of his own novels. He finds himself momentarily in the setting of his own tale of the uncanny, a deserted arcade with dimmed lights in the shop windows:

> What if Paris, the one I imagined, became the real one; what if
> the Passage du Caire was deserted, and it was dark, with the rain
> pattering down on the opaque glass above my head? The shop win-
> dows gleam sinisterly ... Shall I not hear the quiet steps approach
> and the voice that gave my hero the power to migrate from body to
> body pronounce the insidious open sesame: 'If I were you...'[18]

★

Another mid-twentieth-century émigré and traveller, W.H. Auden (1907–1973), found himself in 1938 wandering a winter Europe of restrictions and frontiers, temporarily washed up in Brussels with friends who had fled from Germany. There he wrote the sonnet 'Brussels in Winter', an intense observation of time and place – frozen fountains and cold streets like a maze – which contains the lines

> Ridges of rich apartments loom tonight
> Where isolated windows glow like farms[19]

The smart apartment blocks of this city of temporary refuge are trans-formed in memory and longing into his beloved childhood landscape of the North Pennines, their lighted windows become the lamps of the isolated farms on the slopes of Weardale, looking up from the banks of the river at the foot of the fell. The exile for a moment imagines the lights of the buildings past which he wanders as the lights of the home that haunted his imagination all his life. And yet he is as separated by circumstance from the lights of the apartments as he is by time and distance from the lights of the Pennine farms.

There is a visual counterpart for Auden's image in a Japanese woodblock print from a decade earlier: *Evening at Dotonbori* by Uehara

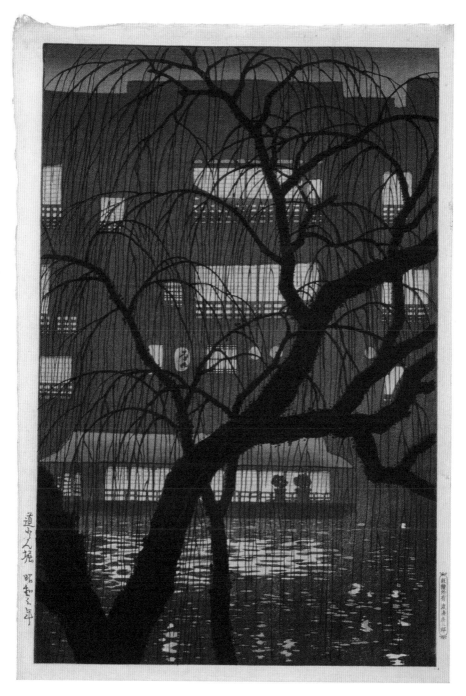

Bright windows seen in night rain over water. Uehara Konen, *Evening at Dotonbori*, woodblock print, 1928.

Konen (1878–1940). Here too the lit building is distanced from the viewer, seen on a winter night, across water, with the foreground occupied by a finely rendered willow tree, whose leafless branches hang straight down like rods of rain. The viewpoint is oddly confined: the spectator is amongst damp vegetation on the unlighted bank of the water, almost as though they were hiding amongst the dripping boughs of the willows. There is mist in the air, a haze of city light in the grey sky. The building depicted is in the theatre and entertainment district, houses of pleasure from which the spectator is separated by the black water and the rainy branches, as sad as the transient sexual encounter with which Auden's sonnet ends:

> And fifty francs will earn a stranger right,
> To take the shuddering city in his arms.

I was standing on a warm September evening on the roof terrace of the Jesuit house in the Rue de Grenelle in Paris, while the urbane guestmaster interpreted for me the patterns of window lights which were appearing in the streets immediately below us. After talking through the expansive view of the city centre spread out all around us, as the towers of Saint-Sulpice caught the last reflected daylight, he focused on the windows near at hand. He spoke of how the patterns of lighted windows had changed over the years, of how only a few lights showed now in buildings which had once been fully inhabited, as apartments were bought as investments by absent owners. He spoke of the blight of short lets arranged on the Internet, how a whole building could be lighted one week, dark the next, and all their stairwells full of ever-changing strangers. Amidst all this talk of transience, he then spoke of a strange continuity: in one of the adjacent streets, uniform stucco refronting concealed an ancient *hôtel particulier* which had been in the ownership of the same family, the de Grinouards, who could trace their ancestors back to the days of the Avignon Papacy in the fourteenth century. We could see nothing

on the street front to mark their house out from the others, but it was extraordinary to know that ancient rooms were concealed behind the smoothly confirming facade: double doors in enfilade with stripes of window light lying on polished floors, courtyards, perhaps a shadowy garden of clipped box and statues. I felt for that moment as if I had been presented with a key to one of the numberless mysteries of the city.

I left for London the next evening on the delightful train which departs just as it is beginning to get dark, so that you see the first lighted apartment windows as it moves further out from the centre of Paris. Then it travels across the flat, evening-misted fields which show only sparse farmhouse and village lights. Through the bright, slick station at Lille and on through dark country to the Channel. And all lighted windows of London to receive you in time for a late dinner, perhaps in Drummond Street, ten minutes' walk away, where the pattern of upstairs lights across the street from the restaurant window – paired sash windows in three-storey Georgian houses – is as specific to the city as its plane trees and flagstone pavements.

The mid-century English artist Algernon Newton (1880–1968) often painted these London streets of modest late-Georgian houses. His favoured subject was small industrial backwaters, yards and humble terraces, especially the banks of what were then working canals. Almost all of his townscapes are completely empty, an absence of people which is initially tranquil but carries slow, troubled undertones. The absolute unpeopledness becomes an important element of his work, as is his ambiguous use of 'golden hour' – the time of lighted street lamps and cloudscapes flooded with the brightness striking up from the sun below the horizon.

Newton's painting of *The Surrey Canal, Camberwell* (1935) appears initially peaceful, with its row of unlighted houses, its one street lamp, its watery reflections and its beautiful, almost rococo, sky. Continuing to contemplate the painting, there is a growing sense of wrongness, of something amiss with the still air depicted in it, as if the air there is a different element from normal air, like the golden oil which

Proust imagined in the lamplit apartments of Doncières. My friend Alan Powers has observed that this effect of airlessness, almost of a vacuum between the buildings and objects in Newton's paintings, is much intensified if they are photographed and reproduced. The very title of the contemporary poet Helen Tookey's homage to Newton, 'Aftermaths', indicates the silent disturbance, seismic activity scarcely perceptible, which she finds to be underlying his work:

As the blue comes on, the canal
shivers, and just for a second
all the charts go haywire.
(Reflection of telegraph pole
Of factory chimney.)
In the ward of the white house
no one will sleep. The single lamp outside
will burn all night.[20]

This embodies a developed, considered reading of the painting in a few lines, the sense that the verticals disturbed or shaken in the canal reflections are like graphs recording the currents of trouble passing under the surface, that the inhabitants of the house beside the street light are like convalescents or invalids, and that some unexplained, invisible event has emptied the streets and changed the nature of the air.

Tookey's imagining of Newton's hospital-house where nobody can sleep make a dissonant half-rhyme with Magritte's alternative title for his own depictions of houses on the quaysides of the Low Countries, *The House of Dreams*, a painting which has also its street lamp and its unnaturally luminous sky. In Newton's paintings of London, the very absence of lighted windows is one symptom of the invisible trouble, the quiet disaster.

The feeling of these paintings is like the complete strangeness of the City forty years ago on the Sunday evening of the August bank holiday, walking from station to station, travelling from Lewes to Cambridge, and seeing nobody at all in the streets between London Bridge and Liverpool Street, and not one lighted window save for the flicker of

'As the blue comes on, the canal shivers.' Algernon Newton, *The Surrey Canal, Camberwell*, 1935.

what must have been the altar candles in the church of All Hallows, London Wall showing faintly in the high Diocletian windows which face the street. But the church was disused at that time and there cannot have been any altar candles.

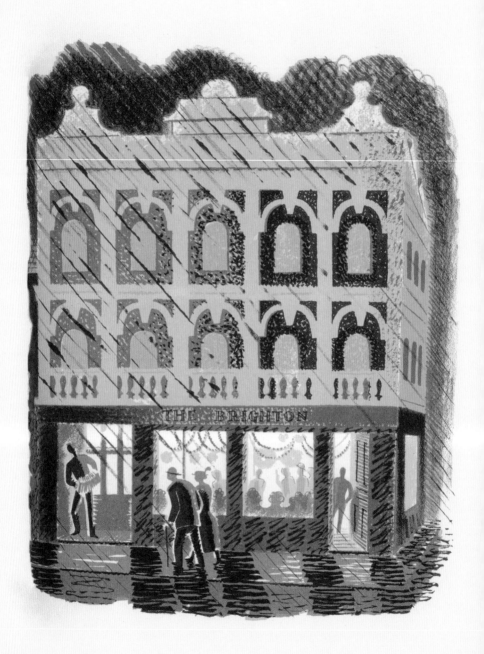

LONDON NOCTURNE

Walking northwards from Mount Street to Marylebone station on a mild, drizzling evening, not long before Christmas. Moist, watery air, blurring the street lights: not so much as a rumour of frost, the air scarcely cooling after the early sunset. In a few years Londoners will have forgotten that there ever was frost – white grass in the squares, spiked rime on their railings. Freezing mist in the morning and cold, red-seeping sunsets will soon be a memory. River fog rendered in the staccato, dry-brush greys of twentieth-century watercolours will be the only memorial of the usual winter weather of my youth.

Oriented by the east–west of churches, by a few landmarks, it is easy to navigate Central London, to let the mind absorb place and moment without concern about direction. To enjoy the heavy railings in the square and the solemn front of the Wallace Collection. To cross crowded, blazing Oxford Street and relish the dim low-rise streets and squares beyond all the more for the contrast. To make an inventory of windows: the shop displays in their vertical barrier of light with dark space behind; the sparse reds and blues of tall, curtained first-floor windows; the flat blue of the cold counters in the lunchtime coffee shops.

A December night in London in the 1930s. Eric Ravilious, *Public House*, from *High Street*, 1938.

More lighted upstairs windows as Oxford Street falls behind, and I am reminded of an odd fragment of narrative about Georgian London houses with their long windows on the first floor: a schoolboy on the top deck of a bus, on a level with the lit drawing rooms, sees his own father in his shirtsleeves, at home with another family. A moment of disbelief and terror, and then the bus moves on and there is no chance of pinpointing that one room in the darkening street of uniform stock-brick houses. An ingenious clothes shop window – sparse points of brilliant colour displayed against broken white – just south of the brightness and noise of Baker Street. A dodge two blocks westwards, and then the lit canopy of Marylebone Station, modest in scale like the porte-cochère of the theatre in a county town.

It is completely dark when the train draws out of the station, and moves between the still-lightless apartment buildings which line the railway. Then the coloured lights begin: station lamps and rain reflections at Dollis Hill, bright white lights strung seasonally on scaffolding and cranes. At West Hampstead station the windows of overground and tube carriages pass and seem to intersect on several converging lines, with all the lights redoubled by the rain-streaked windows, the black-mirror platforms. With the reflections and the dark background it is almost like a modernist animation film of the early twentieth century – a flickering, abstract dance of squares and rectangles of light, yellow for the trains in service and blue ghost light for the empty cars. Then the coloured lights show as the trains pass on into the dark. Lines of Guillaume Apollinaire come to mind:

Les tramways feux verts sur l'échine
Musiquent au long des portées
De rails leur folie de machines

(The tramways green fires on the spine, make music
along the stages of the track, in their mechanical frenzy)[1]

These are the Parisian trams which appear towards the end of his poem 'Le chanson du Mal-aimé' (1913), a work which begins with one of the greatest invocations of winter London in any language. 'Le chanson du

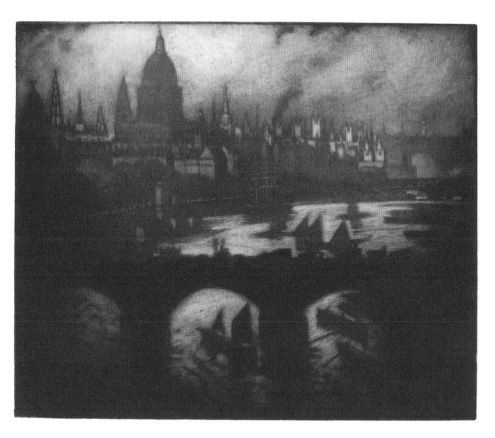

River mist and night coming on. Joseph Pennell, *Wren's City*, 1909.

Mal-aimé' is a poem of great perversity and beauty, one of the most extraordinary products of that first wave of modernism, which was cut short by the First World War. It meant everything to me when I was a schoolboy and undergraduate, and still offers an inexhaustible compendium of the possibilities of poetry. To me it is still an example of elegance of versification and audacity of juxtaposition. The main event of its narrative – the poet's rejection – took place long before the poem began, so that everything in the poem is a labyrinth of allusions and aftermaths. Throughout, it articulates a melancholy which is usually expressed obliquely and with reticence, except for one tremendous, baroque explosion that lists the names and thaumaturgic qualities of the seven swords of sorrow which pierce the poet's heart.

Much of the lamenting, fantastical atmosphere of the poem is sustained by the five-line stanza, with the rhyme on the last line developing and refocusing the rhymes of lines 1 and 3. What has haunted me from that day to this is the sense that the sad, digressive, bizarrely learned poet who speaks the verses is a bearer of authentic secrets, someone who moves through life knowing that he can utter near-magical invocations that stretch back far beyond his conscious knowledge. Twice in the poem he speaks out his assertion of the power and dignity of a poet. The first time that the stanza appears is at a moment of inconsolable mourning in springtime, and once it has been spoken the poem changes texture and grows stranger: metaphors of grief begin to flower into a nest of bizarre narratives. Finally, with the speaker washed up sorrowfully in airless, electric, brilliant Paris, it brings the whole sequence to a suspended, unguessable conclusion.

> Moi qui sais des lais pour les reines
> Les complaintes de mes années
> Des hymnes d'esclave aux murènes
> La romance du mal aimé
> Et des chansons pour les sirènes
>
> (I who know lays for queens, the laments of my years,
> dirges of slaves [thrown] to the murexes, this song of the ill-loved
> and the songs for the Sirens)[2]

Thus the poem ends with one of the highest vaunts a poet can utter: he more than 'knows the song the sirens sang'; he is poet enough to make their songs for them.

The poem ends with that mysterious serenity, but it begins with despair born of desertion in wintery London, with a lonely walk on a foggy night, following two derelict inhabitants of the streets, who bear, in the dimmed light, a passing resemblance to the poet's lost love.

> Un soir de demi-brume à Londres
> Un voyou qui ressemblait à
> Mon amour vint à ma rencontre
>
> (On a half-foggy evening in London
> I met a street boy who looked like my beloved)[3]

Apollinaire's London is characterized above all by the winter fog which diffuses the lights so that they bleed into the sodden air:

Au tournant d'une rue brûlant
De tous les feux de ses façades
Plaies du brouillard sanguinolent
Où se lamentaient les façades

(At the corner of a street burning with all the fires of its facades, bleeding wounds in fog where the house fronts lamented)[4]

The desolate foggy night, the street boy with half a look of the lost love, a drunken woman at a pub door: all of these bring the poet to his realization that love itself is false, despite which the parting in Germany from a woman who went to America (we are told nothing more) continues to haunt and grieve him:

Au moment où je reconnus
La fausseté de l'amour même

(At the very moment when I realized the falsity of love itself)[5]

This episode has fascinated the topographical film-maker Patrick Keiller, whose own works are often beautifully sustained meditations on place and light. He sets his recollection of Apollinaire in the context of his increasing disquiet at persistent changes (none for the better) observed in the view from the window of his third-floor flat in South London.

As we felt ourselves losing ground, both politically and economically, our sense of loss was partly mollified by observing these visible changes in the landscape … satellite dishes began to appear on the houses and flats visible from the window. We would notice them for the first time in the morning when they caught the sun, so that they seemed to have grown in the night. A couple of years later, the dishes began to disappear. I began to think of the entire view as a very slow but visible movement of self-organising matter. Apollinaire's impression of south London suburbs, seen from the train, was of 'wounds bleeding in the fog'. Sometimes it seemed possible to perceive the view as an organic phenomenon.[6]

Here Keiller has extrapolated from Apollinaire's single, wonderful image of the lighted windows of London as bleeding wounds (blood-light seeping outwards onto the blotting paper of the fog) to his own involuntary thought of 1980s' London as an organism, sentient and controlling its own growth, but an organism somehow wounded by the regime which rules it. Later in his essay he writes that the scraps of flesh dropped on the pavements outside fried-chicken shops seem like shreds of the flesh of the hurt city. So Apollinaire's image of the fogs of Edwardian London has an extraordinary afterlife in the imaginative geography of the late twentieth century.

A more serene view of the lighted streets of shops and pubs is shown in the sequence of lithographs by the mid-century artist Eric Ravilious (1903–1942), published as *High Street* with a text by J.M. Richards in 1938.[7] As the art historian Alan Powers has written, this collection is one of the finest results of the preoccupation of English artists of the 1930s with popular English art, with Staffordshire figures and roundabout horses, with pub signs as well as with window displays. It is partly a celebration of the modern possibilities of electric light and ingenuity to transform the shop or restaurant window into an object of entertainment and delight. The mood is mostly cheerful, delighting in English particularities and peculiarities, in model yachts and wedding cakes, in clerical outfitters and taxidermists. But there is also a haunting quality to those of the images which show their shops at night: one evening plate shows a cheerful window full of cottage loaves (the country in the city), but most of the night illustrations have an element of quiet strangeness. Ravilious's townscapes are usually fairly sparsely populated: here they are completely empty. The shop which sells illuminated lettering shines into a deserted street and carries with it a vestige of the sadness of a deserted fairground. The chemist's shop with its lovely backlit flagons of coloured liquids is rendered more than a little lonely by the bare tree and moonlit sky which show above its roof. I have often caught a similar feeling looking across the

The lighted shop in the empty street. Eric Ravilious, *Chemist's Shop*, from *High Street*, 1938.

street below Susanna and Alan Powers's tall brick house in London: there is a fruit and vegetable shop on the corner, and its open front and bright lighting send forth diagonals of yellow light, so that the many customers are flattened into Ravilious silhouettes by the brightness of the light within. I have a recollection of walking with Alan southwards towards Shaftesbury Avenue to gaze into the beguiling lighted window of an old-fashioned yacht chandler's – electric light gleaming on brassware and the lenses of marine compasses, great fists of knotted rope for handrails or sails. And I remember that he told me that the shop front of Bassett-Lowke – whose interior, with its model ships, was drawn by Ravilious – used to be nearby in High Holborn. The yacht shop's collection of elegantly functional things would have appealed so much to Ravilious, and its window display leads the mind out from the centre of London to the creeks and saltings of East Anglia, to the trim south-coast harbours which lie at the end of the web of commuter train lines.

This immediately pre-war collection of shop windows brings to mind a stanza from one of the strangest of the odes in Auden's *The Orators*, a poem written in the autumn of 1930, and subsequently much revised when reprinted under the title 'The Exiles'.[8] In this poem a group of retired agents, or fantasists who believe that they were once agents, seem to be inhabiting a safe house in the form of a remote sporting hotel, with overtones of both country house and public school. The sea is not far away, ghosts come with the snows in winter. They go at nightfall to look at the lighted streets; not Ravilious's electric restaurants and bright-lit shops in London and the south, but gaslit shops in a remote provincial town:

> Or striding down streets for something to see,
>> Gas-light in shops,
>> The fate of ships,
>> And the tide-wind
>> Touch the old wound.

★

G.K. Chesterton (1874–1936) was alive to the quotidian beauty of lighted shop windows on winter evenings, indeed to the whole poetic and romantic potential of the modern city at nightfall. At the beginning of his fantastical tale of *The Invisible Man* he focuses on the window of a confectioner's shop, the popular art of the window display which had delighted Ravilious (although Chesterton's shop is more luxurious than the Baker and Confectioner in *High Street*):

> In the cool blue twilight of two steep streets in Camden Town, the shop at the corner, a confectioner's, glowed like the butt of a cigar ... like the butt of a firework, for the light was of many colours and some complexity, broken up by many mirrors and dancing on many gilt and gaily-coloured cakes and sweetmeats ... the choco-lates were all wrapped in those red and gold and green metallic colours which are almost better than chocolate itself; and the huge white wedding-cake in the window was somehow at once remote and satisfying, just as if the whole North Pole were good to eat.[9]

Chesterton perceived that at nightfall huge Edwardian London became a place of romance, a place whose poetry expressed itself naturally in the quests and mysteries of the detective story, all taking place in a shadowy metropolis lit by gaslights and window lights, lights glowing like the eyes of goblins or the eyes of cats, guardians of secrets and crimes.[10] Chesterton does not make extensive use of the motif of the lighted window in his plots – it occurs most often as a descriptive device to accentuate the otherwise desolate character of shabby or half-abandoned country houses – but gaslights at evening are an essential part of his evocations of the city. Often his narratives begin with a quasi-cinematic survey of a place, often they emphasize the strangeness of the everyday – for example, the unlit, funereal coldness and uniformity of the inner western suburbs, cheered only by the lights of the little mews pub where the action begins.[11]

The sheer variety and extent of the metropolis are also central themes in the celebrated fictions of detection by Arthur Conan Doyle (1859–1930), and the lighted window often plays a central part in the development of his plots. The whole atmosphere of his London stories

depends on fog and twilight, street light and lighted windows, the mysteries concealed in smart villas in the inner suburbs or at the ends of the suburban lines where the metropolis fades into the low-lying fields of the Thames Valley. (One of the strangest and most powerful tropes in his fictions is the repeated implication that his detective, Holmes, is in fact the only living inhabitant of London who does know and comprehend almost every hidden aspect of the vast metropolis, and that the notebooks and indices kept in his rooms in Baker Street embody a near-supernatural directory of the secret workings of a city surely too large for any one intellect to comprehend it.)

The lighted window itself appears as a plot device in a number of the Holmes stories — either the observation of a lit room with its curtains open, or the shadow-play of figures moving between the gaslight and the drawn blind. It is the sight of Holmes's moving silhouette which draws the married Watson back to their old rooms in Baker Street and into the adventure of 'A Scandal in Bohemia':

> One night — it was on the twentieth of March, 1888 — I was returning from a journey to a patient (for I had now returned to civil practice), when my way led me through Baker Street. ... His rooms were brilliantly lit, and, even as I looked up, I saw his tall, spare figure pass twice in a dark silhouette against the blind. He was pacing the room swiftly, eagerly, with his head sunk upon his chest and his hands clasped behind him.[12]

This is the prologue to a narrative of blackmail and intrigue involving foreign royalty; Holmes's eventual discovery of the hiding place of the compromising documentation is a drama observed by Watson through the lit drawing-room window of a discreet villa in the inner suburbs.

In 'The Adventure of the Speckled Band', in which Holmes saves a young woman from an ingenious scheme of attempted murder, the scene has moved beyond the edge of London to a village where Holmes and Watson keep watch at the window of the village inn while the sinister events in Stoke Moran Manor are observed by them, as a series of framed vignettes as lights are kindled and extinguished.

Holmes instructs the intended victim to light an empty room as a trap for the murderous stepfather:

> You must confine yourself to your room, on pretence of a head-ache, when your stepfather comes back. Then when you hear him retire for the night, you must open the shutters of your window, undo the hasp, put your lamp there as a signal to us, and then withdraw quietly with everything which you are likely to want into the room which you used to occupy.[13]

What follows is almost an epitome of the Holmes stories, the kind of scene which has come to define the era and milieu in which they take place: Holmes and Watson in wait, vigilant and poised to intervene, misty darkness falling and the moving lights in a house which appears innocent, but which is to be the scene of a further attempt at murder:

> The trap drove on and a few minutes later, we saw a sudden light spring up among the trees as the lamp was lit in one of the sitting-rooms … About nine o'clock the light among the trees was extinguished and all was dark in the direction of the Manor house.[14]

And so they wait in the dark until they are able to approach the Manor and apprehend the would-be murderer.

Perhaps the most haunting lighted window in the whole canon of the Holmes stories is that which is the focal point of the narrative of Holmes's return to London, after a strategic period of allowing everyone, his loyal Watson and his deadly network of criminal enemies alike, to believe that he is dead. Holmes is shaken, living in secret, moving with great caution since an apparently perfect murder has been committed by an agent also on his own track. A young man has been shot at night, noiselessly and unaccountably, through an open window. The narrative unfolds the stratagem by which Homes traps the assassin. First, he leads Watson to a dilapidated, empty house opposite their old rooms in Baker Street:

> Holmes's cold, thin fingers closed round my wrist and led me forwards down a long hall, until I dimly saw the murky fanlight

over the door. Here Holmes turned suddenly to the right, and we found ourselves in a large, square, empty room, heavily shadowed in the corners, but faintly lit in the centre from the lights of the street beyond. There was no lamp near and the window was thick with dust, so that we could only just discern each other's figures within. My companion put his hand upon my shoulder and his lips close to my ear.

'Do you know where we are?' he whispered.

'Surely that is Baker Street,' I answered, staring through the dim window.

'Exactly. We are in Camden House, which stands opposite to our own old quarters ... Might I trouble you, my dear Watson, to draw a little nearer to the window, taking every precaution not to show yourself, and then to look up at our old rooms – the starting-point of so many of our little adventures?[15]

Holmes has contrived a simulacrum of himself (a dummy in an armchair, and a wax bust of himself conveniently acquired in the course of his journey back from his near-death in the Alps).

I crept forward and looked across at the familiar window. As my eyes fell upon it I gave a gasp and a cry of amazement. The blind was down and a strong light was burning in the room. The shadow of a man who was seated in a chair within was thrown in hard, black outline upon the luminous screen of the window. There was no mistaking the poise of the head, the squareness of the shoulders, the sharpness of the features. The face was turned half-round, and the effect was that of one of those black silhouettes which our grandparents loved to frame. It was a perfect reproduction of Holmes. So amazed was I that I threw out my hand to make sure that the man himself was standing beside me.[16]

With the success which attends all of Holmes's stratagems, eventually the simulacrum on the backlit blind draws the assassin into the trap, into the same empty room where Holmes and Watson are waiting in the dark. The man they capture in the act of trying to shoot at the shadow on the blind with a silenced airgun is an individual ranking so high in Holmes's secret directory as to qualify as 'the second most

The shadow of the false Sherlock Holmes on the blind. Illustration by Sidney Paget, *Strand Magazine*, October 1903.

dangerous man in London'. As so often in these stories, the plot is an ingenious variation on a repeating theme: Holmes anticipates the next move of an adversary, and sets up an opportunity for them to be caught in the act of committing the projected crime. The knowledge contained in his unpublished, omniscient directory of the metropolis, his index of the true, secret nature of London, always triumphs. But what seems most to linger in the reader's mind from these stories is the dimmed gaslight and twilight of the city, and the weather in its streets. Much the same could be said of the London fictions of Robert Louis Stevenson (1850–1894), especially the *New Arabian Nights* (1882), and of the prescient writer of weird fiction Oliver Onions (1873–1961),

many of whose Edwardian narratives begin with twilight explorations of London, including his disquieting novella *The Beckoning Fair One* (1911) in which a dilapidated Georgian house, and that which dwells within it, draws the protagonist down to his destruction.

The London of these fictions: fog, rain and street lights shimmering on wet pavements, seems to have been the way that the metropolis was remembered by expatriates, by those long exiled who did not want to imagine change in their absence. Even after the First World War, Patrick Leigh Fermor remembered Mayfair in this way, in a letter written in October 1938 from the remote country house in Moldavia where he was staying with his princely friends the Cantacuzènes:

> I got a big parcel of books from Hatchards the other day … It made me think of the lights of Piccadilly through the rain on an autumn evening, with a wind roaring across the park, and me peering at the books in the bow-window of Hatchards.

By the end of the First World War, one vital change which had taken place in the nature of the city was the liberty won by women writers and painters to move with freedom and enjoyment through the urban evening and night. After she had left her family home, Sylvia Townsend Warner (1893–1978) lived on modest earnings as a musciologist, delighting in the observation of her surroundings, walking freely throughout the city at nightfall.

> Oh, those long stuffy summer evenings, full of melancholy and the sound of washing-up in the basements of cheap hotels![17]

In the years around 1920, the most distinguished and thoughtful explorations of the evening city were written by women, by Warner herself and by Virginia Woolf (1882–1941). The lighted windows in Woolf's novels and essays are amongst the most acute and enduring observations of London streets and London lights. Woolf's evocations of the contrapuntal lives lived behind the lighted windows of central London define a new way of seeing and apprehending the city. Some of the most haunting descriptions of London in the Second World War,

especially of the ambiguous character, even poetry, of the blackout, are those of Sylvia Townsend Warner, as she feels the city reverting to the lightless condition of the houseless fields.

> The nicest thing about London now is the black-out. It is inde-scribably moving to see that city just quietly abandoning itself to darkness, as though it were any country landscape. Meekly settling down in the dusk, shutters going up in windows, walkers pattering home, here and there a few modest medieval little lanterns being fetched out and set at the thresholds of the subways entrances; and the darkness falling, and the noise thinning out from a mass of sounds to individual sounds, as though the night combed it.[18]

One of the strangest aspects of this survey of the lighted window in the dark is the absence of women artists and writers working in the earlier periods which it surveys. Even in those places and eras when women made a rich contribution to cultural life, such as the Dresden of the early nineteenth century, there are no representations by women of the lighted house or apartment seen from outside. This is not just a result of the restrictions which premodern society placed upon the free movement of women: in Dresden women artists seem to have enjoyed freedom and autonomy, in particular the painter and autobiographer Louise Seidler (1786–1866), who was a member of important cultural circles in Jena, Dresden and Weimar. She was herself painted in 1811 by Georg Friedrich Kersting working by an open window, but I have found no night pieces from her hand, although she moved in circles where houses and cities by night were a frequent subject. Similarly, in France, while Martin Drolling (1752–1817) and his daughter Louise-Adéone Drölling (1797–1831) depicted women as artists at work, they are always shown inside the window, looking out at the view of the city by daylight, or using a window pane as a light source to perfect a tracing.[19]

All of this changes in the twentieth century. The painting *Evening* (1925) by Isabel Codrington (1874–1943) is an illustration of the kind of autonomous urban life of which Sylvia Townsend Warner wrote.

This shows a kitchen interior but with a beautifully judged view out from the window into the blue dusk of the city and its lighted windows. It is a kitchen in the attic flat of an artist who is living modestly, but clearly independently, early in her career. Perhaps the quality in the picture which most strikes the viewer is its tenderness, its sense of quiet celebration of a professional life achieved and enjoyed. The painting dwells affectionately on the ordinary table, with cottage loaf and evening paper. The table is set for one, for the artist who has broken off a modest tea (bread and butter, tinned fruit, biscuits), leaving teapot and plates on the table to record this moment in her own life, a life which would have been infinitely more difficult for a woman of the generation before. She dwells with affection on the humble, mismatched second-hand chairs, but also on a moment of beauty and extravagance: a potted rose on the window sill. The view of blue wintery dusk and distant lighted windows outside is beautifully handled with a balance between the window lights in the distance and the gleam of lamplight reflected in the pots stacked on the cupboard by the window. Although this painting is still of a view outwards, the rooms within are in the sole possession of the artist, and she can move at will through the city outside.

After the Second World War, Joan Eardley (1921–1963) had taken possession of the city: her studio was in the centre of Glasgow, amidst bomb sites and stone tenements, overcrowded and in decline. She painted what was around her: the children who played in the streets, the shattered cityscape of the years after the war. Sometimes she would have the company of an art-school friend, traumatized by the war but at ease in the humbler parts of the city. Often she walked and painted alone. Her renderings of the tenements and the street children are absolutely her own: idiosyncratic paintings of subject matter difficult to sell at the time, although the heads of children in front of walls covered in graffiti have become one of the most recognizable images of post-war Scottish art, as have her violent, almost completely ab-stracted, renderings of the clifftops and storms of the Kincardineshire village of Catterline. Both her urban and her rural images have become

An artist's kitchen with a view out into London. Isabel Codrington, *Evening*, 1925.

Grandeur and desolation in post-war Glasgow. Joan Eardley, *Glasgow Tenements, Blue Sky,* 1950–55.

so familiar (her posthumous success has been very great) that her idiosyncratic handling (she embedded objects in the thick impasto of the late landscapes, some of the pastel drawings are on the rough side of sandpaper) and the starkness of subject have been softened by time.

Glasgow Tenements, Blue Sky makes its first impression through the sheer skill of the handling of paint to achieve the effect of rough, substantial stonework, of damage and repair, of roughcast which has fallen away and been partly replaced. The serene cobalt of the sky defines the time of day as after sunset: it also sets up a deliberate discord between its own clear serenity and the scarred texture of the buildings. But

it has also a dignifying effect on those buildings, emphasizing the distinction which they retain even in decay: the massing of stonework, the tremendous central chimney stack, the tall elegance of the door which leads from the tenement stair to the open space behind, which must be, in part, bomb site – few tenements would have so lavish an allowance of space for a drying green. In short, the elegance of the sky serves to bring out the similarities between tenement building and the castle-building of the Scottish past. There are faint, finely handled, indication of street light and car headlamps to the left – on the other side of the street another tenement building rises, growing misty and insubstantial in the dusk. The bright colours of the washing on the line jump forward to the eye, as does the blue dress of a child going in late to the tenement door. It is only after the eye has settled to the picture that the very dim lights in curtained and uncurtained windows begin to register. Many are unlighted with white blinds or curtains, or the panes themselves, catching the last light outside. A few windows are dimly lit behind blinds in the soot-blackened building on the right, one on the top floor with economically painted lamplight behind a brown blind. Scottish buildings can seem unusually dark in the evening because of the wide persistence of the use of heavy wooden shutters. This is one amongst many of the drawings and paintings which Joan Eardley made in the run-down, troubled centre of Glasgow, affirming her freedom to move and draw in a townscape of bomb damage and decay.

Glasgow is unlike any other British city: perhaps the nearest comparisons might be Hamburg or Boston, comparisons which might catch some of the visual effect of the west-end streets of well-designed tenement buildings, the sense of the nearness of the docks and the river. But it is also one of the European cities which embraced modernism most wholeheartedly – not only in the large-scale patronage of local contemporary art (which fostered the same art school that drew Joan Eardley into the city centre) but also in the promotion of technology and, in the main, the willingness of the major engineers, shipbuilders and merchants to continue to live in the city in which they had prospered.

These factors have shaped a townscape which is wholly distinctive, not just in the bomb-damaged city centre (all rebuilt now, very badly, and slashed with motorways) but in the old inner suburbs to the west, on the hills above the river. Plain blocks of substantial *fin de siècle* apartments, channelled yellow ashlar, raw red deco sandstone, an astonishing, precipitous view down Gardner Street to the riverside and the places where the docks and the great cranes used to be. The road which follows the crest of the hill is deep with garden trees, with dense plantings on the downhill side screening the shipowners' mansions from the street. And from minute to minute, between the branches, the view out over rooftops to the ragged sunsets of the cold past above the stark, iron geometries of the working port. The houses are handsome, even beautiful, mostly refined latest-classical of the mid-nineteenth century, sited with care on the slope of the hill to command the best views out over the valley. At nightfall in the last century there would be a glimpse sometimes into a lamplit drawing room, and the blues and scarlets of post-impressionist landscapes over the fireplace: Galloway or the Western Isles transfigured in prismatic colour. And looking outwards there would be the sparse, ample lights of the substantial villas, blank areas of darkness in the foreground gardens. Further down the slope the close-patterned lights of smaller villas and the grids of brightness of the tenement windows at the bottom of the hill. Then orange street lights and, in the past, splintering-white arc lights and the luminous mist off the river. The only cityscape which bears a real resemblance to this is that of the Elbechausee in Hamburg: smart villas in the tree-lined street, with the docklands and vast container ships at the bottom of the hill, the sources of wealth always kept in view.

Many of the classic descriptions of continental cities of the nineteenth century apply even more precisely to the new growths of Glasgow and Manchester than they do to the more stately, accreted London.

Great cliffs of lighted windows. Adolphe de la Valette, *York Street, Manchester*, 1913.

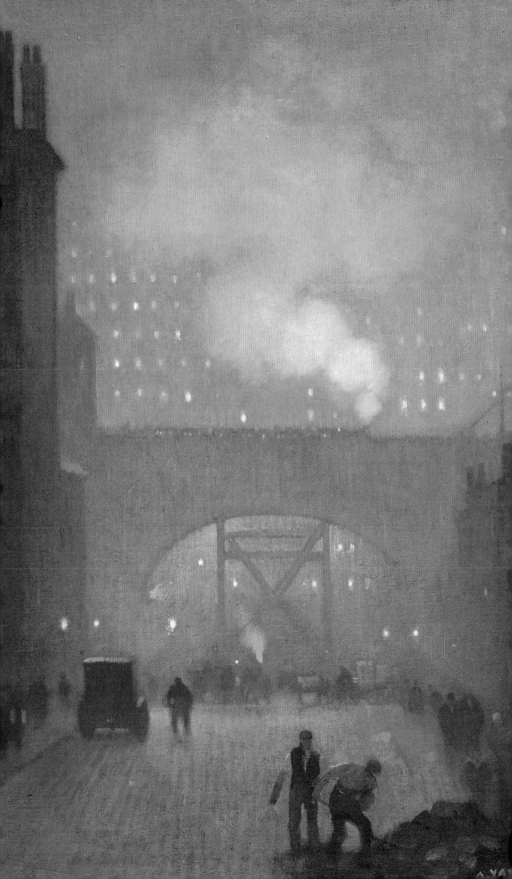

Baudelaire's urban descriptions are eloquent of the combination of the natural and artificial: coal-smoke-thickened fogs, stars only partially visible, the fog-dimmed moon, the bright lamps in the windows:

Il est doux, à travers les brumes, de voir naître
L'étoile dans l'azur, la lampe à la fenêtre,
Les fleuves de charbon monter au firmament
Et la lune verser son pâle enchantement.

(It is sweet, through the fogs, to see the kindling of the star in the blue above, the lamp at the window, the rivers of coal-smoke rising to the sky, and the moon pouring forth her pale enchantment.)[20]

As depicted in the paintings of Pierre Adolphe Valette (1876–1942), the industrial city acquires an aesthetic of its own, the smoke-thickened fogs of the nineteenth century being the essence of his art. The fog not only defines the lighting of his paintings, it contributes to a degree of characteristic compositional flattening, a distant memory of the conventions of the Japanese prints admired by European artists. Valette's art is grounded in the streets of central Manchester, the viewpoints uniformly low, so as to emphasize the cliffs of industrial buildings with their enormous grids of lighted windows, filling the space that would, in any previous painting of place, be occupied by the sky. Perhaps the point of the lighted windows in these paintings is their massing, their lack of individuality in colour or arrangement. These are wholly urban paintings, paintings of town-centre industry. Almost ironically, they produce an effect very similar to the superficial perception of lighted mills – illuminated palaces – which Dickens attributed to those who pass through northern towns on the train, without thinking for one moment about their utilitarian harshness.

The lights in the great factories, which looked, when they were illuminated, like Fairy palaces – or the travellers by express-train said so – were all extinguished.[21]

Valette's paintings represent a break with the schools of painting in the other British industrial cities leading up to the turn of the twentieth century: Grimshaw confined himself usually to the western suburbs

of Leeds, a romanticized version of the mill owners' suburbs, where
the flare of the factories is visible only as a distant illumination, their
smoke only as an element in the unnatural colouration of his daytime
skies. He did paint docks in Glasgow and Liverpool, studies in the
indistinct intricacies of ships' rigging, and in the reflection of gaslight
on wet cobbles. He once painted the Headrow of Leeds, a solemn
street of Victorian buildings, but the mills which brought the city
into being remained out of sight. Much the same could be said of the
Glasgow painters: although there are many interiors and still lives,
they tended not to paint the city itself, choosing rather coastal towns
in Fife or Galloway, the mountains on the coast north of the Clyde and
the islands lying offshore. There are memorable renderings of misted
landscapes from the Glasgow school, but their settings are uniformly
rural:[22] it is Valette's achievement to have found a visual vocabulary for
the actualities of fog and smoke which shrouded the places of industrial
production. It was only a decade after Valette's death that Joan Eardley
turned an artist's attention to the centre of Glasgow.

Baudelaire's lamp at the uncurtained window – *la lampe à la fenêtre*
– is realized in a quietly poetic London painting by George Clausen
(1852–1944) *Reading by Lamplight: Twilight Interior* (c. 1909). A woman
is reading, absorbed, leaning forward into the circle of light cast by a
paraffin lamp on a low table. She is in a comfortable sitting room, to
all appearances her own room. Here the dim room and the lamplight,
and the absolute concentration of the reader, hark back to the absorbed
stillness of Georg Kersting's *Man Reading by Lamplight* from almost
exactly a century earlier. The season would seem to be late spring
or early summer: there are white summer curtains already at the
window and a few blooms of lilac are casually disposed in a glass on
the table. Beyond the window is the luminous blue twilight of the city.
This painting is very close to the world of the protagonists of Virginia
Woolf's novels. The two areas of light and energy in the painting, the
lamp (with its satellite reflection in the polished dish on the wall) and

the lucid dusk at the window, suggest both private autonomy and the potential to go forth into the city.

<center>★</center>

This is exactly what Virginia Woolf does in her essay 'Street Haunting', written in 1930. She writes at length only about the place, the hour, the season – an extended and meditative exploration of those moments in the city which are observed in passing by the characters in her novels. The whole semi-autobiographical essay is an evocation of twentieth-century London at evening, so precise and so sustained that it has become a classic of writing about place, a notation of experience so precise as to contribute something intangible to the place described. Her winter evening walk south from Bloomsbury to the Strand potentially shadows every reader's walks through the same districts. Her evocation of the rural darkness of the square gardens is precise in itself, but also prompts thoughts about the degree to which London is urban in a way which incorporates a degree of (perhaps stylized) longing for the country:

> How beautiful a London street is then, with its islands of light,
> and its long groves of darkness, and on one side of it perhaps some
> tree-sprinkled, grass-grown space where night is folding herself
> to sleep naturally and, as one passes the iron railing, one hears
> those little cracklings and stirrings of leaf and twig which seem to
> suppose the silence of fields all round them, an owl hooting, and
> far away the rattle of a train in the valley.[23]

She catches also with absolute precision the mixed occupancy of the districts through which she moves, the windows with their commercial or domestic patterns of light alternating with the pools of darkness in the squares.

> But this is London, we are reminded; high among the bare trees
> are hung oblong frames of reddish yellow light – windows; there
> are points of brilliance burning steadily like low stars – lamps;
> this empty ground, which holds the country in it and its peace,

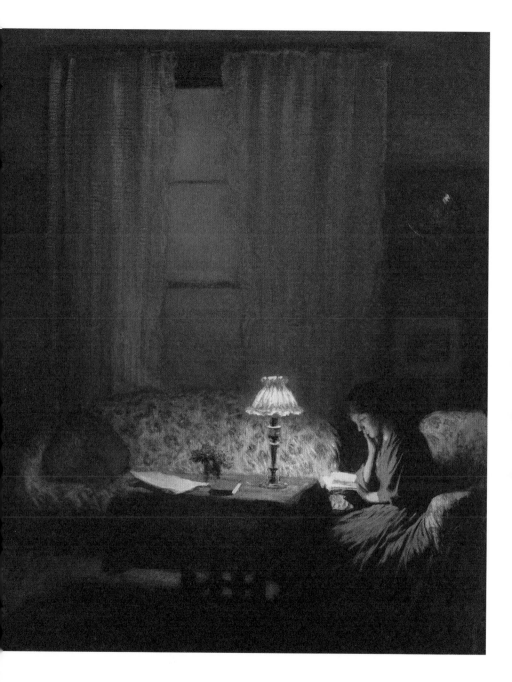

The lamp by the unshaded window. George Clausen, *Reading by Lamplight: Twilight Interior*, c. 1909.

is only a London square, set about by offices and houses where at this hour fierce lights burn over maps, over documents, over desks where clerks sit turning with wetted forefinger the files of endless correspondences; or more suffusedly the firelight wavers and the lamplight falls upon the privacy of some drawing-room, its easy chairs, its papers, its china, its inlaid table, and the figure of a woman, accurately measuring out the precise number of spoons of tea which – She looks at the door as if she heard a ring downstairs and somebody asking, is she in?[24]

She is also acutely of her time in observing shop windows as phenomena in themselves, Ravilious's subjects, a vital part of the texture of Chesterton's London narratives:

Let us dally a little longer, be content still with surfaces only – the carnal splendour of the butchers' shops with their yellow flanks and purple steaks; the blue and red bunches of flowers burning so bravely through the plate glass of the florists' windows.[25]

The final observation on the northward walk home is how the pattern of lighted windows is sensitive to the hour of the winter evening, in the same ways as the departure of the crowds from the centre of the city:

In these minutes ... the streets had become completely empty. Life had withdrawn to the top floor, and lamps were lit. The pavement was dry and hard; the road was of hammered silver.[26]

Virginia Woolf's awareness of the evening city, here expressed as the sole subject of her essay, is active in her novel *Night and Day* (1919), which ends in evening London with an elegant sequence of variations on the theme of the lighted window. As the narrative moves to resolution in the mutual realization of the love between Katharine Hilbery and Ralph Denham, it does so in a succession of windows and nightfalls. After Ralph has stood watch for more than one night outside the house where Katharine lives,[27] the last act of the comedy begins with his being invited in from a suddenly opened window. Thereafter, the relenting Katharine travels up to Lincoln's Inn Fields to meet Ralph as he comes out from his office:

The great gas chandeliers were alight in the office windows. She conceived that he sat at an enormous table laden with papers beneath one of them in the front room with the three tall windows. Having settled his position there, she began walking to and fro upon the pavement.[28]

As she wanders and waits, she is enchanted by the 'blend of daylight and of lamplight' in the streets, but she misses him:

> She hastily turned back into Lincoln's Inn Fields, and looked for her landmark – the light in the three tall windows. She sought in vain. The faces of the houses had now merged in the general darkness.[29]

Her generous friend Mary Datchet then steers Katharine through an evening of distraction, until they return eventually to Katharine's home to find Ralph waiting there after all, and the plot moves on to its conclusion. In the final chapter Katharine and Ralph launch themselves out into the city, her family house now open to him, though the street carries for them the recollection of his waiting outside in the dark:

> They turned and looked at the serene front with its gold-rimmed windows, to him the shrine of so much adoration ... how they came to find themselves walking down a street with many lamps, corners radiant with light, and a steady succession of motor-omnibuses plying both ways along it, they could neither of them tell.[30]

In the end, they find themselves in the street below Mary Datchet's window – Ralph following his impulse to speak to her, to thank her – while Katharine waits outside reading the lights:

> Katharine stood where he had left her, looking at the window and expecting soon to see a shadow move across it; but she saw nothing; the blinds conveyed nothing; the light was not moved. It signalled to her across the dark street; it was a sign of triumph shining there for ever, not to be extinguished this side of the grave.[31]

Ralph returns, admitting that he could not bring himself to knock, and they stand together in silent tribute to their friend:

> They stood for some moments, looking at the illuminated blinds, an expression to them both of something impersonal and serene in the spirit of the woman within, working out her plans far into the night – her plans for the good of a world that none of them were ever to know.[32]

And in the closing lines of the novel, the lights of Katharine's family home bless them, enfold them, as they say goodnight: there is no longer a division between the one in the street and the one behind the lighted windows:

> Quietly, they surveyed the friendly place, burning its lamps either in expectation of them or because Rodney was still there talking to Cassandra. Katharine pushed the door half open and stood upon the threshold. The light lay in soft golden grains upon the deep obscurity of the hushed and sleeping household. For a moment they waited, and then loosed their hands.[33]

Thus ends the extraordinary series of nocturnes which has brought the novel to a close, where so often the lighted windows of a house or an office have played a part in the movement of the narrative, sometimes standing in for the dweller or worker behind the window. The lovers are together on the threshold in the golden light of an open door, light spilling out into the street, light which is both inside and outside.

One of the associative fantasies in 'Street Haunting' takes its departure from a shop selling antique jewellery. This draws forth a reverie of Mayfair, of Woolf's imagined self wearing one of the elegant things which she has been surveying, standing at a window with a party just ended, and the summer night moving towards dawn.

> Only motor-cars are abroad at this hour, and one has a sense of emptiness, of airiness, of secluded gaiety. Wearing pearls, wearing silk, one steps out onto a balcony which overlooks the gardens of sleeping Mayfair. There are a few lights in the bedrooms of

great peers returned from Court, of silk-stockinged footmen, of
dowagers who have pressed the hands of statesmen.[34]

This is a revisiting of the world of her 1925 novel *Mrs Dalloway*, which
concludes with one of the most beautifully realized London evenings
in fiction. The device which Woolf uses to convey the freshness
and clarity of her own perception of summer London is the adroit
one of the native who has been long abroad and has returned to see
everything with fresh eyes. Peter Walsh is setting out for Clarissa
Dalloway's party – he has noted on finishing dinner at his hotel how
the post-war coming of evening in London is like the beginning of
a new day:

> One might fancy that day, the London day, was just beginning ...
> the day ... shed dust, heat, colour; the traffic thinned; motor cars,
> tinkling, darting, succeeded the lumber of vans; and here and there
> among the thick foliage of the squares an intense light hung ... For
> the great revolution of Mr Willett's summer time had taken place
> since Peter Walsh's last visit to England. The prolonged evening
> was new to him. It was inspiriting, rather ... the leaves in the
> square shone lurid, livid – they looked as if dipped in sea water –
> the foliage of a submerged city. He was astonished by the beauty.[35]

He begins to make his way to the party, heading south through
Bloomsbury towards the Dalloways' house in Westminster, his mind
flickers over the deaths of acquaintances, half-automatically he buys
a paper and checks the county cricket scores, abandoning the paper
almost immediately. Somehow memories and speculations then fall
away, and he becomes wholly attentive to what is around him:

> Beauty anyhow. Not the crude beauty of the eye. It was not beauty
> pure and simple – Bedford Place leading into Russell Square. It was
> straightness and emptiness of course; the symmetry of a corridor;
> but it was also windows lit up, a piano, a gramophone sounding;
> a sense of pleasure-making hidden, but now and again emerging
> when, through the uncurtained window, the window left open,
> one saw parties sitting over tables, young people slowly circling,
> conversations between men and women, maids idly looking out ...

stockings drying on top ledges, a parrot, a few plants. Absorbing, mysterious, of infinite richness, this life.[36]

Here is Woolf's sense of the intricacy of the modern city: the idea of lives, sensibilities, occupations, all existing simultaneously and making, in the precise fall of her sentences, the ordering of her lists of things perceived, one counterpoint of the whole urban evening.

Towards the end, the narrative returns to shadowing Clarissa Dalloway herself, charting her success as a hostess (mysteriously she becomes convinced of success when the evening wind blows the curtains into the room).

> The curtain with its flight of birds of paradise blew out again. And Clarissa saw – she saw Ralph Lyon beat it back, and go on talking. So it wasn't a failure after all! It was going to be all right now – her party.[37]

Late in the evening, withdrawing for a moment from her party when it has reached its height, Clarissa goes to look out, and in the sight of her neighbour going quietly to bed in the opposite house, once more Woolf offers her sense of the whole city as contrapuntal, one vast consonance of lives and sensations:

> She walked to the window ... she parted the curtains, she looked. Oh, but how surprising! – in the room opposite the old lady stared straight at her! She was going to bed ... in the room opposite. It was fascinating to watch her, moving about, that old lady, crossing the room, coming to the window. Could she see her? It was fascinating, with people still laughing and shouting in the drawing-room, to watch that old woman, quite quietly, going to bed alone. She pulled the blind now ... There! The old lady had put out her light.[38]

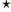

Not far away from the London of Peter Walsh's evening walk, and a decade later, when things had soured and darkened, a mysterious event took place within the same geography of the Georgian streets and

squares of central London. This narrative of an apparition and a lighted window gains its power from incongruity, its setting on the fringes of the London beau monde of the 1930s, Clarissa Dalloway's world but a decade and more later. In *Noble Essences* (1950), his recollections of friends and contemporaries, Osbert Sitwell (1892–1969) relates this vision of a supernatural double, a doppelgänger, seen in a window just before the Second World War by the society painter Rex Whistler (1905–1944). In a sense, Whistler's talents were themselves ghostly in that almost all his work is in historicist styles, impersonations of the dead. The vision in the lighted window took place in Fitzroy Street in the small hours of a summer morning in the late 1930s: Whistler had worked late and had gone to the pillar box in Fitzroy Square, leaving the long windows of his first floor apartment lighted.

> The night was dark, it was a little after two in the morning, and as he returned home along the other side of the street … he was amazed to see clearly a man seated at his own desk in the furthest window, and apparently working. This unexpected intrusion confounded and disturbed him, and he stood still to watch: at that moment, the figure raised his head, and looked straight at him – and he saw that it was himself. While he still struggled under this impact, the figure opposite dissolved.[39]

It is hard to know what to make of this purely private revelation and prophecy of disaster, vouchsafed to a rather melancholy young painter whose milieu was the West End of London, the country houses of the years between the wars. He was indeed killed in the war, resisting all attempts to find him a safe posting as a war artist. His reputation went into almost total eclipse for the rest of the century. Characteristically, my art historian friend Alan Powers was already aware of his work in an informed, thoughtful way by the late 1970s, remembering the high status which he had enjoyed in the last years of his short life, and anticipating the modest revival of his work which has taken place in recent years. In the years when Alan and I often walked together in London, the resonance of Whistler's sighting of his fetch in the lighted window haunted Fitzroy Street for us, changing its aspect, making it

a place of memory of the onset of the war that shaped the world into which we were both born.

How wonderful those London evening walks with Alan were, and how much I learned from them. We walked in circles outwards from Alan and Susanna's flat (and, later, their house) just to the south of St Pancras Station, sometimes travelling a few stops on the quiet evening tube to a new point of departure. I think we only wandered once or twice up past the parks and amongst the stucco villas of St John's Wood, but much of the atmosphere of all our walks is captured by George Clausen's painting *Summer Night, St John's Wood*. It shows the view from the front windows of his house at 61 Carlton Hill, where he lived from the beginning of the century until the Blitz. We see the street fronts of two substantial stucco villas of the nineteenth century illuminated against a deep summer sky: the painting combines a feeling of serenity (evening London could be surprisingly tranquil even in the late twentieth century) with an air of quiet and settled happiness, expressed in the stars just showing in the bright sky, in the coloured curtains with the lamplight behind them.

Our walks were mostly around Bloomsbury, with frequent excursions further south into Covent Garden, Soho, Seven Dials. Quite often we would cross the Strand and come to the Embankment, then move onwards along the river, sometimes stopping for a drink (among the many maps which Alan carries in his memory is one of the Arts and Crafts public houses of London), sometimes for something to eat, but never lingering for long, aware of how much could still be seen in the compass of an evening. We wandered through the Inns of Court (which I remember as open to a walker in those evenings) or down to the remnants of the Adelphi, with the baroque Water Gate marooned in its little overshadowed garden by the railway bridge.

I think we took only a few walks around Spitalfields (which was not then as it has now become), one of them on an autumn Sunday afternoon with a tattered, weeping, polychrome sunset at the ends of the streets of once-fine houses. These walks have remained very clear in memory. So have those days spent roaming more widely in the East

'A sense of pleasure-making hidden, but now and again emerging.' George Clausen, *Summer Night, St John's Wood.*

End circling outward from the Hawksmoor churches. (Even writing those words calls to mind the strange carved altars with deep-cut drapery and mournful-looking cherubs in front of Hawksmoor's church of St Alfege in Greenwich, seen as our last call one day, with

the lights coming on in the shops on the other side of the street.)
We were fascinated by surviving streets of elegant houses which had
become (for that moment) almost disused, or had been converted into
little factories, modest offices. There were worn, darkened brickwork,
flags of gutter vegetation, and all along the narrow roads the fine, tall
proportions of the buildings. I suppose it was our shared interest in the
ruin-painter, the backstreet-grandeur painter James Pryde (1866–1941)
which caused us to develop what was then an almost-private urban
aesthetic: nightfall sightings of fine rooms, glimpsed by lamplight or
strip light, in the streets below the sooty *terribilità* of Hawksmoor's
great stone steeples. We were fascinated by inside and outside – by
the potential of uniform facades to hide rooms with panelling, even
with over-door or overmantel paintings, the kind of rooms in which
Pryde's indoor scenes take place. It is still a marvel to me how much
Alan knew about what was behind the facades of those London streets,
his extraordinary memory for the descriptions in the volumes of *The
Survey of London*.

We made plans to see the painted work in the Master's House of
the Foundation of St Katherine in Butcher Row. I remember reading in
the *Survey* about the landscapes there, the seashores and watchtowers
and distances, the delicate, painted ships standing offshore. There
was a house in Soho with a staircase painted with ships too, under
those effortless pseudo-Italian skies which every journeyman painter
of the eighteenth century seemed able to produce. Perhaps that was
something we only knew from the old volumes of the *Survey*, maybe it
had perished in the war, but those London rooms painted with ships
and blue waters are particularly haunting for the nearness of the river.
We often wondered what part these old painted rooms in London
houses had played in forming the idiosyncratic, out-of-time aesthetic
of Rex Whistler, even as Alan himself was painting a panorama of
Gothick ruins and foliage all round the walls of a dining room in
Clareville Grove.

It was on a recent summer evening that we walked southwards
through Bloomsbury with another eighteenth-century painted ceiling

as the objective of our stroll. Gentle air and the street light catching in the edges of the leaves, the bright cafes and a few late shops in Marchmont Street, with lights coming on in the windows above. Russell Square was still full of people as we skirted the gardens, made our way down the austere side elevation of the museum, and rounded the corner with its lovely curve of massive railings. There were crowds in front of the pubs in Great Russell Street as we turned for a moment aside to see what was on display behind the grille in the lighted window of the picture dealers Abbott & Holder. Then we made our way westwards, crossing at the lights, then down narrowing Great Russell Street, until we paused to look up at the symmetrical, buff-painted stucco front of number 99.[40] The sky was summer-bright cobalt above us by now, the windows were lit, and the painted ceiling was shining out as it has for almost three centuries. There is a swagged curtain to frame the lighted space within, where the walls of the staircase are continued upwards in steep feigned perspective, framing a painted heaven of brilliant cloud. And there are the figures of the deserted Ariadne, the young Bacchus with his

Eighteenth-century painted ceiling, seen at twilight through a lighted window in Great Russell Street, Bloomsbury.

ivy-wreathed wand, and an attendant cherub, all floating in fictive space, in the past, behind the glazing bars of the first-floor window.

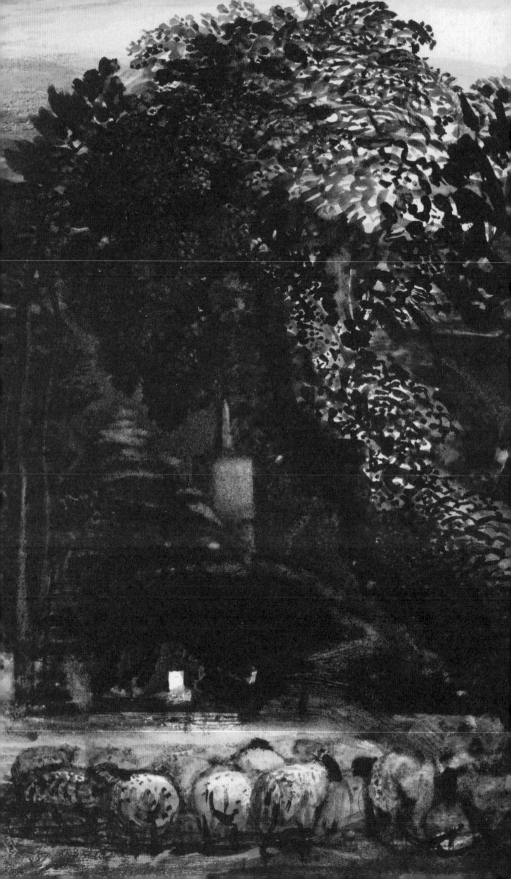

THREE
WINDOWS
IN THE LANDSCAPE

I am walking at night with Andrew through the 'village field', thirty years ago. All that time has left of the deserted medieval village is a scatter of troughs and swellings in the grass where houses and garden enclosures have been, so we are walking between them up what has once been a wide street or a narrow village green. Centuries of grazing sheep have cropped the grass so fine that the ridges in the ground have a look of mown formality: a minimal, hermetic garden under the November moon. This cold walk started as a twilight stroll on the towpath, until moonrise drew us on to walk the loop of the Oxford Canal away from the village, led on by the kindling silver in the water. Having walked this long circuit on the flat land (on summer evenings we used often to run the same course, easy between flowering hedgerows, talking as we went) we had reached the field where the old village once was, with the new village on its hillside above us. A hinge in England: the Edgehill escarpment rising out of the midland clay, midland speech giving way to the voiced *r* of the south and west.

On the slope, a secluded village of about thirty houses and cottages is gathered about a Tudor great house wrecked in the civil wars, abandoned by the family ever after. Over time, orchards and cottages

Enfolding, sylvan England. Samuel Palmer, *A Village Church among Trees*, detail, ink drawing, c.1830.

have stolen into the places where its courtyards and gardens once were, built out of the stone of its ruins. Full-grown oaks are scattered through the fields on the hill, and specimen trees – pines and cedars – have grown to fill the green space between the houses. The whole hill is so deep in trees that the least breath of the autumn wind echoes with the sound of illusory waters; the whistle of the train in the valley becomes the siren of a ship far away over the waves.

On this cold night, the boughs are bare under the moon and, as we approach the path up to the village, the cottage lights on the slope seem at first like stars seen through their branches. We walk for a moment through darkness under dense boughs of old trees, a pond in the hillside catching slivers from the sky, tree-shredded scraps of moonlight like torn foil at our feet. When we emerge into the cool moonlit world of the higher slope, there are glimpses of yellow light in the cottages below the church. Above them, a plume of silvery woodsmoke is still in silver air. The grey stone church sits on its mound, soaked in moonlight. At the end of the arch of trees ahead, a mullioned window is lit upstairs in the stone gate tower which once guarded the entrance to the manor. The lost great court has become a village green sheltered under cedar branches. There is filtered moonshine on the grass, brilliant moonlight streaming through the archway, and amber lamplight in the window above. White-silver light and golden-yellow light ahead, and the boughs of the cedar ink-dark green.

As we come to the level at the top of the slope, trees and hedges thin out on our right and we can glimpse moon-blanched counties stretching away: tree-scattered fields and low hills in the distance. Enfolding, sylvan England: a few fixed stars of window light in the silver-washed valley, white car headlamps sweeping a distant road. On our left is the dark bulk of the Manor Farm, moonlight shivering in fragments on the panes of its leaded windows. This block is all that survives of the fine rooms of the great house, patched together as an enormous farmhouse. It still holds some of its sixteenth-century distinction: the long mullions facing down the walk to the churchyard, the battlements on the roofline. It sleeps and broods in its yards and orchards, visited

from London now and then, mostly silent and lightless. At the heart of the poetry of this secluded village, withdrawn so deep amidst the oak trees and the B-roads, are these moonlit orchards and this great house vacant. It is not so much that it fosters imaginations of supernatural presence, rather that its very emptiness seems part of the invisible power of backwoods England – the unlit hall that awaits the return of the exiled or wandering squire, and the sense of absence and incompleteness that attends the years of waiting.

It is almost as if a Jacobite metaphor was buried in the British imagination: legitimate authority has fled beyond the seas, leaving sham and usurpation and emptiness at home. The vacant, contested manor near the dying town of Cullerne in John Meade Falkner's *The Nebuly Coat*; shuttered, rain-battered Chesney Wold in *Bleak House*. The haunted houses of fiction are often ones which are only partly inhabited: the children and governess alone in the inexplicably isolated Bly of *The Turn of the Screw*; the bachelor antiquaries and necromancers, past and present, who inhabit but a few rooms of the remote, troubled mansions of M.R. James's imagination. As in the fictions of Kipling and de la Mare, there is always the possibility that a long-empty house, particularly an old house in a remote village, will summon an inhabitant to itself. I sometimes wonder how much the weekend visitors from London feel that they own or inhabit this brooding house. Does the silence quicken and quieten again at the moment when the key turns in the lock on a Friday evening in winter?

We pass into brilliant moonlight under the arch of the gate. On summer evenings (barely imaginable on this cold night) we sometimes play fast, improvised games of fives in this gateway, which is almost as big as a real court, cracking the ball off the front and back walls, dropping shots off our gloves into the corners by the arches. As was the habit of idle apprentices, or slacking undergraduates, three hundred years ago. Our breath streams out grey in silver light as we pass through the arch. In the garden of the Tower Cottage – the house carved out of the gate tower and the porter's rooms – glimmers of frost outline the pyramid bean poles, the canes which wait for the

August hollyhocks. We walk onto grass between the garden hedge and a blank stable wall. Rose stems are stretched on the stone, their spines barbed with frost.

Ahead of us, the village street rests under the moon: broad grass verges, willows and yews at cottage gates. One downstairs light in the Old Rectory behind its clipped hedges. Glimmering brightness above, where hoar frost has settled on broad stone roof tiles. No sound on the wintery air: not a whimper from the spaniels or terriers in the ten stone cottages, no voices, no cars, no trains. We stop for a moment, unwilling to exchange this shining night, this suspension of time, for the electric light and bustle of home. The cold is working through our winter jackets and heavy sweaters, but we cannot go in just yet. This winter brilliance and its shadow, silver and viridian, are as wonderful as any summer evening lounging, star-watching, on the leads of the tower amongst the tree tops, or fooling around with a ball on the shadowy green below their branches. It is so quiet that it feels as if the frost has silenced all of England, holding it in stillness by the strength of the cold.

The cold moves us on and we open the gate in the wall. Through a dim, brick-paved passage, and we come into what must have been the kitchen court of the great house. The long low range of the farmhouse where we live fills the north side of it; beyond the garden wall is the roof of a stone cottage and the fruit-tree tops. The sombre bulk of the Manor Farm seems distant, hidden by shadows and branches. The gate tower lifts above the roofs into the moonlit sky. There is lamplight behind the leaded panes of our big sitting room upstairs, and butter-yellow light from our kitchen window lies on the frosted paving of the yard. Through the glass panes in the door we can now see the room – yellow walls, blue woodwork and a big table with four places already laid at one end. There is a scented geranium in a terracotta pot at the other end of the table. And now we go in, coming home out of the silver night, every homecoming concentrated in that one lit kitchen window. All walks home after dark touch on times past and to come – recall the ages of the curfew and the folding star – anticipating

the home which is the distillation of all homes, as in Derek Mahon's
The Hudson Letter:

> So take us where we set out long ago,
> The magic garden in the lost domain,
> the vigilant lamplight glimpsed through teeming rain[1]

★

The feeling of seclusion, of a village half-hidden on a slope, shaded and
enfolded by timber, is caught exactly by Samuel Palmer's ink drawing
A Village Church among Trees. The season of Palmer's drawing is late
summer and softer moonlight lies richly on the tree canopies, on the
full fleeces of the foreground sheep. The church is enclosed in the
depths of the branches, its little spire lost in the leaves, protected from
the weather, from the colder moons which will come with autumn.
This image offers a general sense of deep, cultivated countryside,
of homecoming and security, rather than showing a likeness of one
particular village. The most telling detail strikes the viewer last: there
is a small rectangle of pure white paper on the horizon line where the
slope of the village street rises out of the pastureland. This one small
gap in the dark tonality of the ink drawing is the economical depiction
of a single lighted cottage window. Perhaps it is only the light of one
candle, one oil lamp, but so dim is the register of light in the drawing
as a whole, being a night scene perceived by an eye attuned to the dark,
that it shines out afar through the shadows and the quiet moonlight.
This little gap is the emblem of homecoming, as the great star-tangled
trees are the emblem of shelter and protection.

It is like the cottage light which the lost brothers in Milton's *Comus*
seek in the forest: humble, but to them as lovely as a star.

> some gentle taper
> Though a rush-candle from the wicker hole
> Of some clay habitation, visit us
> With thy long leveled rule of streaming light,
> And thou shalt be our star of Arcady.[2]

It is like the trails of light in water from the lit windows of the cottages seen during Wordsworth's youthful evenings rowing on the lake and walking by its shore:

> ... I listen while the dells and streams
> And vanished woods a lulling murmur make;
> As Vesper first begins to twinkle bright
> And on the dark hillside the cottage light,
> With long reflection streams across the lake.[3]

It is like the cottage candle, seen by Hopkins as he trudges past alone, a tired priest on a misty night:

> I muse at how its being puts blissful back
> With yellowy moisture mild night's blear-all black,
> Or to-fro tender trambeams truckle at the eye.
> By that window what task what fingers ply ... [4]

Palmer's quietude, the fallen-leaf silences of remote England, also dominates the opening chapter of Hardy's novel of 1886 *The Wood-landers*, as the barber comes to Little Hintock on 'the louring evening of a bygone winter's day' and walks down into the cluster of cottages in the dip in the woodland:

> [he] paced cautiously over the dead leaves which nearly buried the road or street of the hamlet. As very few people except themselves passed this way after dark, a majority of the denizens of Little Hintock deemed window curtains unnecessary; and on this account their visitor made it his business to stop opposite the casements of each cottage that he came to.

The stillness is eventually broken by the crackle and brightness of the fire in the cottage which he seeks. These few paragraphs evoke dim lights, woodsmoke on cold air, an era which has just passed out of living memory. Hardy's evocation of the experience of being out among the sparse lights of evening, among the cottages in the woodland combe, echoes the huddled cottage roofs amidst trees of Palmer's early landscapes.

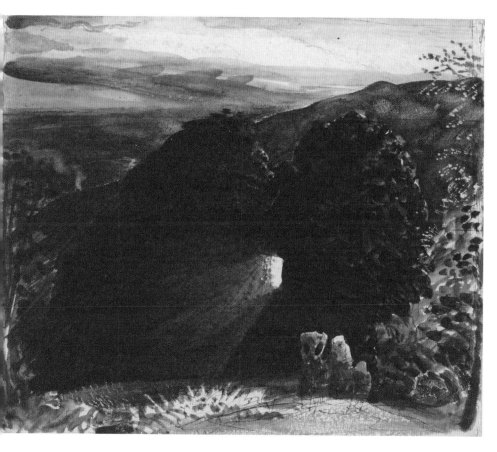

Revelation in the Kentish countryside. Samuel Palmer, Indian ink drawing, *Dark Trees through which a Bright Light Breaks*, c. 1830.

Half a dozen dwellings were passed without result. The next, which stood opposite a tall tree, was in an exceptional state of radiance, the flickering brightness from the inside shining up the chimney and making a luminous mist of the emerging smoke. The interior, as seen through the window, caused him to draw up with a terminative air and watch. The house was rather large for a cottage, and the door, which opened immediately into the living-room, stood ajar, so that a ribbon of light fell through the opening into the dark atmosphere without. Every now and then a moth, decrepit from the late season, would flit for a moment across the out-coming rays and disappear again into the night.[5]

A stranger light in the country dark is shown in Samuel Palmer's sketch in Indian ink, *Dark Trees through which a Bright Light Breaks*.[6] This image, in the Victoria and Albert Museum, is broadly and rapidly executed, ultimately mysterious, but specific as to place and time. From a hill with a reaped cornfield on its slope, the view looks down into a narrow valley with a broad landscape beyond. High moonlight washes the sky, gleams on smoke and water in the middle distance, touches and defines the billowing tops of two great trees in the valley. There are three sketchy figures in the foreground: a family, a suggestion of Ruth's gleaning in the basket balanced on the woman's head, a hint of the Flight into Egypt in the grouping of the figures. The mystery in the drawing comes from the rectangle of light, like lamplight streaming from an open door, which shines out between the trees. The light is more brilliant than any lamp or candle, defining the contour of the hill, reflecting up into the leaves.

The drawing appears to offer a deliberate enigma: there is no hint of a dwelling with a door; indeed there is hardly room between the trees for any such dwelling. So we have a mystery in this abrupt and deliberate conjunction of blinding light and dark landscape, set at Palmer's sacred harvest time, and with quasi-sacred figures in the foreground. Palmer's early work shares with English traditional song a compelling directness in the poetic juxtaposition of apparently disjunct images. The mother, father and child are moving across the gleaned fields towards a radiant dwelling in the sheltered valley. The divine is immanent in the harvest fields and chestnut coppices of Regency Kent; the imagery evoked is of unconquerable light and of surrounding (but not encompassing) dark from the first chapter of the Gospel of St John. The literal presence of the Light of the World in England is stated in an image as direct as it is haunting.

An equally enigmatic image of brilliant light in darkness is offered by the 1925 woodblock print by Kawase Hasui (1883–1957), depicting *Shinkawa at Night*.[7] But here there is no apprehensible spiritual implication, although there is a sense of the numinous capture of a passing moment, as light from an invisible source shines along a little

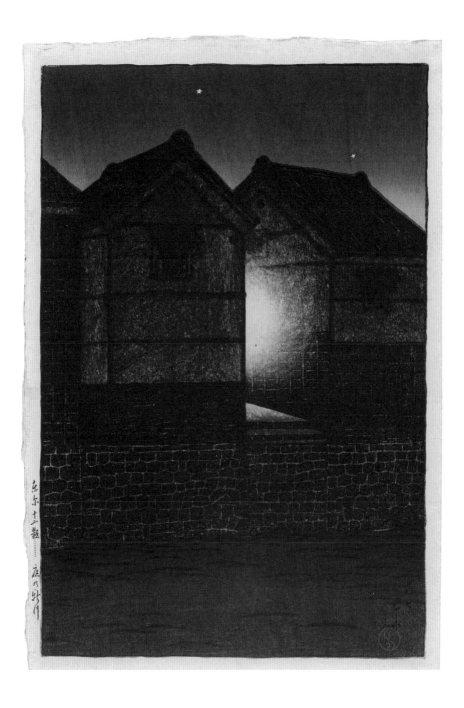

Inexplicable light in the alley by the water: Kawase Hasui, *Yoru no Shinkawa*, from the series *Twelve Scenes of Tōkyō*, woodblock print, 1919.

alley running down to water, perhaps between warehouses, with two piercingly bright stars in the cobalt sky above, which hints at moonrise behind the gables. The image is of great simplicity: there is little detail on the walls of the shuttered buildings, the stone-built embankment and the dark water below are evoked with skilled, minimal drawing and subtle gradation of colour. The tonality overall is muted, so that the brilliant stars and the pale light from an unguessable source form a stable triangle of bright things at the centre of the composition, a capture of the quotidian fallen for an instant into a pattern of great beauty.

<center>★</center>

On a night of winter moonlight, the gentle spillage of light from oil lamps and candles set in cottage windows is perfectly represented in Robin Tanner's etching *Christmas, 1929*. Tanner came to printmaking because of the revival of interest in Samuel Palmer after the First World War: the rendering of the fall of moonlight on the bare trees beyond the village owes much to Palmer. This view from the tower of St Andrew's Church at Castle Combe in Wiltshire looks down on the roof of the butter market at the crossroads, and along a village street lit by the cold moonlight, which also lights up every detail of the bare trees and rolling ploughlands which stretch to the horizon. In the street, little groups of neighbours are talking, strolling, perhaps leaving the inn or returning from church. There are lights in the windows, beautifully rendered in their variations of intensity. How little difference these minor illuminations make to the night and the moon: only in the foreground, where the street is shadowed by the tower itself, does a lighted doorway show bright enough to silhouette the departing guests and a ball of mistletoe hanging from the beams of the porch.

It must have been lonely and strange making the drawings for this work, up on the leads of the tower in the quiet and the frost, cut off for hours from the stir of life in the street below, watching the lamps and candles go out one by one in the gabled houses and behind the

Castle Combe in Wiltshire seen from the church tower. Robin Tanner, *Christmas, 1929*, etching,

mullioned windows. And then, inevitably, coming down the tower steps in the darkness before dawn, past the old works of the clock, emerging into a weary Christmas Day. It is easy to imagine a return to a cottage room at first light, the iron of the latch chilling the hand, strengthless winter sun quickening behind leaded panes, powdery wood ash cold on the morning hearthstone.

<div align="center">★</div>

A very similar village street, but from before the War, is evoked in Kenneth Grahame's *The Wind in the Willows* (1908), at the point where his animal characters come the nearest both to the dwellings of humans and to their own most human aspects. The Rat and the Mole are out on a winter night, on their way home from innocent exploration of the countryside, when they come near a flock of folded sheep

> blowing out thin nostrils and stamping with delicate fore-feet, their heads thrown back and a light steam rising from the crowded sheep-pen into the frosty air.[8]

And they risk coming near to the human world which they usually avoid, since the winter evening will have drawn all the humans safely to their firesides:

> The rapid nightfall of mid-December had quite beset the little village as they approached it on soft feet over a first thin fall of powdery snow. Little was visible but squares of a dusky orange-red on either side of the street, where the firelight or lamplight of each cottage overflowed through the casements into the dark world without. Most of the low latticed windows were innocent of blinds, and to the lookers-in from outside, the inmates, gathered round the tea-table, absorbed in handiwork, or talking with laughter and gesture, had each that happy grace which is the last thing the skilled actor shall capture – the natural grace which goes with perfect unconsciousness of observation. Moving at will from one theatre to another, the two spectators, so far from home

Rat and Mole pass down the lighted village street and long for home. James Lynch, *Dulce Domum*, 1994 (illustration for *The Wind in the Willows*).

themselves, had something of wistfulness in their eyes as they watched a cat being stroked, a sleepy child picked up and huddled off to bed, or a tired man stretch and knock out his pipe on the end of a smouldering log.[9]

Even in the early twentieth century, as in Hardy's nineteenth century, many houses are lit by the light of the fire alone, and no villager runs to the extravagance of candles on an ordinary evening. Curiously, it is seeing their fellow creature, a caged bird falling asleep in the warmth inside, that strikes them both as the most moving of the shows that they have seen in the lighted windows,

> But it was from one little window, with its blind drawn down, a mere blank transparency on the night, that the sense of home and the little curtained world within walls – the larger stressful world of outside Nature shut out and forgotten – most pulsated. Close against the white blind hung a bird-cage, clearly silhouetted, every wire, perch, and appurtenance distinct and recognisable, even to yesterday's dull-edged lump of sugar. On the middle perch the fluffy occupant, head tucked well into feathers, seemed so near to them as to be easily stroked, had they tried; even the delicate tips of his plumped-out plumage pencilled plainly on the illuminated screen... Then a gust of bitter wind took them in the back of the neck, a small sting of frozen sleet on the skin woke them as from a dream, and they knew their toes to be cold and their legs tired, and their own home distant a weary way.[10]

This is a moment which every reader remembers. It also opens the saddest part of Grahame's gentle fable – the Mole's longing to revisit his little, very Victorian, very neat burrow, and the cheerful resolution of that episode in the improvised Christmas feast, complete with carol-singers, which ends the chapter.

This is in stark contrast to the unrelieved outsideness of John Clare, hungry and exhausted, walking in 1841 away from the asylum near London where he had been confined, trying to return to his native village in Northamptonshire, and to the dead wife whom he still believed to be waiting for him.

It now began to grow dark apace, and the odd houses on the road began to light up, and show the inside lot very comfortable, and my outside lot very uncomfortable and wretched.[11]

As though the scenes inside the lit cottages are all those things that he had lost, and from which he is now excluded by mental illness, poverty, sheer misfortune, as he trudges on in the dark.

<div align="center">★</div>

Robin Tanner's etching of a remote, beautiful western village, its style governed by the rediscovered English art of the nineteenth century, withdraws from the more troubled post-war world into a country retreat, the consolation of quiet lamplight in a remote village. In the same way, the painfully self-aware protagonist of John Cowper Powys's *Wolf Solent* (also published in 1929) walking home after an evening spent in an inn in a country town takes consolation from a candlelit cottage window, to allay his fear of modernity, of an England wrecked by 'electric lights and concrete roads':

> In one of the smaller houses, where for some reason neither curtain nor blind had been drawn, Wolf could see two candles burning on a small table at which someone was still reading. He touched Mr. Valley's arm, and both the men stood for a time looking at that unconscious reader. It was an elderly woman who read there by those two candles, her chin propped upon one arm and the other arm lying extended across the table. The woman's face had nothing remarkable about it. The book she read was obviously, from its shape and appearance, a cheap story... For leagues and leagues in every direction the great pastoral fields lay quiet in their muffled dew-drenched aloofness. But there, by those two pointed flames, one isolated consciousness kept up the old familiar interest, in love, in birth, in death, all the turbulent chances of mortal events. That simple, pallid, spectacled head became for him at that moment a little island of warm human awareness in the midst of the vast non-human night.[12]

The protagonist reacts with a strength of feeling which surprises both him and the reader: this woman in a cottage window becomes the

epitome of all the beauty that he would preserve from destructive modernization, which configures itself in his mind as ever-brighter artificial light ruining the shadowy countryside. Indeed he becomes so involved in his mind with the reader in the window that she becomes almost a supernatural figure, a spinner of destiny reading the narrative of his own future life.

An element of the uncanny also attends one of Thomas Hardy's strangest poems, 'Seen by the Waits'. This is also set in the West Country, this time on a December night. The poem – a dislocated, haunting fragment of narrative – turns on the single lighted window in an isolated manor house, and the village carol singers' glimpse of the squire's widow dancing by herself with lonely, delinquent joy. The poem has a disquieting quality of truth and sorrow, the unintentional discovery of a secret better unknown. Cold moonlight and the shadows of the trees lie over the singers on their way home towards the lights of the village, but, unlike the moonlit night of Robin Tanner's etching, the singers have been driven deep into the silence of their own thoughts by what they have seen.

> Why she had danced in the gloaming,
> We thought, but never said.[13]

<p style="text-align:center">★</p>

A window and an unhappy marriage are the scene and subject of another of Hardy's poems, 'The Moth-Signal'. It is late summer, and the window is that of a cottage on the moors near a prehistoric long barrow. The verse is ambiguous in mood: a moth released to destroy itself in the candle flame inside signals to a faithless wife that a lover waits outside.[14]

> 'What are you still, still thinking,'
> He asked in vague surmise,
> 'That you stare at the wick unblinking
> With those deep lost luminous eyes?'

> 'O, I see a poor moth burning
> In the candle flame,' said she

The husband, unsuspecting, offers an answer which is at once trite and an expression of pity for all fragile things driven to seek light and shelter as the year turns to autumn.

'Moths fly in from the heather,'
 He said, 'now the days decline.'

So the wife goes out saying that she wants to look at the changes of the moon, but goes in fact to meet the lover who has been waiting by the tumulus. But she gives him no welcome, only the bitterest regret, the thought that the burnt moth is a prophecy of their future.

'I saw the pale-winged token
 You sent through the crack,' sighed she.
'That moth is burnt and broken
 With which you lured out me.'[15]

The last stanza draws back into the deep time of the heath with its half-obliterated monuments, as the corpse in the barrow grins at the thought that so little has changed in the perversity of the human heart. The poem compresses an extraordinary implication of feeling into its ballad stanzas, not only the evocation of time and place, the quiet uncanniness of the isolated house near the long barrow, but also the unhappy prophecy of sadness to come, the woman who can be happy with neither husband nor lover. The year declining, the moth self-destroyed, happiness illicit and out of reach.

A cottage window on a late summer night is also the scene of one of Hardy's most idiosyncratic autobiographical verses, dating from 1899, 'An August Midnight'. The tone is affectionate, detached, observant as the poet sits alone in his sixtieth year, the silence only deepened by the sound of a clock far away in the house:

A shaded lamp and a waving blind,
And the beat of a clock from a distant floor:
On this scene enter – winged, horned, and spined –
A longlegs, a moth, and a dumbledore[16]

The insects, 'guests', interrupt his planned work, smear the ink, batter at the oil lamp and change the direction of his thought to a moment of delighted speculation as to why this humble company, out of all of creation, have assembled around him and his lamp on this one still night. Nothing happens in the poem, as such, but it is rich in implication that to the reflecting mind every moment is the intersection of lives and consequences.

<div align="center">★</div>

For W.B. Yeats, in the years after the Easter Rising, the significance of the lighted window seen across the darkened Irish country became a double one: sometimes it was the scholar's or sage's lamp illuminating a tower room in peaceful seclusion. Later in his work, lights in the windows of burnt-out big houses were hauntings, uncanny re-enactments of the errors and disjunctions of Irish history.

The positive associations of the lighted window for him were all with Milton, and with the solitary Platonist in *Il Penseroso*,

> ... let my lamp at midnight hour,
> Be seen in some high lonely tow'r,
> Where I may oft out-watch the Bear[17]

Even more important to Yeats was Samuel Palmer's rendering of Milton in his poetic etching *The Lonely Tower*.[18] Yeats identified his own tower house at Thoor Ballylee with the tower in Palmer's print. After he had bought the tower in 1916, but before he had moved into it, he imagined one of his fictional other selves walking beneath its lit window in 'Ego Dominus Tuus':

> *Hic.* On the grey sand beside the shallow stream
> Under your old wind-beaten tower, where still
> A lamp burns on beside the open book[19]

A few years later, in 'Meditations in Time of Civil War', by which time Yeats was actually spending his summers in the tower, he imagined how the lighted window might appear to passers-by as a symbol of meditative seclusion in a troubled time:

A winding stair, a chamber arched with stone,
A grey stone fireplace with an open hearth,
A candle and written page.
Il Penseroso's Platonist toiled on
In some like chamber …
Benighted travellers
From markets and from fairs
Have seen his midnight candle glimmering.[20]

In the last three lines the identification of Thoor Ballylee with Milton's and Palmer's tower is so close that Yeats is offering Palmer's etching, in all its serene complexity, to his reader's imagination as a rhyme or simulacrum of his own dwelling. The association deepens the arcane and poetic invocations in Yeats's poem, its layers of time and allusion, the hint that time behind the window may not be moving at the same pace as time moves in the fields below.

'Let my lamp at midnight hour / Be seen in some high lonely tow'r.' Samuel Palmer, *The Lonely Tower*, 1868.

Palmer's etching occupies layered times and places in a similar way: it is at once England in the early nineteenth century and Virgil's Italy, so that the Renaissance light from Milton's verse shines out over an imaginative convergence. The hay wain with its waggoner and the wind-blown thorn trees are purely English, but the clothes of the shepherds in the foreground belong to classical antiquity. An English barn owl stands in for the little owl of Pallas Athene. There appears to be a sketchy indication of a stone circle on the flat ground over which the moon rises. The mountains and the tower are shadowy and ambiguous, Pennine and Appenine at once, while the tower itself is only seen as silhouette, either an English peel or the Campanian ruin called Virgil's tomb. Palmer's own symbol for a landscape transformed or spiritualized – a recumbent crescent moon with the ghost of the full moon behind it – lies on the horizon. But it is the detailing of the night sky which renders the etching otherworldly: the vast stars which swarm like fireflies, moths, enormous golden bees around the brilliant light at the tower window, as though they were drawn to it by sympathetic magic.

★

Later in the work of W.B. Yeats, in the despairing 1930s' poem 'The Curse of Cromwell', a lighted country house appears, but the lights and the very house itself prove to be phantasmal, a haunting:

> I came on a great house in the middle of the night,
> Its open lighted doorway and its windows all alight,
> And all my friends were there and made me welcome too;
> But I woke in an old ruin that the winds howled through[21]

The poem is a denunciation with the accusing finger pointed at England – the title and the rebel-ballad measure indicate as much. The ghost-house offers a momentary vision of a lamented past, with the fierce certainty that the present has gone wrong beyond repair. The refrain which closes every stanza of the poem is unambiguous in its finality, its defiant emptiness, its angry refusal of dialogue or meaning:

O what of that, O what of that,
What is there left to say?

Later still in his career, Yeats wrote the desolating short play *Purgatory*, whose central image is also a ruined house lighted for a moment by the light of the past. Here, too, everything is spoiled and past hope.[22] By the time that he wrote it, Yeats was in deep despondency about the future of Ireland: the moderates who had made him a senator were out of office, and the conservative revolutionaries led by de Valera were in charge. Like Yeats's other anatomy of the unfinished business of Irish history, *The Dreaming of the Bones*, in which the unforgiven ghosts of those Irish rulers who invited the Normans into Ireland appear, the form is that of a Japanese Noh play disconsolately subverted. The visit of a traveller to a haunted place resolves nothing.

In *Purgatory* a visit to a ruined house on an anniversary invites only repetition and re-enactment. It calls forth the ghosts of the past at the lighted windows – the daughter of the house who made a catastrophic marriage, the unworthy husband who brought the house to ruin. The protagonist, their son, fallen to the condition of a beggar on the roads, kills his own uncomprehending son, in the apparent belief that the boy's death is somehow a sacrifice to release or heal the mother's soul. The ghosts return, the sacrifice fails, the haunting is repeated. Any reflection on the bleak illogicality of the action of the play leads back to the parallel with *The Dreaming of the Bones*, that there can be no resolution to the still unfinished story of a disastrous marriage and an unjust master (whether it is the story of a family or of a nation) but in the violence which thinks to break a cycle and perpetuates it instead.

There are other literary manifestations of the deserted, intermittently lit house which is real and unreal by turns, as night and the moon come and go, like the possessed Victorian mansion in Alan Garner's *The Moon of Gomrath*. The whole narrative is a wonderful invention, a battle between light and dark fought out across intermittently suburbanized countryside near Manchester, sobering in its

seriousness, in the full imagination of how the mid-twentieth-century child protagonists, who are caught up in the struggle, might in actuality feel about seeing and touching death, about a sojourn in an earthly paradise. There is also a beautifully sustained sense of old roads and old places flickering into life within a few yards of the bypasses and the new-build estates. The final confrontation is set around the wrecked mansion of a Victorian industrialist, enchanted by the forces of the dark who hold one of the children as a hostage, a scene somehow more menacing for the willingness of evil to use what comes to hand, with no requirement for ancientness or authenticity.

> The path bordered a terraced lawn, approached by steps, and on
> the lawn was a mansion of stone, built in the heavy Italian style
> of the last century. All the windows glowed with a light that was
> stronger than the moon, but of the same quality, and lifeless.[23]

When the rescuers try to light fires to stave off the attack, which they know will come with nightfall, they tear branches from the overgrown, banal rhododendrons that have run wild in what were nineteenth-century pleasure grounds.[24] At moonrise the fires are caught in the dead light from the enchanted house:

> And though the light it gave was small, and could not even dim the
> fires, the moment it touched the ruins they shimmered as in a heat
> haze, and dissolved upwards to a house. The windows poured their
> dead lustre on the grass, making pools of white in the flames.[25]

One of the most memorable of the inventions of the narrative is the way that, since the house is only re-edified in the glimpses of the moon, when the rescuers are within they see a hint of an utterly void otherworld beyond the windows, when the moon is in the clouds and the house is a ruin in the human world.

> they found him standing at the broken window, looking out into
> the night, which was as silent and impenetrable as the caverns of
> a mine.

'To the valley this house is "here" when the old moon is on it and not at other times; but to the house the valley is "there" only in the moon. So I am asking what is out "there" now, and I am not wanting to know the answer. Let us watch for the moon to come and then through this window as fast as we may.'[26]

The supernaturally illuminated window, the window lit by a light from elsewhere, is a repeating motif in Garner's poetic and considered stories: this mansion at Alderley Edge, a ruined Manchester church in *Elidor* whose broken windows shine with light from the otherworld.

★

A charm at nightfall is the subject of Samuel Palmer's *The Bellman*, an etching also made to illustrate Milton's *Il Penseroso*. It is less an illustration than a poetic invention of Palmer's own, prompted by one of Milton's list of the quiet sounds of the night.

Far from all resort of mirth,
Save the cricket on the hearth,
Or the bellman's drowsy charm,
To bless the doors from nightly harm.[27]

It seems to have been the custom in several countries for the town watchman or bellman, as they went on their rounds, to sing some kind of rhymed prayer invoking divine protection on the sleeping households that he passed. The Night Watchman of Nuremberg does this at the end of the second act of Wagner's *Die Meistersinger*;[28] the Caroline poet Robert Herrick's fleetingly evoked 'Bellman'[29] does the same; both invoking protection especially against the supernatural dangers of the night. So Palmer's bellman (straw-hatted and smocked like the shepherds and reapers who toil in the paradise-fields of his imagination) walks at moonrise into a transformed English village, blessing it as he marks the hour of curfew. The village nestles below a great mountain, under the light of a brilliant moon which rises into a notch in the hills. Moonlight strikes up into the clouds, glimmers amongst the candles

of a great flowering chestnut, touches the horns of the sleeping cattle in the foreground. The place is ambiguous and enchanted, being both Regency England and Italy long ago.

It is a little citadel of latticed windows and lamplight: the street plunges downhill through a double arch beyond which window lights define the curve of buildings. The gentle swell of the thatched roofs echoes the billowing hedge which enfolds the sleeping cattle. Outside the handsome Elizabethan house on the left figures sit under an arbour, a tender couple lit by the spill of lamplight from the house, like Palmer's own image of Virgil's shepherds eating ripe apples together at the close of day. The eye is drawn upwards by the church tower to the mountain and the silver-flooded sky. The curve of hill road just catches the moonlight, answers the moonlit curl of the rising wood smoke. The scatter of lights on the slopes, the windows of upland farms up amongst the trees and the shadows, lead the eye in a gentle spiral to the moony double crest of the range.

It is like driving on the road which leads up steeply out of Calderdale and onto the moors beyond Heptonstall, past the lighted windows of the gritstone terraces on the slopes over Hebden Bridge, with the woods and sounding waterfalls of Hardcastle Crags falling behind as the road twists its way out of the valley. At first only a few lights are visible off in the valley to the left , a scatter of cottage lights, like those observed in Sylvia Plath's poem 'Wuthering Heights':

> Now, in valleys narrow
> And black as purses, the house lights
> Gleam like small change.[30]

As we climb, the receding points of light in the wing mirror cluster closely, the streets and windows of one mill town in a steep dale. A long stone village unrolls in the headlights, with one lit window upstairs in the shuttered pub, then passes behind into darkness as the car climbs the shoulder of the moor. At once the wing mirror fills full with constellations of street lights, estates of lighted upstairs windows, bead-strung lights of peripheral roads – towns and cities spread out

A little citadel of latticed windows and candlelight. Samuel Palmer, *The Bellman*, 1879.

through the river valleys and along the canals. Only a handful of high stars ahead, miles of wind and dry grass and darkness.

This shelterless moorland to the east of Haworth is inevitably associated – as in Plath's poem – with the novels of the Brontë family and especially with Emily Brontë's *Wuthering Heights*. Amongst the many dualities of that narrative is that of upland and sheltered valley, those who have the force to be at home up in the wind, and those (more civil, more polished) whose affinity is naturally with the gentler valley. This is dramatized especially in the episode when the young Cathy and Heathcliff, having stolen away onto the moors by night, make their

way down into the shelter of the Lintons' garden, so that they may observe the family through the lighted window of the drawing room. The episode ends badly, with the intruders discovered, and Cathy injured by the guard dog, but, for the first moment, Heathcliff seems to be narrating something hitherto outside his experience, a vision of warmth and civility:

> They had not put up the shutters, and the curtains were only half closed. Both of us were able to look in by standing on the basement, and clinging to the ledge, and we saw – ah! it was beautiful – a splendid place carpeted with crimson, and crimson-covered chairs and tables, and a pure white ceiling bordered by gold, a shower of glass-drops hanging in silver chains from the centre, and shimmering with little soft tapers. Old Mr. and Mrs. Linton were not there; Edgar and his sisters had it entirely to themselves. Shouldn't they have been happy? We should have thought ourselves in heaven![31]

In sad fact the children are discovered quarrelling nastily over an ill-treated lapdog, but the moment has a force beyond that as a momentary glimpse of another order of life, calmer and safer than that of the inhospitable uplands. Much of the poetic force of the novel is in its contrasts, none more marked than that between the warmth and quiet of various rooms that are described and the violence of the weather scouring the haunted landscape outside.

At the end of the journey, coming down the gentler slope towards Low Bradley, the village windows glimmer up brightly in the spring evening, dark moor tops stand on every side, distant street lights and the main road are hidden by the fold of the slopes. When we arrive at our friend's house, broken moonlight is playing in the quarries of the leaded windows, touching the flanks of the yews, tracking the curve of the garden wall. A thread of cold air drops from the fell behind the house, the moon is in a cloud again, but the cottage lights are bright on the hill.

This moorland journey calls to mind a meditation on window lights and travel in upland country by the Belgian playwright Maurice Maeterlinck (1862–1949), a passage from his *Wisdom and Destiny* of 1899,

As you climb up a mountain towards nightfall, the trees and the houses, the steeple, the fields and the orchards, the road, and even the river, will gradually dwindle and fade, and at last disappear in the gloom that steals over the valley. But the threads of light that shine from the houses of men and pierce through the blackest of nights, these shine on undimmed. And every step that you take to the summit reveals but more lights, and more, in the hamlets asleep at your foot. For light, though so fragile, is perhaps the one thing of all that yields naught of itself as it faces immensity.[32]

Small lights shining out in a darkening landscape are a recurring subject of the Japanese prints of the mid-twentieth century. There is Takahashi Shōtei's woodblock print of a group of small houses at evening with the still-bright slopes of Mount Fuji rising above them. Shōtei lived from 1871 to 1945; this print, *Mount Fuji seen from Mizukubu*, was made in the last decade of his life. Late light, faintly tinged with

Little lights below the mountain. Takahashi Shōtei, *Mount Fuji seen from Mizukubu*, woodblock print, 1930s.

red, is lingering on the snows at the summit of the mountain. The shadow of evening has already swept over the little group of wooden houses in the foreground, a hamlet of modest buildings along a ridge with a stream, partly sheltered by what looks like an older stone wall. Colour has retreated from the lower ground up to the mountain top and the sky; the grey world of evening in the intervening territory is evoked with sparse monochrome patterns of rock shadows and stirring mist. Windows in the nearby houses show pale lights from small lamps behind paper screens. Looking out from those paper windows, the world would seem already to be fading to darkness.

The image is at once remote, in the unfamiliar idiom of the buildings, and familiar in its echoes of the granite tops and steep slopes of Aberdeenshire around Bennachie and Tap o' Noth. So much so that I can imagine this haunting woodblock print from another angle, as if seen from the mountain top: how the sun would shoot long rays from the west, how mist and grey dusk would fill the valleys, and how the little lamps in the houses below would stab at the dark as soon as the sun dipped below the horizon.

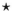

We have lost the feeling of being alone in open country in the dark, and have forgotten how much emotion can be stirred by a single light shining in the distance. The very action of straining to see acts as a trigger to the memory, bringing to mind journeys in the past, lit only by the stars and by the sparse constellations of cottage lights along the roads. The country dark of Europe before the First World War, the walk from the little station through the night, is evoked for the sleepless narrator of Proust's *À la recherche du temps perdu* by the sound of distant trains.

> I heard the whistling of the trains, nearer or further away, like the song of a bird in a forest, fading in the distance, evoking for me the deserted countryside where the traveller hurries to the nearest station; and the little path that he follows which will become fixed in his memory by the anticipation which he feels of new places,

of unaccustomed actions, of recent talk and farewells under the stranger's lamp, which still follow him in the silence of the night, until the approaching happiness of his return home.[33]

This evokes a whole landscape of unlit or moonlit country roads (with a beautiful complication of tense – the whole journey anticipated and yet circumscribed by the imagination of return, of the final walk home); it brings to mind quiet railways with numerous branch lines and small, unattended stations, and the absolute familiarity of the route through the fields between a rural halt and the lights of home.

Those words bring the ironstone village where we used to live to mind once more: windy nights amongst the great sails of the trees, and the sound of the train from Banbury to Coventry carried on gusts out of the west. Or midwinter nights, with the frost thick on the roof tiles, and every click of the wheels and the rails rattling up through a mile of frozen air. That sound of trains heard at a distance over darkened country is consoling yet absolutely remote: the train is passing through, going from town to town without stopping. (I remember a wonderful last line from a newspaper obituary about a dead man's voice belonging to the past, like the whistle of a train heard at dusk in a valley where the railway line had long been abandoned.)

Eric Ravilious's *Train Going over a Bridge at Night* (1935) emphasizes this disjunction, the brilliantly lighted train occupying almost a different dimension from the bare country through which it moves. The train travels between cities, carrying the city with it, and it hardly relates to the territories through which it passes. Everything in the picture emphasizes this: the light, racket and smoke of the moving train, and the dim stillness of the moonlit fields. Illumination from the train changes the landscape only for an instant: caught in the leaves of the two straggling trees near the embarkment, which show fleeting silhouettes of branches, reflected back from the parapet of the bridge. The eye is drawn to the engine, to the bright smoke from its chimney, to the figure of the driver dark against the fire of the boiler furnace.

The same phenomena are observed by John Meade Falkner in that strangest of Edwardian novels *The Nebuly Coat* (1903), a novel of remote

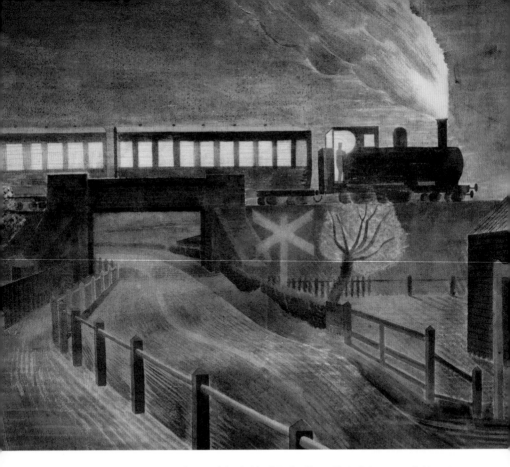

Racket of the train, dim stillness of the fields. Eric Ravilious, *Train Going over a Bridge at Night*, 1935.

Dorset which tells a generic story of missing heirs and secret marriages, but using a narrative technique so idiosyncratic, so strange and oblique in focus, that the result is genuinely disquieting. It is typical of these dislocations that a crucial discovery at a remote junction station on a foggy night is preceded by a long, finely observed description of how a mail train would appear if the weather were clear.

> On a clear night the traveller can see the far-off lamps of the station at Cullerne Road, a mile after he has left the old seaport town... Only the increasing sound of the trains tells him that he is nearing his goal, and by degrees the full rumble becomes a clanking roar as the expresses rush headlong by. On a crisp winter day they leave behind them a trail of whitest wool, and in the night-time a fiery serpent follows then when the open furnace-door flings on the cloud a splendid radiance.[34]

This effect of the furnace reflected and magnified in smoke is the one that Ravilious captures in this strange painting. Very often the haunting quality of Ravilious's work is based on his choice of an ordinary place, seen in extraordinary conditions. This picture captures a transient wonder to be seen only by the traveller who has disembarked from the last train at a country station and started for home. The glare and fire of the passing train dazzling behind their eyelids long after it has gone, blinding them to the dull moonlight and the road home.

<p style="text-align:center">★</p>

Not all distant lights across the fields are hauntings or illusions. I remember a misty autumnal drive down from the hills of the Welsh Marches and through Herefordshire as an early winter afternoon turned to evening. Soft yellow points of light blotted in the wet air, lamps in scattered farms. These gentle punctuations of the broad landscape seemed trusting, welcoming, even consoling. Moving through stillness, in this quiet drive over the wet roads with hardly another car to be seen, each farm shone out a light of home over the monochrome hedgerows and the dimming fields. Electricity came to the Welsh Marches only after the Second World War – before that those hillside farms would have shown only the specks of light from oil lamps and candles – yellow, far off and small as fireflies.

This old pattern of lights in the country evening is evoked with great precision in Proust's memory of the view out from Combray in his childhood, especially as a wet afternoon was moving to evening:

> Sometimes the weather turned for the worse, and it was necessary to return and remain locked up at home. Here and there in the distant countryside, to which the darkness and dampness gave a semblance of the sea, isolated houses, hung on the side of a hill immersed in the night and in the water, shone like little boats which have folded their sails and ride motionless at anchor for the whole night.[35]

A humble, even tender, light in the dark and rainy countryside is shown in *Barber's Shop in Kanagawa, Rainy Night* (1931) by Ishiwata Kōitsu (1897–1987). This woodblock print uses an unusually restricted palette

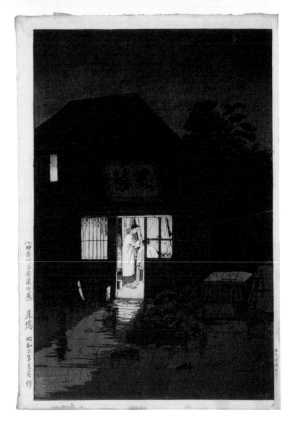

A small light in rainy darkness. Ishiwata Kōitsu, *Barber's Shop, Koyasuhama*, woodblock print, 1931.

to great effect: pelting rain has soaked timber buildings and thatched roofs and flooded the paths, so that all of the print is black and ash-grey (with one touch of grey-green on the shrub by the door). In contrast to this the pale lamplight in the shop, with its open doorway, only shows faintly yellow in contrast to the young barber's white overall and the sheet round his customer's shoulders. Equally pale light shines from an upstairs window of the modest house. There is so little light inside, but the whole of the night outside is so drenched and blackened with rain that by contrast that little human light offers itself as a refuge from the all of the dark.

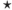

When I was a graduate student, I often visited Geoffrey Keynes in the country outside Cambridge. Leaving that silent, ample house and cycling to the train was almost like making a journey from the past to the present. I think the last train left the station at Dullingham just late enough to allow of leaving immediately after dinner. He would always come to the front door and embrace the departing guest in the bright

light under the porch. I remember these visits as winter, the shock of the cold air, breath steaming in the light falling onto the gravel in front of the house. Once the door closed, I would head round to the stable yard to collect my bicycle. Even though there was little time to spare, I would always look in through the lit windows of the house – gazing into rooms which were almost revenants in themselves because their contents had been gathering and evolving all through Geoffrey's long adult life, since before 1914. His study was to the right of the front door – the bookcases housing his prodigious library, glimmering silver lustre china on the mantelpiece, and hanging beside it Edward Calvert's little tempera painting *The Return Home*. This image is well known as an engraving – the biblical shepherd riding home through an intensely English landscape – but the painted original is even more intense with its odd, vehement colouring: evening sky almost terracotta, blue-black hills. There was one window on the flank of the house through which I could see the flagged kitchen which now served as a dining room, the housekeeper clearing the dinner table, a gaudy lustre tea service on the white-painted dresser, Tudor portraits and Regency topographies on the walls. As I came into the stable yard, I forced my eyes closed trying to get my night vision back all at once, with the lighted windows of the house and all its riches still shimmering behind my eyelids.

Soon the village and its trees were behind me, and I rode through the frosty dark on empty roads. Taking no chances at crossroads, I unclipped the front lamp to read the fingerposts. Just as my eyes adjusted to the dark, the lit signal box came into view, shining far across the flat landscape. One bitter night of east wind and driven hail I was invited into it from the platform and given welcome stewed tea until the lighted windows of the train came into view, running late over the crusted ditches and sodden fields. Then out through the sharpened wind, struggle with the bicycle, and into the train whose doors crashed shut with the noise which marked the 'slamstock' trains of that time. It only took about twenty minutes for it to carry me back to the brilliant orange street lights of Cambridge, away from the silences and sparse lights of the past and the cold fens.

FOUR

NORTHERN TOWNSCAPE, WESTERN SUBURBS

It is evening now and I am walking home. The last light is gathering on the Salisbury Crags to the south, and all along the grave, classical streets the first rooms are lit, and people are drawn to their windows. I am walking along Regent Terrace with my dog as the cold dusk settles on the stone-crowned hills of Edinburgh, as the white globes of the New Town street lights flicker on. From the corner of my eye as we pass, I catch glimpses of high, unshuttered rooms in the substantial houses of this continuous terrace which wraps around three sides of the Calton Hill. By a stroke of genius in urban planning, these streets are one-sided, a single row of houses backing onto private gardens on the slopes behind, looking out over public gardens sloping downhill. As you move along the curve of the terraces, the views out change: Holyrood Park and its rocky outcrops to the south, a recession of rooftops to the south-east, then tenements and the river to the east. Sheltered by trees only in the brief northern summers, these are windy, granite-cobbled streets, as austerely grand as the pillared ramparts of Robert Adam's imagined classical castles. These are sombre northern houses which front the wind, with long winter views from their high, sparse drawing rooms.

Moonlight suffusing the cobalt night. Victoria Crowe, *Landscape with Hidden Moon*, detail, 2018.

Some of the rooms glimpsed through the lighted windows are like autobiographies: a dark-walled, masculine library or study; oars with painted blades hanging on the wall, a pair of big engravings of college courtyards or quadrangles seen in bird's-eye perspective. Green shaded lamps, a flicker of flame in the fireplace, an armchair by the fire. The winter fastness of a professional man, an athlete in his youth. On along the flagstone pavement, the necklace of milky street lights casting their light upwards on the deeply cut, shadowy stonework. A glimpse through a glazed fanlight of a plaster copy of the Parthenon frieze running around a pale, spacious entrance hall. A middle-aged woman stands at the window of another drawing room, green walls and shimmering pictures of seashores and red tiled roofs over harvest fields, the impressionist summer Scotland of the early twentieth century. These fine pictures by Scottish painters who had studied on the Continent are one of the last manifestations of the cosmopolitan networks of Renaissance and Enlightenment Scotland. Pictures of this quality were painted in this street where we are walking, when Francis Caddell lived here in the 1930s, his spacious rooms decorated in the cobalt, emerald and orange of the Russian ballet.

Moving on through the white lamplight, we pause for a moment outside the studio of our friend the painter Victoria Crowe in Calton Terrace, outside her vast, quiet room, unlit now, closed off by blinds, where she paints portraits and extraordinary poetic landscapes, paintings about evening and passing time. Often these represent the very end of the twilight or moon-clouded night, with light so muted that only the human eye could make sense of the environment, the camera having failed long since. In her *Landscape with Hidden Moon* (2018), the viewpoint is deep in a mixed woodland with Victorian specimen trees – a country house park at night, with the distant lights of cottages. The slow downward seeping of light half-silhouettes the pattern of branches against the soft blue, moon-suffused sky. Tree-trunks flow into their shadows among the dapplings of moon on the woodland floor. Far to the left, in the depths of the trees, the horizon line is suggested by the juxtaposition of two precisely distinguished

blue pigments. It is the distant lights of the cottage windows which balance the composition – a line of cottages is implied, perhaps also a sparsely lit country road – defining the edge of the planted woodland without diminishing its quiet. The relation of painter and viewer to the perfectly observed lights (their yellow just tinged with red in contrast to the blues and greys of the foreground) is detached and serene. The cottages are neither an intrusion nor a refuge: they do not offer an alternative to the moonlit night, but are a part of it, subsumed into the silent attentiveness of the whole.

Windows and mirrors are recurring themes in Victoria Crowe's work – the tangle of winter branches opposite the studio window seen by morning and evening light; Venetian mirrors which reflect and refract the snowy northern afternoon in their bevelled edges. Reflections of a flower stem in window glass just as the winter landscape outside fades from view and the window turns black. She wrote to me once about flowers and the light coming from a window opposite:

> During the dark winter there was a great juxtaposition of a white orchid on my kitchen window sill and, outside, a very bright window silhouetting bare winter branches ... how to paint white petals against white electric brightness?

This she sees at once as a crucial puzzle for a northern painter: how to paint, as well as all the blues of twilight, the shadings and translucencies of white.

★

Sparse, hesitant flakes of snow. The dog and I pass on where Calton Terrace gives way to the tremendous length of Royal Terrace, with the pearl globes of street light diminishing into the distance. A few houses beyond the corner, a ground-floor window with open shutters. Standing in the window embrasure is a young man in white shorts and vest, looking out across the street and darkening gardens, checking the weather before going for a run. He swings his arms, loosens his shoulders. He must be planning to run fast, so lightly dressed on such

a bitter evening. A click of a closing door and he overtakes us, a white figure moving swiftly between the pools of light cast by the moon-white street lamps. He flickers in and out of spilled illumination from fanlights and unshuttered windows, all along the vast St Petersburg palace facade of Royal Terrace. For a moment he is like the ghost of Sparsholt from Alan Hollinghurst's novel, then he is gone in the dark at the far end of the long perspective. This is a townscape so tremendous and austere, conceived on such a scale, that on such an evening, when the first flakes of snow come with the twilight, it becomes an epitome of the neoclassical north, a Baltic of the imagination, overwhelming in its vastness, in the chill grandeur of the rooms glimpsed through its lighted windows.

We could see those same lights through the branches of the winter trees from the strange two-storey apartment at the top of an Edinburgh tenement where we lived for a few years. Our windows looked across the rainy chasm of Leith Walk down the formal avenue of London Road, its receding chains of street lights stretching to the vanishing point, with the distant floodlights of the sports grounds off to the left. We were sitting with our friend Sophie at the round table by the window, jasmines and flowering geraniums in the window embrasure, the shutters open. Sophie is an art historian who spent many years living on the shores of the Baltic, knowing every step of Caspar David Friedrich's youthful walk from his father's house in Griefswald to his talismanic monastery ruins at Eldena. She has travelled to and studied the art collections in many cities of northern Europe, carrying in her mind a whole world of northern painting from the turn of the German nineteenth century to the turn of the twentieth in Scandinavia. It was she who first told me of the magical figure of the woman who stands in the window with an oil lamp in Eyolf Soot's (1859–1928) beautifully imagined 1885 evocation of homecoming out of the northern winter

Light from the beautiful room behind the orange blind. Francis Cadell, *Interior with Orange Blind*, detail, 1928.

evening. The oil lamp on our round table, the Kugelhopf cake and linden-flower tea which we have brought out to welcome her on her arrival off the last train from the north, are both quiet homages to her familiar world of romantic and Biedermeyer domestic paintings. As we talk, we range over the scenes which she has studied and visited – snows and seashores, summer islands, yellow window light in the long twilights of winter.

As we sat there we began to wonder if anyone's sight lines in the monumental tenements on the other side of the avenue might give them a view into our own lighted window. They would see a view like a Danish or German painting of the 1820s, the kind of painting which Sophie knows so well: shaded light, a little glass oil lamp lit on the table. A room with high ceilings and shadows clustering under the cornices. The moving flame of the lamp, the three of us sitting quietly looking out at the rain, at the receding lights of the avenues and their reflections, looking out on a world of windows.

You can see from the regular patterns of lights that this part of Edinburgh was laid out as a triumphal entrance to a neoclassical city. But it was built when northern classicism and the Enlightenment were both running out of energy, and eventually the formal entrance to the city from the south was moved to the other side of the Calton Hill. The street lines, the disposition of terraces on the spur of the Calton Hill, and of avenues and crescents on the gentle slope running for a mile down towards the sea, are stately and inspired, but the process of building was very slow, and the take-up of building plots dragged on for half a century of decline. The result is ragged by day: a patchwork of speculative building with shops at ground level, too much traffic in the wide streets below the palace facade of Royal Terrace on its high wooded slope. But the fine bones of the design reappear when night falls, and a kind of magnificence steals back as the street lamps and windows are lighted, especially if rain or falling snow softens their outlines.

Looking across the avenue to the second-floor flat on the corner opposite, on that rainy night, a rarely lit window was illuminated by

a hard overhead light, which showed a bare white-walled room and a young woman and man waltzing beautifully through its empty space. It was enchanting, seeing the graceful dancers so brightly lit and so distant, and conjecturing the music, whose downbeat we could see, the inaudible waltz tune that must be filling their apartment. We imagined music from the early nineteenth century, music that wove between our conversation and their dance: Schubert Ländler, early Viennese waltzes. The whole dance lasted only a minute or two before they closed the shutters, and I can never remember that window being lighted again.

At the end of the evening, when they climbed the internal staircase to the bedrooms in the attics, I went to fetch a book from my study at the back of the flat, whose shutters were still open. Looking out there was the same effect of surveying a rainy world of lighted windows. The back windows of the Georgian houses and tenements in Union Street glowed in a rich variety of colours – different qualities of lamplight, different coloured blinds, one apartment where a candlelit dinner party was sitting late by the window, and then a whole constellation of street lights and window lights as the New Town sloped down towards the Forth, with the dark hiatus of the river and the lights of the Fife coast beyond. Yellow lights of main roads, the subdued pearl-and-opal light striking upwards in the New Town streets which keep their old street lamps, the well of dark trees surrounded by the patterned, regular windows of Gayfield Square.

My thoughts moved to a far comparison, a distant visual rhyme – a misty night, houses on a slope to the water, their windows showing against the dusk. Kawase Hasui's *Oshima: Okada* uses the woodblock medium with great subtlety and skill to show this scene of what seems a fishing village on an evening when the air is so saturated with damp that a thin mist has reduced colour to a uniform muted grey. The perspective is steep, ingenious, so that the houses are seen as though from a higher viewpoint than the level, folding grey waves of the misty waters beyond them where a single motionless boat is reduced to a shadow by the thickened air. The degree of contrast between the

Small folds of rooftops sloping to the sea: Kawase Hasui, *Oshima: Okada*, woodblock print, 1930s.

yellow light in the windows and the uniform pallor of the misty air serves to intensify the effect of gathering fog of the colours of air and water becoming one as the light goes.

Sophie had retired to the canopied bed in the spare room with its attic window view of rooftops and chimneys and distant hills: a room which itself had something of the atmosphere of the early nineteenth century, a lodging for a brilliant young woman, a singer or painter in a Biedermeyer novel. I stood for the moment at the back window of our bedroom – another idiosyncrasy of that strange flat that the main bedroom with fireplace and coved ceiling should be like a spacious room in a castle, a room more suited to a tower house in Fife than to the top floor of a block of Georgian flats. I had fixed my eyes beyond

the river and the street lights on the northern shore and was looking out to the highest points to the east, where the occasional light showed on the slopes behind the Fife towns: farmhouses, cottages, the occasional old fortified house with its walled garden and clump of wind-blown trees.

<p style="text-align:center">★</p>

Lights in an empty house, lights moving through deserted rooms, are a constant feature of the kind of inconsequential ghost story which is still passed on by word of mouth. In the subtler versions, the light is patently light from another time, candlelight, or the light of an oil lamp passing from room to room, rather than the static brilliance of electric light. Several of the tower houses and smaller fortified houses of East Fife had stubborn reputations for being 'troubled' or haunted when I was a boy. Only a walled garden remained, half seen amongst trees by the St Andrews road, where one house had spontaneously caught fire – or so it was widely reported – as the culmination of a ferocious campaign of poltergeist aggression. An exploration of the site one hot August noontide ended abruptly at the sight of little spirals of dust dancing all along the drive through the heavy, windless air. Even Kellie Castle seemed to stir into life when the family was away – lights shining out from the top-floor windows over the beech trees and towards the coastal towns, bringing the police car racing up to brake in the gravelled yard and watch the lights going out one by one in the locked and empty tower.

There was a third house, the worst of all, in its dark knot of trees on the promontory, bearing an unlucky name and a worse reputation. But it was a very beautiful house, or the wreckage of one at least, and the view from the edge of its coppice swept across barley fields and the estuary as far as the hills of Angus, as far as the coast of the Lothians. I would walk the paths through those fields on evenings in early summer, decades ago, with a retriever dog at my side whose fur was the colour of the ripening grain. Serene, pastoral Scotland was all around us, even if concrete pillboxes overwhelmed by brambles

were a reminder of the nearness of the sea and the old importance of this quiet promontory as guardian of the Forth and its ports. There were small stands of beeches at the turns of the path, red-roofed cottages dipping in and out of view on the far side of the barley. Everything was tawny and sunlit; brightness flashed and gathered in the distance on the sea.

But the castle wood was still and close, no insects moved beneath its branches. Only two steps into their shadow and you lost the noise of the rustling fields. You could see the doorcase of the house with its carved heraldry if you advanced a few steps further into the viridian tunnel of the trees. It should have been nostalgic, or even enchanting – evening light falling on the castle in the wood – but the quiet there seemed always oppressive, the overtones of the silence out of tune. I felt that I would not like to stand there when night fell, simply because of the unquenchable, irrational fear that one of the dead windows might show a light, and that my consciousness of that light would grow slowly as the day failed and that one window began to appear just a little less dark than the others, as if a candle had been kindled in an inner corner of an abandoned panelled room. Perhaps it was only the result of what my godmother had told me that her godmother had told her: about the house amongst its trees sulking through the years between the wars, half lived in, shuffled between reluctant cousins, dealing out disproportionate misfortunes to its inhabitants. Decades have passed now, the house is repaired and inhabited again, the gardens replanted, the coppice thinned. Maybe whatever dwelled there has been propitiated, slaked or satisfied, or has simply grown bored and gone elsewhere. These visitations are, in Sylvia Townsend Warner's phrase, inevitably 'flippant and derisive', and in that flippancy resides much of their horror.

On that distant summer evening I stood for a few minutes more under the dimming cloister of trees, and then turned back gladly to the light and murmur of the fields. I went home, fed the dog, read, and eventually slept under the painted beams of my beautiful top-floor room in my parent's house, visited by the onshore wind and the moving

beams of the lighthouse out on the island. The squares of light framed by the glazing bars circled the garlands and knots painted on the ceiling, projecting shadowy, shifting astragals all night long over their muted tones of ploughland-ochre, ice-blue and dust-rose.

★

Over the ice and the islands in the dark, there fell thin flakes of the unremitting snow. I was walking down through the centre of Stockholm at mid-afternoon nightfall, seven degrees below zero in the dark of January. Already the shops and windows were lit all the way down Nybrogatan, and I could see brilliant street lights and open space at the end of the narrow street. Dusk had taken me by surprise, as I made my way into the city from the university, heading towards the National Museum. I was in no hurry, enjoying the quiet streets before most people had started to make their way home, enjoying the dry cold, the flickering splinters of snow in the air, the bright displays in shops.

I stopped for a moment to look in the windows of an antique shop near the end of the street. All the objects on display seemed to accord well with the winter evening, with a whole aesthetic of fleeting winter light: a marble head and shoulders of a nymph or goddess, the glimmering surface holding its own cold illumination within it. Simple rectangular mirrors with a socket for a candle, to hang between the long windows of grey-panelled saloons, doubling their flames as the evenings came on. Long chandeliers like waterfalls of light, crystal stars and faceted glass globes.

I came out into the open space and could see, in the light from the street lamps, that the water on the other side of the street was frozen: black ice on which the snow was settling already. In a day or two the surface of the water would be indistinguishable from the land. The Dramaten Theatre was on my left, guarded by wonderful girdled columns with white glass globes of street light hanging from them. These paired moons on their nineteenth-century standards were

higher and more brilliant than the soft pearl lights of the New Town of Edinburgh, and they gleamed on the gilded crests of the columns and on the gilded figures on either side of the main door, with the shifting silver of the snow mingling with their lights.

I crossed to Nybroplan and then wandered through the old royal garden, Kundsträdgården, with the lines of its clipped hedges sharp under the falling snow. A bronze warrior, a Baltic hero, more than life-size on a high granite plinth. The figure of King Karl XII, looking aggressive and rococo at the same time, striding forward, waving a bronze sword at the darkness over the waters, across the bridges with their street lamps and the wooded islets, across long miles of cold ocean, in the direction of Prussia. The snow was building up on his brazen shoulders.

This walk through the hushed magnificence of the winter city takes on, in retrospect, a dream-like quality, and out of one of the monuments at Nybroplan my memory has made something entirely belonging to a dream. What I remember is an extensive square with trees and inky shrubbery, and with the deepening snow further muffling the sounds of that quiet afternoon hour. And that I came upon a bronze statue of another Marischal or hero-king, gesturing on a granite plinth, and that I had come quite near to it when I realized that at ground level, menacingly over life-size, was the bronze figure of winged Time. And Time was shown in the act of inscribing the hero's deeds, sufferings and virtues on the stone plinth. The figure was so huge and so close to me, the only walker in this quiet place, that I was startled and stepped back. The whole work seemed wonderfully of a piece in subject, medium and scale: a fitting memorial to the ice battles of forgotten northern wars, desperate assaults on snowy coastal fortresses.

Except that these is no such square and no such statue. In Oxford, several years later, I tried to disentangle these memories with the help of my Swedish-American friend Henry: we looked at source after source, until he produced the brilliant solution that I had combined, in a dream or in dreaming memory, the inscribing figure from the plinth

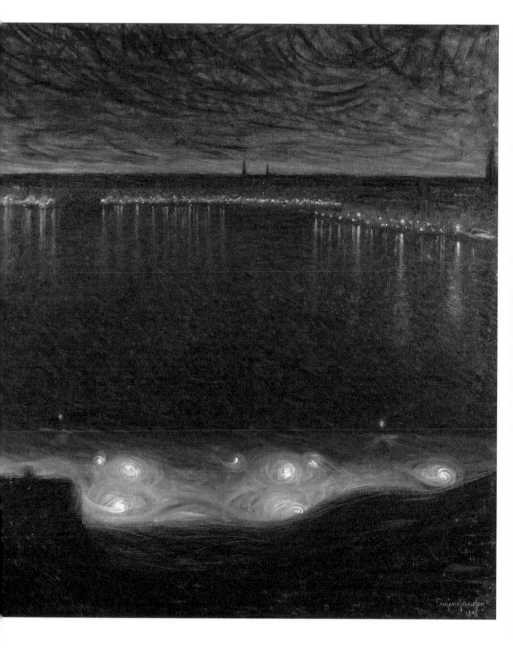

Constellations of lights in water: Eugene Jansson, *Riddarfjärden, Stockholm*, 1899.

of the memorial to the nineteenth-century inventor John Eriksson in Nybroplan, with the pair of bronze wings which stand by themselves on a plinth on the quay, nearer to the National Museum.

I walked on past the Opera, my hands deep in the pockets of my Scottish farmer's tweed coat against the cold. The building turns a plain stone flank towards the quay, with the vast Royal Palace glimmering across the frozen water. This face of the opera house is ornamented only by a rococo-revival canopy over the side door, bearing the three crowns of the royal arms, like the tester of a state bed, but made in metal. And, on either side, plain glass boxes projecting from the old building, holding the still-empty tables of the restaurant. I walked on down the quay to the National Museum. Just before I turned into its bright hall, I looked back at the islet opposite with its gables and tower, its trees labouring under their burden of snow. It looked like a place far away to the north, a fastness in a mountain lake, rather than in the centre of a great capital.

I was the only visitor to the National Museum in its last hour of opening, and there were few staff in the galleries. The dream-like quality of the evening returned, as I navigated alone through the rooms of mostly unfamiliar pictures. I was reminded of a mildly disquieting tour of the Kunsthalle in Basel many years earlier – I had been dropped off at a hotel by friends who were driving home to Italy, and I was alone in the wintery city. I made my way to the Kunsthalle at nightfall, where I was the only visitor. Having no sense of what the collection contained, and unaware of how many collectors and artists had taken refuge in Basel from the wars and persecutions of the mid-twentieth century, I moved from room to room astonished that so many celebrated paintings were housed in this one gallery. I was absolutely alone and it was dark outside the windows. The gallery took on the aspect of a museum of lost things, and I began to wonder if I was to some degree hallucinating, seeing so many familiar works gathered in one unfamiliar place.

In the deserted galleries at Stockholm, when I came to the 'national romantic' paintings of the turn of the twentieth century, I began to

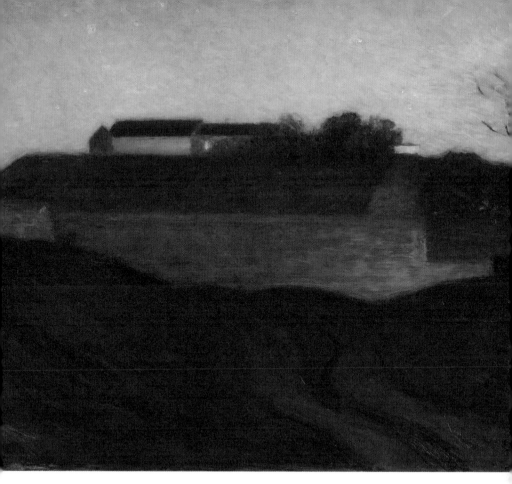

One sole light in the fortress by the sea: Richard Bergh, *The Fortress of Varberg*, 1894.

recognize works which I knew from reproduction, works which I had discussed with our art-historian friend Sophie. Summer islands, snowy evenings, the lingering dusks of the north. A whole movement in painting which turned attention to the surroundings of daily life, in the same way that the Dutch seventeenth century or the Danish Biedermeyer had done.

A lighted window is the first thing to strike the viewer looking at *The Fortress of Varberg*, painted in the 1890s by Richard Bergh (1858–1919). A single human light shines out from the low buildings which lie within the stone ramparts of the forbidding star fort on the Swedish coast. There is a gentle tension in the painting, between the stark architecture

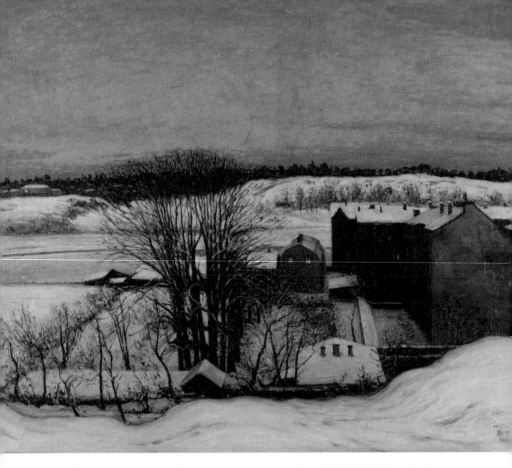

Street lights as ghosts of suburbs not yet built. Karl Nordström, *Winter Evening at Roslagstull*, 1897.

of the fortress and the domesticity of the single light. This tension is felt also between the hard geometry of the defensive walls and the gentler shapes of landscape under the summer night. Soft, broad brush strokes form the contours of what seem sand dunes around the defences, a gentle breeze stirs the leaves of wind-pruned trees, stars rise in a pale sky, whose bright horizon hints at reflections from water and the nearness of the sea. But the overall mood is quiet, the sense of past conflicts long settled in memory, and the peaceful present inhabiting the giant structure which those conflicts left behind. And the wind-shaped dunes and trees fold softly round the star ravelins of the fort.

This contrasts with the loneliness of *Winter Evening at Roslagstull* (1897) by Karl Nordström (1855–1923), which is in the Gothenberg Art Museum. Colour is the dominant element of the painting: blue of early evening in the sky and the muted blue of the snow in fading light, contrasting powerfully with the deep yellow of the street lights and of the scatter of lighted windows in the foreground. The scene is an edgeland: a suburb is being built on what was farmland and woodland. Already new tenement buildings are closing in on a farmhouse with a walled enclosure and trees. A line of street lamps already slants across a snowy hill, and new buildings will follow on this country lane which is in the process of turning into a street. Off to the left a street lamp is burning alone, the anticipatory phantom of an unbuilt house. For the moment the building which shows a light in the distance is in the country, backing onto the forest on what was, at the turn of the twentieth century, the northernmost development of Stockholm. The water is not far away. The handling of the recession of the shadowy snow and the patterns of tree branches is quietly attentive, the colour finely judged. For all that the effect is sombre, even lonely. The viewpoint is isolated on the snowy hill, with piling, untrodden snow on the foreground slope, and facing away from the lighted streets of the city into a landscape which is not quite country any more.

I came out into the winter night, walking up the quay to meet a colleague at the Opera Café: the cold was strengthening, and over the ice and the islands in the dark there fell thin flakes of unremitting snow.

It had already been snowing for two days when we arrived in Princeton. I had assured the colleague with whom we were staying that we could find our own way home from Mass along a straight Main Street in the middle of a winter afternoon. He seemed to find the idea of going to church strange enough, the idea of walking home bizarre. The church was a fine building, I thought as we came out into the just-dimming afternoon – poised in style between a simple English Gothic and an

intricate Italian one, neat craftsmanship everywhere in evidence. Several years later, one excessively hot June evening in Rome, a priest friend from that part of America told me that the craftsmen from two villages in the Marche had moved en masse to New Jersey to build a group of churches, of which this was one. This well-worked revival Gothic seemed strange, as did the black-and-white half-timbered Tudor shop on the right-hand side of the Main Street, in a town where the vernacular was a refined latest Palladianism, as exemplified by the wooden houses which we passed in our walk – always symmetrical, the windows unerringly spaced around a central door – or by the restrained nineteenth-century Grecian revival of official buildings, facades classical by proportion rather than by ornament, and with occasional restrained flourishes – a pediment, a pair of fluted columns set *in antis* within a blocky portico. And trees in all the streets, their shadows cast onto the brick or wooden buildings of the earlier nineteenth century by the street lights which were beginning to flicker into life as we made our way past a row of fine colonial-style brick houses just past Palmer Square. One of the shop windows was already lighted – an antique shop window, with a formal portrait of an eighteenth-century officer in an unfamiliar uniform.

As we came to the edge of the town centre, lightless Gothic university buildings gave way, on both sides of the street, to white-painted classical houses with uniform green shutters. Then the view of the houses on our right was obscured by boundary trees and fences, the broad sidewalk dwindled to a narrow path in the grass verge. The afternoon was beginning to fade fast now, so a few lights sprang up behind many-paned windows far behind the trees. We became very much aware of headlights sweeping over us, or shining in our eyes, as cars passed. A snow-white Palladian mansion rising out of snowy grounds was fading from sight on the other side of the road as the twilight came down and blued the snow.

Then we turned off the main road into near-darkness, snow wraiths and the shadow of thick trees. At once there was no sidewalk and we were walking in single file on the edge of the tarmac. Some of the

A lonely poetry of empty roads on snowy nights. Linden Frederick, *State Highway*, oil on linen, 2004.

muddy verges of the unfenced lawns were now mercifully frozen, so there was somewhere for us to take refuge from the headlights which appeared suddenly on the winding, wooded suburban streets. As we walked on, anxious about traffic, about being challenged, we began to see the different patterns of the lighted windows of the suburban houses in their spacious plots. There were the regular grids of the classical houses, the long horizontal stripes of the international modern. As we walked, we felt increasingly ill at ease, as our sense grew that these are streets where almost nobody has ever walked, where nobody is meant to walk. In these suburbs, cleaners and gardeners are compelled to arrive by car.

Reflecting on places which enforce separation, on far-scattered, isolated lights between winter trees, I thought how precisely this American mood is captured by the contemporary painter Linden Frederick, by the photographers Todd Hido and Gregory Crewdson.[1] In a sense theirs is an electrically lit iteration of the melancholy, alienated townscapes of the nineteenth century. The work of all three artists also has a haunting quality, often depending on the absence (or careful positioning) of figures, and always deriving from the positioning of the viewer.

Linden Frederick (1953–), whose *State Highway* (2004) is reproduced here, although technically a much finer painter than Grimshaw, has all of Grimshaw's ability to connect with his viewers and to speak to them of their own experience, to make a lonely poetry out of provincial towns and empty streets on winter nights. As with Grimshaw, much of what is poetic in his works is expressed by the lighted window at some distance from the viewer. Again like Grimshaw, the positioning of the viewer is often uneasy or sad: somebody else's lighted home seen in the course of a very long, weary night drive, an uneasy incursion into a silent suburb which has settled for the night, or a lingering at night in a deserted town centre which is no longer wholly safe. Often the paintings address the experience of an outsider wondering about what it might be like to live in such an unknowable, ordinary place. Like both Crewdson and Hido, his works are melancholy and contrive

to suggest powerfully that their stillness is a stillness just about to be broken. Frederick has written that his paintings are depopulated because they are 'about you, the viewer'.[2] This idea echoes Joseph Leo Koerner's analysis of how the emotive landscapes of Caspar David Friedrich convey feeling by the positioning of the viewer. While, in different modes, both Hido and Crewdson focus on the lack of space and amenity in the dilapidated suburbs of America, Frederick often paints the deep country, isolated houses by the long turnpike roads, a scatter of summer dwellings along a remote shore. It is so unlike the pattern of settlement of the old world where there is always another house, if not another village, within sight. These carefully framed and composed views of lighted houses are also a reminder of the enormous scale of the dark land lying around them. This is felt even more with the shore pictures: two vast darknesses of land and ocean, with only a little lighted settlement between them.

A word that unites all three visual artists, Crewdson, Hido and (to a degree) Frederick, is *dilapidation*: the visual signs of lack of will, resources or opportunity to make things other than as they are. Thus especially Hido and Crewdson present a townscape inhabited by unseen people who have little money and few options. Humble buildings which may once have made some attempt at smartness are now uniformly shabby, their surroundings neglected, even desolate.

This sense of desolation and trouble in the suburban nocturnes of Todd Hido (1968–) stems in part from the positioning of the spectator: like the viewer in many of Grimshaw's English streetscapes, the observer is moving, perhaps on foot, around territory where nobody is supposed to walk at all, where any sort of visitor is a threat. The feeling of bad times and constricted lives is everywhere in these images of 'homes with the lights on but radiating no warmth'.[3] Todd Hido identifies 'white paint chipping off picket fences' as a characteristic feature of the streets where he makes his house photographs as 'meditations on the lives of others'.[4]

One particularly haunting image is of a lighted window in a modest yellow-painted wooden house on a misty summer night. It is a small

one-storey house with a brick chimney and an upstairs window in the gable wall. Mist is gathering all around the house; there is sense of rain that's just cleared, of clogging water in the air. Some aspects of the image are almost hints of a Romantic tradition: mist on pine trees behind the house, the softening and diffusion of the light from the downstairs window. But the eye begins to work in the dim light, and begins to pick out unmowed verges, overgrown shrubs around the little house, the pitted tarmac of the road. Despite the aesthetic appeal of colour and composition, the mood of the image is overwhelmingly lonely.

A townscape of desperation is the subject of the Christmas poem 'God Rest Ye Merry, Gentlemen' by Derek Walcott (1930–2017). It is set in the centre of Newark, and finds hidden echoes of the Incarnation and Nativity in the deprivation all around the poet. After showing the sad injustice of the lives of those washed up in a city centre at night in winter, people who have perhaps never had anything to celebrate, Walcott quietly invokes everyday electric lights as analogues of miraculous lights and stars:

> Daughter of your own Son, Mother and Virgin,
> Great is the sparkle of the high-rise firmament,
> in acid puddles, the gold star in store windows[5]

The poem ends making a parallel between the suffering of Christ and the desperate sorrows of this and earlier cities.

Gregory Crewdson (1962–) is the inheritor of all the disquiet of nineteenth-century night paintings. His photographs, sometimes of empty streets at nightfall, sometimes of meticulously staged groups of figures, show suburban America tilted just a degree out of balance. The disasters implied in haunted Victorian nocturnes have begun to manifest themselves; imaginations of disaster have just taken on palpable form. Usually this is conveyed by the reactions or inexplicable

'Homes with the lights on but radiating no warmth.' Todd Hido, 1997.

Desolate and disquieting streets. Gregory Crewdson, *Untitled*, 2006–08.

deeds of his posed figures: a smartly dressed man standing frozen in the middle of the street in heavy rain, his car abandoned; the look of incredulity on a woman's face as she perceives something which we cannot yet see. In one image there is a glimpse of a naked couple sleeping on a mattress in a ruined suburban garden, once trim now full of detritus, survivors. Some of the expressions and gestures of the protagonists are familiar from the disaster movies of the popular cinema but, in Crewdson's work, there is always the implication that the disaster is great, unnamed, real.

In *Untitled* we are shown a distinctly shabby street of wooden houses, under an almost rococo sky of pink and grey after-sunset clouds, whose elegance contrasts sharply with the buildings crammed together on narrow lots. The viewpoint is rather high, as if from a

raised porch, which centres the composition on the mess of poles and cables that roofs the street. The first hint that there is something adrift which affects more than one house in this suburban street: despite the relatively high light level, there is the paradox that many rooms have defensively drawn curtains with light behind them. Evidently it is a warm summer evening and several windows are open, but there is nobody on the porches, nobody at all. Everywhere, there are overgrown hedges, patched-up gardens; perhaps even sadder is the one garden with a miniature picket fence (an object in itself desolate in its failure as a defence, its parody of suburban smartness), which has made some attempt at order or renewal with a few bedding plants. Despite the tangle of wires and the weeds growing up through the sidewalks, the fall of light on the worn paint of the wooden houses, on the full trees behind them, is conventionally beautiful.

But of all the deserted crepuscular streets which have been surveyed so far, this is the most desolate, and the most disquieting. A car with two men in it is halted by the sidewalk, and its headlights are the strongest light in the composition, inevitably drawing the eye. It casts a strong black shadow on the roadway from a light source not naturally present in the rest of the scene. Once this has been perceived, the mood of the image darkens further. The car has come from elsewhere, and its presence is menacing: inexplicable and unexplained. It is impossible and troubling even to speculate where it has come from, what is happening elsewhere in the city of which this dilapidated, threatened suburban street is a part.

All of these artists of the lonely twilight houses are, to some degree, the heirs of Edward Hopper (1882–1967). Roughly executed and wholly haunting, Hopper's night paintings (which have been compared, in their sheer melancholy affect, to the desolate sound of the train horn heard across darkened America[6]) derive much of their power from a carefully considered viewpoint. This is a crucial motif and strategy of much of Hopper's work, the skilled placing of spectators as themselves transient and ill at ease. So often the viewpoint is located in a rooming house or hotel in an unfamiliar city, or is the viewpoint of someone

walking in the streets of a city long after dark. So often the subjects are the vignettes seen through the apartment block, or snack-bar windows, sad in themselves but intensified by the sadness implied in the position of the spectator. Quite simply, you would have to be lonely to notice these nightly manifestations of loneliness all around you.

The solitary figure who sees through these uncurtained lighted windows – a woman in a bedroom seen from behind, a young couple sitting in a comfortless top-lit room, or on a narrow porch on a sweltering night – is rarely depicted by Hopper. In the early (1921) etching *Night Shadows* he shows the kind of solitary figure who will be the eyes of his later works, in which there are few visible observers, no Romantic *Rückenfiguren*. The invitation is always to identify with the viewpoint, even to start constructing a narrative, however fragmentary, explaining how the viewer has come to this place. Much of what this viewer sees is observed obtrusively: people are too much crowded together, there is too little privacy on these humid city nights which enforce open curtains and windows. All of these images have in common some sense of intrusion.

Many of these pictures are summer pictures but catch only that aspect of summer which manifests itself as a sullen heaviness of air. The summer city is the sadder for the hot nights, the airless rooms, the feeling that the more fortunate and more affluent have gone to the shore and the mountains, leaving behind harsh light and empty streets.

The viewpoints of some of Hopper's most haunting paintings place the spectator in a car journeying away from the summer city, towards the forests and the hills. In the depiction of a white clapboard villa offering summer lodgings in *Rooms for Tourists* (1945) the viewpoint is that of a passing driver, perhaps a driver who has left too late the business of finding somewhere to stop for the night. The driver sees a place which is well-maintained, even elegant, its lighted downstairs room apparently welcoming, but the whole is somehow staged for transient consumption, in the coarse, blunting floodlighting which is concealed behind the hedge.

The viewer of the painting positioned as transient driver. Edward Hopper, *Rooms for Tourists*, 1945.

The scene in Hopper's justly celebrated painting *Gas* (1940) could come from a similar fragmentary narrative of loneliness and benighted travel – a glimpse of a few seconds of the station owner's life, seen once and unlikely ever to be seen again. The gas station, for all its neatness and its bravely illuminated sign, casts so little human light into the growing dusk of the forest. But the viewpoint here is dislocated: while the most probable observer would be a passing motorist, the composition is seen from slightly above the forecourt, as if from an adjacent building, offering perhaps an alternative narrative of an isolated couple or family in the isolated gas station. As with many of the most moving Hopper paintings, it is summer, probably late summer: deciduous trees

A little human light in the growing dusk of the forest. Edward Hopper, *Gas*, 1940.

are in full leaf, and the roadside verges have dried to tawny brown. The motorist drives on, leaving behind the small human light in the forest.

In the 1940s, during and immediately after the Second World War, the American painter George Ault (1891–1948) focused much of his work on the depiction of a single human light in a lonely place. What Ault painted, in a series of varied depictions of the same scene, was a single overhead street light where a road passes through a small group of rural buildings. The culminating painting in this sequence, *Bright Night at Russell's Corners* (1946), reduced this much-studied scene to its essentials: it is the darkest of the whole series, the one with the brightest light and the least detail. George Ault's light feels here like a star at the crossroads, a star which has shone throughout the war.

This is but one of many fine readings to be found in Alexander Nemerov's wonderful essay on this sequence of wartime paintings

by George Ault, paintings which Nemerov sees as one of the most profound American responses to the war: their 'darkened and haunted mystery – a lonely junction at night ... made me think these pictures spoke to their times'. In their very darkness and emptiness he sees the successful result of Ault's attempt to 'find a compelling visual image for the sorrow and moody loneliness others felt then too'.[7] Unlike the expressions of loneliness, even despair, found in the works of Hopper and his successors, in Ault's paintings of light in darkness, Nemerov sees a hidden sense of the numinous at work: 'Ault's works have the air of secrets found just off the beaten track ... art as a secret and saving gift',[8] and, marvellously, Nemerov connects Ault's splinteringly bright street light in these paintings to the bright, guiding star in Sassetta's *Journey of the Magi*:

> That star seems an apt model for the large and eponymous streetlight in *Bright Light*, making the lonely crossroads a place of religious reverence and holy guidance, even for a person like Ault ... who spent his life retreating from his mother's piety.[9]

Thus Nemerov's perception, by extension, connects Ault back to the spiritualized landscapes of Samuel Palmer and his circle: inexplicable, holy light shining across the nights of England or America.

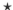

This light, as found in Ault in the 1940s and in the shore paintings of the contemporary Linden Frederick, the sheer vastness of the continent to landward of the small New England towns with their sparse, contingent street lights or window lights, finds a miraculous echo in the final words of *Homage to Mistress Bradstreet*, the poem written in 1956 by John Berryman (1914–1972) as a memorial of the first woman poet of anglophone America, the seventeenth-century Anne Bradstreet. The poem moves to its final image of the taper and the firefly, by way of Anne Bradstreet's deathbed leave-taking 'in the rain of pain and departure'. This is expressed as a drawing away from those who will outlive her, compared in part to a movement away from the

water-eaten land of East Anglia round the coast and out to the Atlantic, the journey of the ships of the early New England settlers. In turn this is changed into the movement of the soul into air, as paradoxically sure as the wavering candle set in the window to shine over winter in New England, long ago:

> I must pretend to leave you ...
> ... I say you seem to me
> drowned towns off England,

Love remains when the body is cast aside, music is born of silence, the spirit is at liberty:

> I run.
> Hover, utter, still,
> a sourcing whom my lost candle like the firefly loves.[10]

One long-forgotten book of verses can become a source and an origin, a little wayfaring light to lead unimaginable future poets, like the one who gives this imagined moment voice, the flickering light of the firefly, the transient candlelight in the vast dark of America, but rendered lasting, and set free.

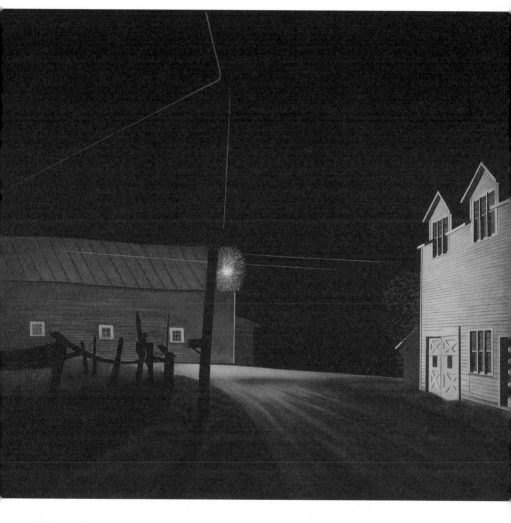

'A compelling visual image for sorrow and moody loneliness'. George Ault, *Bright Light at Russell's Corners*, 1946.

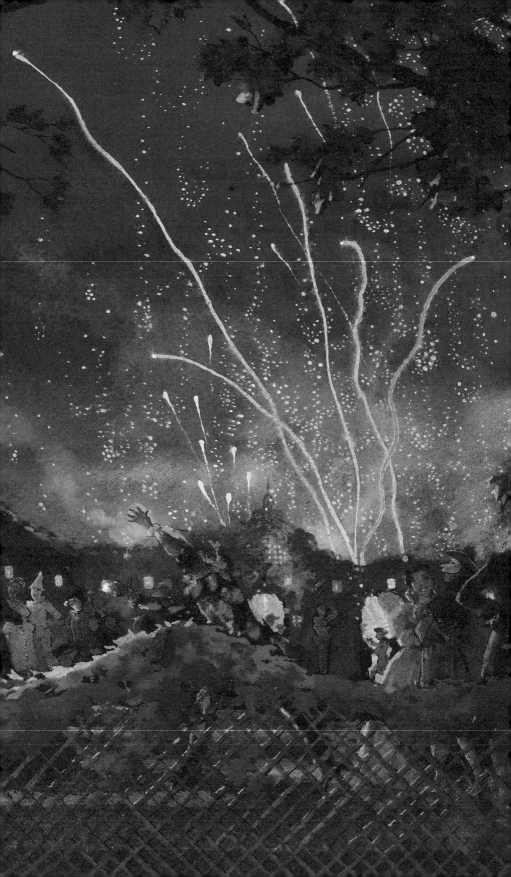

SUMMER NIGHT ILLUMINATIONS

High summer and the 'long lease of pleasant days'; the river flowing past the end of the street, with hardly a ripple on the calendar. Days and nights marked by the breath of the lime trees sweetening and strengthening, drawing to its saturated height with the height of the summer. After midsummer, my friend and colleague Mark Williams came to dinner, and the old dog and I walked back with him along the Thames towpath as far as the little humped bridge over the Hinksey Stream.

A warm night, with just a touch of moisture in the air to carry and spread the scent of the lime flowers: scent so present and enfolding that we moved through it as if through a mist. And the cobalt dark was full of lights: street lights and pub lights falling behind us across the fields, a single window in the ghostly 1930s' Georgian house built out over the water by the bridge, lights of distant bicycles casting long, wavering lines of white in the river. Orange sparks of cigarettes on the narrowboat decks. There were one or two lamps in the college buildings on the other bank, pinpricks at the end of the tunnel of trees, as distant as the stars above us. A line of security lights in the meadows, half-hidden by the drowsing trees, like lights for a country fair seen over the fields.

Rockets in the sky and lanterns in the garden: Konstantin Somov, *Fireworks*, detail, 1929.

Conversation spiralled on and outwards as we moved on: Shake-speare and summer nights and sympathetic magic; 'draw her home with music'; the grammar of Utopia and the speech of angels. We said goodbye, lingering on the humped bridge over the Hinksey Stream. An undertone of rot and summer and standing water added itself to the scents of linden and mown grass, a combination which, Mark said, is replicated almost exactly by a men's cologne called Ditch. Then he vanished quietly, with an enchanter's skill, into the warm darkness.

An old dog sets a slow pace, so I wandered homewards slowly, conscious of the warmth of the air through which I moved. Shake-speare's summer night in *The Merchant of Venice* was still turning in my mind: 'draw her home with music'. So the distant lamps in Christ Church became one with the candles in the window of Portia's villa:

> That light we see is burning in my hall.
> How far that little candle throws his beams

To which Nerissa (friend, attendant, truth-teller) adds the haunting, place-defining line:

> When the moon shone we did not see the candle.[1]

The bright window at the far end of the tunnel of trees on the other bank also called Shakespeare's most-cited window to mind, when Juliet's appearance above is like daybreak for her lover in the dark orchard below, and he seems almost to believe the metaphor that she can dim the moonlight:

> Arise, fair sun, and kill the envious moon.[2]

As I sauntered on with the dog snuffling at the hedge, indeed the moon sank for a minute into the clouds over the playing fields, and only then did I notice the little lights flickering in the boathouses on the other side of the river. Green lights on sensors or emergency lighting, jumping two and fro on the upper stories, reflected and multiplied in the plate glass of the balcony windows, forming fugitive perspectives of dancing green sparks. For that moment, the uniform, utilitarian buildings

on Boathouse Island were transformed to magic houses glimmering by the river, and then the moon rode clear of the cloud and its light mirror-silvered all the glass, picked out the little ripples in the water, and lit us home with moonshine,

> Peace, ho! The moon sleeps with Endymion
> And would not be awaked.[3]

Back into the strengthening breath of the mown grass, the linden-saturated air, past the ghost house by the bridge, which was dark by now, and home with my old dog padding along beside me, thinking all the while about magic houses, houses of apparitions, inhabited by moving coloured lights.

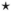

The hall chandelier of the apartment on the top floor of the palace represented the sphere of the heavens by night, a globe of cobalt enamel inlaid with golden stars. It seemed a proper guardian of the great enfilade of silent, pitch-dark rooms which stretched ahead of us. As I introduced myself and my two friends to the cheerful, slightly punk, curator, I noticed that she wore a cut-out wooden brooch of a hand making the usual Mediterranean gesture against the evil eye. Clearly she was taking no chances with the genius of the place, with the elegant shade of the collector who had assembled this, the last great Roman cabinet of wonders. Even now, in the south, such was his reputation when alive, it is considered rash to pronounce his name aloud. Outside the shuttered rooms it was the blazing morning of St Peter's day and 38 degrees Celsius in the shade, but the high rooms were cool and silent, 'trapping within them', as their creator had written, 'the air of other days'.

Our visit followed a long-established ritual: the opening of the great doors of the next room in the enfilade, a pause in the rich darkness until a shutter was opened, and one narrow beam of summer light would pick out the wonders of that room – a bust by Canova, late-baroque waxworks, a Neapolitan chandelier in the form of a crystal

Montgolfier balloon. It was very like the account given by a curator friend of being shown round the same collection in its former location in the Via Giulia, and being shown round by the Master himself. The collector – a great Anglophile – had retained only the faintest trace of an Italian accent, speaking habitually in the cultivated English learned in the villas around Fiesole in the days of Henry James. As now, all the shutters were closed and the apartments were in darkness. But then the shutters were never opened at all: the Master would shuffle to a table lamp and switch it on and it would illuminate one bust or one picture. Then back to darkness and the cosmopolitan, patrician voice out of the dark saying '*Do* be careful not to trip over the *flex*.' And thus for hours: one object illuminated and discussed, and another little lamp switched off again in the great dark rooms. As my friend had said, 'it was like the end, the very end, of the Grand Tour.'

As we went through stupendous room after stupendous room, it struck me that this strange if beguiling place offered a series of lighted windows in reverse: when shutters were opened, the daylight outside (too bright for eyes which had adjusted to the inhabited darkness) appeared as almost-dazzling illuminations in the window frames. Over the little *pietra dura* table in a shadowy corridor where the Master had taken his solitary meals, there hung a little interior painting of the kitchen in a Florentine palace, bathed in brilliant summer light pouring through its window. This painted light was so radiant as to become a kind of bright window in itself.

But in one room, the double-height library, there were four small works which contrived to be, at once, lighted windows and magic houses. Set into the plinth of a bookcase were four glazed panels, and behind them were cut-out perspectives, lit from behind. These four scenes were in the style of the mid-eighteenth century, and consisted of cut-out flats and figures, four formal gardens with courtiers moving between their tall hedges and statues, as if on the opera stage. The curator didn't know the origin of these pieces, and we guessed from their style that they were probably Dutch or German. Later research suggests that they are most likely examples of the peep shows or

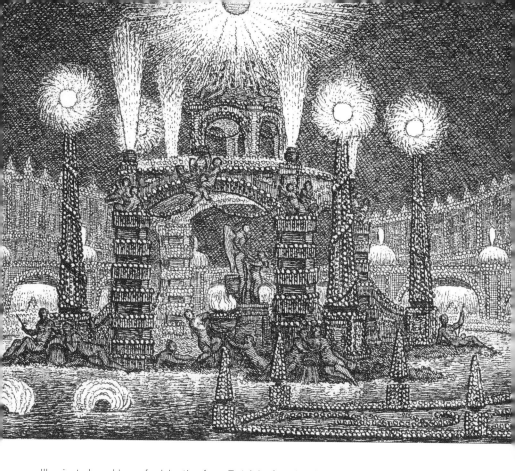

Illuminated machines of celebration from *Traité des feux d'artifice pour le spectacle*, 1747.

perspectives published in the mid-eighteenth century by Martin
Engelbrecht of Ausburg, maker of 'illuminated, varnished and cut-out
images'.[4] It is perhaps significant that this description includes the word
'varnished' – suggesting that elements of Engelbrecht's little scenes
consisted of paper rendered transparent by varnish.

The whole phenomenon of works of art designed to be lit from
within or from behind has been little studied.[5] When I saw the
little Engelbrecht scenes in the museum in Rome, they connected
almost at once with those English and European paper theatres on
which Alan Powers is an expert, especially with a beguiling Danish
paper theatre which has at least one backlit scene. They brought to
mind Thomas Gainsborough's *Showbox* with its oil paintings on glass

Domestic uses for transparent prints on varnished paper. From Edward Orme's *An Essay on Transparent Prints and on Transparencies in General*, 1807.

illuminated from behind, an object which has long fascinated me. I began also to think about baroque transparencies for festivals, of the lighting in the temporary sacred theatres which were devised by the Jesuit artist Andrea Pozzo (1642–1709) and their present-day echoes in the internal lighting of the *Heilige Gräber*, Easter sacred theatres still erected annually in the Tyrol, of which I had seen an example in the museum at Innsbruck.[6] The two traditions are clearly related, and exist in a remarkable place where the theatre, the sacred installation and the landscape painter's studio converge. The ceremonial and sacred transparencies and stage illusions form a clearly defined tradition in themselves. This is distinct from a parallel tradition, using some of the same techniques, especially those involving varnished paper or cloth, of the light-boxes and transparent drawings made by painters experimenting with the depiction of light, and with paintings illuminated from within.

The sacred and ceremonial tradition clearly has roots which stretch back to the Middle Ages and beyond, and this mid-eighteenth-century depiction of a large installation of reverse-lit pictures on transparent grounds comes at the culmination of that tradition. The custom of placing lights in windows on days of secular or sacred festival is an ancient one, as many of the illustrated festival books of the Renaissance and baroque testify. Candles in windows also seem to have acted as a small-scale celebration: the candle in the window of Portia's villa, the 'lords that are certainly expected' and welcomed home to their

mansions with starlight in Coleridge's *Rime of the Ancient Mariner*; the illumination of every window in the town palace when a noble family comes home from *villegiatura* in the country, as described in Jonathan Keates's fine novel of early-nineteenth-century Italy, *The Strangers' Gallery*. There is a tender story handed down in one of the English old-Catholic families of the reunion of a brother and sister, a nun and a bishop, long in exile in different parts of the Continent, and of every window in a Parisian convent lighted to celebrate his eventual arrival. If the illumination of windows in Continental cities for religious and civic festivals was an expression of shared rejoicing, there is also a darker aspect to these domestic illuminations: after the subjugation of Jacobite northern Scotland in 1746, towns and cities suspected of disloyalty to the Hanoverians were ordered to illuminate their windows for the birthday of a king who was, in the view of the majority of citizens, a foreign usurper. The streets were patrolled by soldiers, and lightless houses raided.

Varnished paper and cloth have long been in daily use for their translucency, so it is possible to conjecture an origin for the festal transparency in easily manufactured decorations for illuminated windows, a tradition which seems to have continued into the nineteenth century, with directions for painted blinds, patriotic transparencies, and even for home-made imitations of stained glass being given in Edward Orme's *An Essay on Transparent Prints and on Transparencies in General*, published in London in 1807.

On the evidence of Orme's book, a Regency home where amateur crafts were practised would have been full of transparencies and reverse-lighted images, domestic versions of the civic transparencies, and indeed of the experimental light boxes of the professional painters which will be considered below. As well as windows and various kinds of lampshade, his *Essay* advises backlit varnished prints as a summer chimney board, with a lamp placed behind it in the hearth.

The origin of the large-scale use of transparencies seems to have been in seventeenth-century Rome, in the temporary sacred theatres designed for installation in churches. Throughout his career the Jesuit artist Andrea Pozzo was particularly preoccupied with the manipulation and representation of light: this includes the painted representation of brilliant, heavenly light on the still-astonishing *trompe l'œil* ceiling of the church of Sant'Ignazio in Rome, manipulated daylight through a hidden window of gold-coloured glass above the shrine of St Ignatius in the church of the Gesù, and, following many precedents, the widespread use of gilded or metallic sculptured rays to represent supernatural light. His use of concealed light in the installations for the 'Forty Hours', when the consecrated host is displayed for veneration, developed earlier use of lamps and candles to include, in his 1683 installation in the Gesù, the Sacrament 'displayed with lights in front and behind to make the perspectives stand out'.[7] This, and subsequent sacred theatres by Pozzo, made increasing use of concealed light to articulate fictive windows into the light of heaven: gaps in clouds or in the voids of soaring triumphal arches. The daylight in the church was screened by blinds, and to the visitor coming into the darkened space of the nave the flats of the sacred theatre would have shone out from the east end of the church as the frames for an unearthly light.

There is evidence of a continuing tradition of such temporary sacred architecture from the persistence to this day, in the town and village churches of the Tyrol, of the custom of erecting baroque sacred theatres, *Heilige Gräber*, for Easter.[8] These range from a simple painted flat representing Christ in the tomb, with a pair of cut-out figures of guards or mourners, to astonishing baroque scenographies, great fictive

Tyrolean sacred theatre for Easter Week, with back-lit cut-out figure of Christ. Johann
Nepomuk Pfaundler, *Heilige Grab*, 1770 (church of Holy Cross, Schönberg im Stubaital,
Tyrol).

palaces between whose arcades and upon whose balconies are enacted
multiple scenes from the Passion. These 'holy sepulchres' range in
date from precious eighteenth-century survivals to contemporary re-
creations: as a whole they are a vital surviving witness to a whole world
of baroque ephemeral and theatrical architecture. The continuities
from Pozzo are very visible, in the eighteenth-century designs such as
those from the Benedictine Abbey of St Georgenberg-Fiecht and the
Capuchin church in Bozen.[9] They are also visible in a glorious surviving

example by the eighteenth-century priest–painter Johann Nepomuk Pfaundler (1823–1811) at the Church of the Holy Cross in Schönberg, with its magnificent fictive architecture, its ingenious insets of globes of coloured light, and its borrowing, through pierced rays in its backdrop, of light from the church window to surround the silhouetted figure of the resurrected Christ.[10]

One or two examples of the *Heilige Gräber* from the later nineteenth century, which are entirely backlit, offer links to secular festival architecture, and also to the more domestic technique of pricking through pinholes in a print or diorama, and setting a light behind it. The example in the Church of the Assumption at Pettneu am Arlberg, made by the firm of Eduard Zbitek at Olmütz (now Olomouc in the Czech Republic) is exhibited in a darkened church. The flat, black-painted structure is entirely defined by backlighting, presenting a glowing arch of lights surrounding the Cross and mourning angels, and flanked by two armoured men also drawn entirely by pierced openings for light to shine through. Only the figures of Christ in the Tomb and the figure of the Resurrection which surmounts the whole are three-dimensional, lit by concealed lights.[11]

A point of contact between this festal and sacred tradition of structures incorporating light and the more domestic transparencies and show-boxes is be found in two small eighteenth-century

dioramas-in-boxes in the Salzburg Museum (formerly the Carolino-Augusteum): these are 'scrolling diaoramas of sacred and secular subjects, painted on thick paper and pricked for back-lighting'.[12] Though the influence may not be direct, these are reminiscent of the series of backlit dioramas, the *Transparents*, constructed from the 1780s by the French artist called 'Carmontelle' (Louis Carrogis, 1717–1806). These are set within boxes, to be shaded round with curtains, backlit by sunlight from a window, or by candles. These depictions of elegant figures, strolling amongst the monuments in French versions of English landscape gardens, were painted on transparent paper. These were clearly designed as a domestic entertainment, to be scrolled through, accompanied by commentary and anecdote.

The Baron de Frénilly recorded in his memoirs that, sixty years after having seen while at his father's home a backlit show by Carmontelle, he still vividly recalled how the figures seemed to be in motion, and how Carmontelle captured their footsteps, mannerisms and actions as they moved past.[13]

These installations, contemporary with the magnificent experimental *Showbox* of Thomas Gainsborough (1727–1788), come at the beginning of a series of artists' devices, all designed to investigate and

Louis Carrogis ('Carmontelle'), *Transparent, backlit panorama of a garden*, 12-foot transparent diorama of a garden with *fabriques*, late eighteenth century.

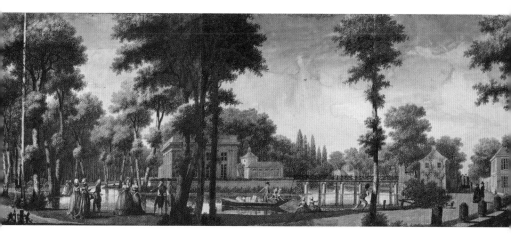

display the movements of light within the landscape. They are both indicative of an increasing cult of walking, of landscape tourism, of observation of nature, and also of a dissatisfaction with the existing conventions for depicting sunlight and moonlight. These little il-luminated houses, made in increasing numbers towards the end of the eighteenth century, were part of a wider impulse to investigate anew the movement of light in the landscape.

One of the most beguiling objects in the collection of the Victoria and Albert museum in London is the wooden *Showbox* constructed in the 1780s to the design of the English artist Thomas Gainsborough. The viewer looks through a magnifying lens into the interior of the box, where a series of delicate, loosely painted landscapes give the appearance of being lighted from within. In fact they are a series of paintings on glass which can be placed one by one in front of the light. Gentle illumination, which appears to come from deep inside the scenes depicted, is provided by three candles, their light shaded and diffused by a silk screen.

These scenes are varied depictions of England with all its changes of light, season and weather. In East Anglia the light of a spring morning spills through trees to glimmer in a woodland pool where cattle have just been watered. On a summer night, in a broad wooded valley, perhaps in the Welsh Marches, shepherds and sheep rest on the grassy banks of a little tarn, with bright moonlight rising behind the hill and the clouds in the sky. In the North Country, in autumn, we look down into the waters of an upland river, scattered trees on the far bank, and a bare mountain peak rising in the distance, sunlight in patches through wind-torn cloud. On a moony summer night, a brightly lit cottage by a pond amidst woodland slopes casts its reflection, and the shadow of the figure in the doorway, across the water. Brilliant moonlight traces the outlines of the treetops above.

The *Showbox* inevitably raises questions as to why Gainsborough invested such skill, indeed such tenderness, in this fragile optical device, which can by its nature have only one viewer at a time. Much is answered in a superb article by Frances Terpak, which traces the

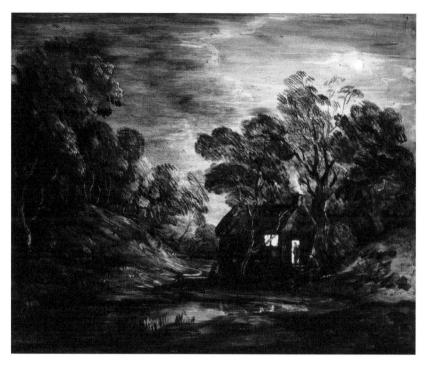

The painter's *Showbox*. Thomas Gainsborough, *Wooded Moonlight Landscape with Pool and Figure at the Door of a Cottage*, backlit oil painting on glass, 1781–2.

visual spectacles and illusions that enchanted the London of the later eighteenth century.[14] It is clear that Gainsborough was a delighted consumer of these, and that they are highly likely to have given him ideas for his own domestic spectacle of light and the landscape.

Thomas Jervais (d. 1799), an Irish painter of enamelled glass, had a number of successful London exhibitions in the 1770s and 1780s. His works reproduced paintings by those who specialized in light effects: Cuyp, Vernet, Wright of Derby. Jervais's renderings of moonlight and firelit scenes took particular advantage of the transparency of his medium, when lit from behind.

There is, of course, a long tradition of painting on glass, including a lively popular tradition of reverse-glass painting in central Europe, and the potential for glass painting and the manipulation of light

had been realized by the mid-seventeenth century. Credit for the invention of the magic lantern, light focused through a lens to project an image from a glass slide, seems to divide fairly evenly between the Dutch physicist and astronomer Christiaan Huygens (1629–1695) and the Jesuit polymath Athanasius Kircher (1602–1680). Certainly both were demonstrating magic lanterns by the third quarter of the seventeenth century. Both seem also to have given thought to ways in which magic-lantern images might be animated. The catalogue of Kircher's museum at the Collegio Romano, published in 1678, includes a number of optical devices: peep shows and a *Theatrum Catoptricum* which gives an impression of an infinite palace or garden by the use of angled mirrors, as well as the magic lantern itself.[15] So this is another iteration of an illusory or magical image presented within a lighted box or projected from it.

One London spectacle which Gainsborough is known to have relished is the *Eidophusikon*, devised, in collaboration with the actor–manager David Garrick, by the French theatre designer and painter Philippe-Jacques de Loutherbourg (1740–1812). This was a small-scale mechanical theatre, with particularly intense sound and lighting effects, using the recently invented (and very brilliant) Argand lamp. Scenery, machinery and lighting were combined to offer animated prospects and spectacles of shipwreck and storm. It was shown in London in 1781–82, the very years when Gainsborough was beginning to experiment with his own *Showbox*. As one contemporary recorded,

> Gainsborough was so rapt in delight with the Eidophusikon that for
> a time he thought of nothing else – he talked of nothing else – and
> passed his evenings at the exhibition in long succession.[16]

But why did Gainsborough invest so much time in this elaborate contrivance? Partly it may be accounted for by his recorded enchantment with the *Eidophusikon* and a desire to produce a personal response to it, albeit a much quieter, more contemplative one. Partly it may be a response to the sheer visual potential of a whole range of contemporary experiments with pictures and light, but there remains the possibility

that the experiment with the location of light behind and within the image had a particular importance for his practice as a painter.

In the later eighteenth century, generally, painters became increasingly aware of the varied light effects produced by changes of season and weather. In general (of course there are significant exceptions) earlier eighteenth-century landscape painting had remained faithful to the admired effects of Poussin and Claude, whose works were particularly prized by British collectors. Thus, even northerly landscapes are depicted as though lit by Italian skies, by the gentle slanting golden sidelight of late afternoon in September in the south. There is a parallel tendency in eighteenth-century painting to light all landscapes as if they were depicted on a stage with painted flats and lighting from the wings. This inheritance from the conventions of the later baroque casts clear light onto the foreground, usually from top left, regardless of where light sources are positioned within the picture.

This perhaps gives a clue to the use and fascination of the glass paintings within Gainsborough's *Showbox*: each is a study in the fall of light, or the movement of light from the distance of the depicted landscape, to illuminate the foreground, as could be observed in nature. Deep interest attaches to these sketches on glass, once this experimental aspect is recognized, and the verisimilitude of the sunlight through broken cloud in the northern scene, or the realistic fall of lamplight and moonlight in the cottage by a pond, can be seen as a part of the process by which Gainsborough tested his own observation. Once the eye is sensitized to his scrupulous recording of the movement of light in the views depicted in his easel paintings, it becomes easier to understand his fascination with this lovely optical toy which places the *Showbox* light, transformed and naturalized candlelight, so deep within the landscape.

Equally serious, and just as finely observed, backlit transparencies and show-boxes were current in the Germany of the early nineteenth century, in the circles of Romantic painters, whose evening and night pictures were discussed in an earlier chapter.

The innovator in the creation of these Romantic transparencies was Jakob Philipp Hackert (1737–1807), whose own rooms in Rome contained an overdoor of a moonlit landscape lit from behind by the light in the anteroom. This object, achieved with a combination of watercolour, collage and cut-and-varnished paper, mounted between two sheets of fine glass, clearly produced a considerable effect on his visitors – it is recorded that his circle would sit in silence contemplating the sweet melancholy of the feigned moonlight.[17] Hackert's most celebrated transparency was the 1785 *Italian Landscape by Moonlight*, which was installed at Emkendorf in Holstein, the country house of the cultivated aristocrats Julia and Friedrich von Reventlow.[18] This was also installed as an overdoor (it is still there) in their red drawing room. During the day it was covered by a more conventional decorative painting, but in the evening it was uncovered and bright lamps set behind it so that it spilled a mild illumination like the moon itself into the darkened room. Julia von Reventlow clearly set considerable store by it: when she wrote to Goethe in 1794 inviting him (in vain) to pay them a summer visit, as well as the song of nightingales, she offered their artificial *Italienischen Mond* as one of the attractions of Emkendorf.

The Dresden painters also experimented with the artistic possibilities of transparencies and reverse-lit pictures, and with the kinds of experience, sometimes involving music, which could be contrived around them in a darkened studio. Continuing the Gothic theme of his most celebrated oil paintings, Ernst Ferdinand Oehme, in 1832, made a transparency of a pair of monks in a ruined abbey looking towards the brilliant moon rising behind the broken tracery of the east window. Caspar David Friedrich took these works wholly seriously: if these transparencies, of which only one seems to have survived, appear in retrospect as little more than salon entertainments, elegant toys, it is useful to bear in mind the hopes that Friedrich expressed for their potential as the deepest expressions of the emotional landscape. No less than Gainsborough, he seems to have thought of them as experiments in the truest rendering of light and season in nature.

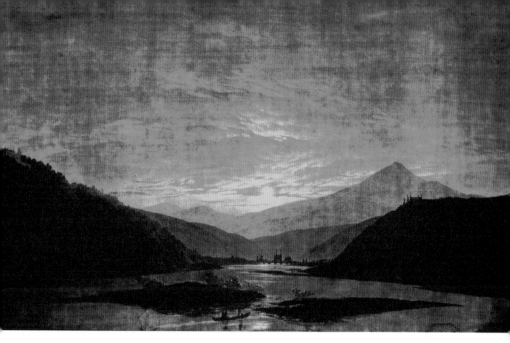

A metamorphic transparency: four landscapes and times of day on one sheet of transparent paper. Caspar David Friedrich, *Gebirge Flusslandschaft* (*River Landscape in the Mountains*), 1830–35, here shown reversed and backlit for a moonlit night.

Around 1835 Friedrich experimented with transparencies of intensely romantic subjects – a fairy-tale forest, a woman playing a harp with a moonlit Gothic town in the background – shown in a light box in front of variable coloured light filtered through vessels filled with wine and water. He wanted these exhibitions to be accompanied by music.[19] There is also record that when he exhibited one of his transparencies he would move the lamp which lit it from behind to produce effects of different times and moods – the gentle light of evening or melancholy darkness. Friedrich's one surviving transparency, now in the Gemäldegallerie at Kassel, has for its subject a broad river in a mountain landscape, executed in watercolour and tempera on both sides of a sheet of transparent paper.[20] It is a most ingenious contrivance, capable of being viewed in four different ways, carrying strong reminiscence of Friedrich's quartet of pictures, the *Four Times of Day*, now in Hanover. The front side illuminated normally shows a misty, almost grisaille, landscape by day with the distance melting into mist with hints of distant hills; the same side illuminated from behind shows mild moonlight over the same quiet scene. The

cut-out sun doubles as moon. When the reverse side is conventionally illuminated it is a night piece, with little visible detail, but when it is lit from behind a quasi-magical illusion is produced of a brilliant moonlit night. A Gothic city appears in the distance sheltered in a bowl of hills, under a rich reddish-toned sky of moonlit clouds, reflected in gold-glimmering water.

Many elements of the sensibility of the early nineteenth century are still valued in modern Denmark, a country which dignifies its art of that period with the name *Guldalder*, 'the golden age'. The present-day inheritor of the romantic show-boxes and transparencies are the light boxes of paper toy theatres, which preserve many 'golden age' elements in their designs and dramas. One of these is the use of reverse-lit varnished paper backdrops, so that a version of Friedrich's transparencies can be exhibited on the miniature stage, with, for example, the fading in of the light of dawn behind a night scene. My friend Alan Powers has long been an expert on every aspect of toy theatres and the popular graphic art of the early nineteenth century. When he was a graduate student he lived in a very small cottage in Grantchester, which already had many of the qualities of wonder of the assembly of pictures and things which he and his wife Susanna have put together in their tall London house over the last forty years. In the cottage, a beautiful Danish paper theatre sat on a shelf in the parlour.

It is a miniature version of the Chinoiserie pantomime theatre in the Tivoli pleasure gardens in Copenhagen, with a drop curtain representing a peacock with spread tail. Even in this miniature version the peacock can be made to fold its tail and sink down to reveal the stage setting for the Harlequinade. One of these stage sets has a backdrop with varnished highlights and pricking through for backlighting, which shows the Tivoli Gardens as they would have been on a summer night in the mid-nineteenth century. A crowd has gathered before a little domed pavilion at the junction of two walks: the pavilion is in a fantastical Moorish style, perhaps a forerunner of the early-twentieth-century Moorish Palace still at Tivoli today. Its dome is fluted with spirals of red and blue. To the right moonlight falls between the trunks

Backlit theatrical illusions in miniature. Printed Danish toy theatre scene, showing the Tivoli Gardens, Copenhagen, mid-twentieth century.

of an avenue of tall trees, where an elegant company are listening to music from a source which remains just out of sight. There are pale statues and lamp standards amongst the trees, which have paper lanterns hanging in their branches, as thick as ripe apples. Myriad points of light shine from the pinpricks illuminating the pavilion, so that it glitters and shines against the sombre trees and the moonlit sky. It has the charm of pantomime or ballet scenery – the silver palace in the transformation scene – which has manifested itself in a real garden. But pleasure gardens are themselves a theatrical version of reality, and here garden and pavilion alike are represented as the backdrop to a theatrical performance, further removed from reality still by being a paper simulacrum of the summer theatre, designed as a domestic diversion for winter evenings when the avenues of the pleasure gardens are leafless, and their pavilions and theatres are shuttered and dark. So careful is its design, so ingenious the use of transparency and

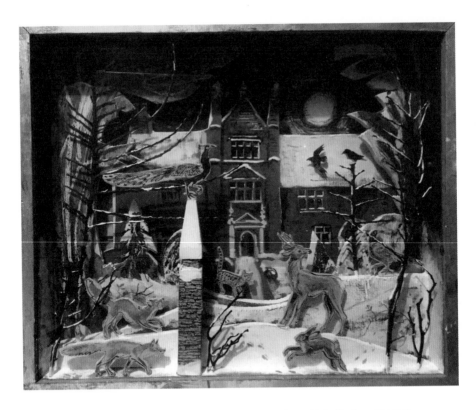

Enchanted Norfolk winter night. Mark Hearld, *Shadow Box with Burlingham Old Hall, Norfolk.*

pricked-through light, that this little printed sheet representing the summer night carries in itself a haunting and beautiful reflection of the whole tradition of magic houses, show-boxes, back-lit illusions.

Summer ending and the sunlight cooling over the reaped fields between Norwich and Burlingham, where we are going to stay for a day or two with our friends Margaret and Peter Scupham in their old house. It is a lovely place at all times of the year: a sheltering Elizabethan farmhouse under a thatched roof, with a tower porch added in some long-vanished summer of prosperity, after a run of good harvests. Margaret's dappled garden, anchoring the tower in its flat land, is tawny and crimson-black with dahlias at this time of year. A first hint of bonfires in the air, when we drive out in the afternoon to a bleak flint church at the end of a

lane above the marshes, stark and whitewashed within, with ghosts of murals. The three living men and the three dead men.

We are glad of the ample warmth of the kitchen, its brightly painted walls and furniture, when we return in late afternoon. It is the time of the year when the house smells of the first keeping apples spread on paper for the winter which is coming. On one of the bookshelves upstairs is a shadow box by the contemporary artist Mark Hearld, which shows the house in winter. In the foreground are bare trees, fox and night birds, with the windows of the house all dim in the background. It is a fine manifestation of the long tradition of show-boxes and shadow boxes, with its sky painted with streaks of sombre colour evoking winter wind tearing over fields in the dark.

We talked about its lighted windows, and Peter's exceptional memory for verses and books produced a line or two of a sentimental Irish song about a wanderer's return, from sixty or seventy years ago:

The moon was shining brightly
T'was a night to banish all fear

And, when I followed it up later and identified the first line as 'It's ten weary years since I left the old home', I found that indeed the main image of the song is of firelight glowing in the windows of a cottage, to draw the wanderer home. Then he remembered the row of bright town windows at the foot of illustrated pages in old astronomy books, and again his memory identified an exact title: Robert Ball's *The Story of the Heavens*, first published in 1910. He remembered looking at it with wonder during the Second World War, at its dark silhouettes of houses with very yellow windows, and then at the complex patterns of white starlight in the sky above. To a wartime child used to the blackout, these were pictures from another world, brilliant towns of uncurtained windows. (The haunting, defining sentence from Alan Hollinghurst's *The Sparsholt Affair* rose in my mind: 'It was that brief time between sunset and the blackout when you could see into other people's rooms.'[21]) Memory and novel alike evoked an era when window light was controlled by authority; an era of comfortless houses,

of little lights moving through dark rooms which were freezing in winter, airless in summer.

In the kitchen at Burlingham, Peter remembered how he had been formed as a poet by the experience of walking in the blackout and in the cold, low-light 1940s: 'I was a night walker before the days of television, glancing as I passed through the streets at the walking, talking, silent lives behind the windows. The only bright lights in the nights of the war years were searchlights and reflectors.' He remembered more – the absolute, wartime dark of the house – going to bed in the cold darkness with a candle in a tin candlestick. Or maybe with a little lantern, a 'little monstrance carried through the hugeness of the night. Those wartime nights seemed the bigger for the frailty of light set against them.'

> A black sheet must permit no frond of light
> To touch the flowing acres of the moon.
> Warm and small, I explore with a dying torch
> An under-the-table world in a guarded house.[22]

He thought for a moment and then his memory summoned his wartime self in yet more detail, the way that they had been sustained by memories of the lavish shop windows of the later 1930s, the 'stilted magic' of the pre-war Christmas displays. And later by reading descriptions of lit shop windows in Dickens and Chesterton. So much so that Eric Ravilious's 1938 book of lithographs of shop windows *High Street* took on extra power, with their idiosyncratic displays and bright evening lights.

All that pre-war lavishness was concentrated for his family into one object which sustained them through the war years and which is with them still. A square Christmas lantern in simple imitation of stained glass, with cut-out cardboard shadow-tracery framing brightly coloured scenes printed on translucent paper. In a modest way, this mass-produced ornament, probably from the Czech Republic, is an inheritor of the whole European tradition of transparencies, showboxes, paper theatres. Peter thinks that it was bought about 1937 at

Woolworth's threepenny and sixpenny stores. One side shows a church by a bridge, another side a cottage amidst pine trees, with crescent moon and big stars in the sky above. There is a silhouetted deer in the foreground, strayed out of snowy infinite forests.

In his poem 'The Christmas Lantern' Peter remembers himself and his sister, two children counting the lantern's cut-out stars in the blacked-out house:

> I think of nights your lucencies beguiled,
> While the house rocked to the soft blundering guns.

He also commemorates its talismanic status for his own family after the war:

> I set you here above my sleeping children:
> The branched reindeer at the huddled bridge,
> The simple house, offering her candled windows.
> For their eyes now, your most immaculate landscape
> And all the coloured rituals of love.[23]

Margaret and Peter offer to bring out the lantern to show us, so we move through the old house's flagged corridors until we come to the big red-walled drawing room – I remember when Peter first showed us the house he spoke of this room as 'a Christmas room' – and heavy velvet curtains are drawn against the late summer sun. Outside the heavy flowers of late summer, dahlias and phloxes, glow against viridian

'The branched reindeer at the huddled bridge, / The simple house, offering her candled windows.' Cardboard Woolworth lantern, with transparent paper, probably Czech, 1930s

boxwood and old brick. A special lamp has to be set up on a bookcase, then the treasured card and paper lantern is brought out from its wrappings and the light switched on in the darkened room. A moment with a whole hinterland of time around it. Then Peter's voice from the shadows: 'We get it out every Christmas still; when it goes, I will go.' But for now it shines out blessedly in the old room, in the old house amidst the stubble fields.

<p style="text-align:center">★</p>

The cottage light of Margaret and Peter's lantern is a visual rhyme for Samuel Palmer's wonderfully observed spillage of cottage lamplight into frosty moonlight, above hurdle-penned sheep safe in the yard: *Christmas, or Folding the Last Sheep.*

 This etching, from 1850, conveys a powerful sense of homecoming to warmth and safety. In the cottage kitchen seen through the open door, the shepherd's wife is placing dishes on the lamplit table; beams of generous light radiate from the lattice window, as bright as the inexplicable radiance from the dark copses in Palmer's early visionary drawings. This epitome of safe gathering, of coming indoors out of the winter cold, was deliberately evoked in one of the last works of the Scottish poet, sculptor and gardener Ian Hamilton Finlay (1925–2006). In the 'English parkland', an area of mown grass and small monuments which was the final installation in his artist's garden at Little Sparta in the Pentland Hills to the south of Edinburgh, is a little drystone sheepfold, its wooden gate bearing a neat plaque reading 'ECLOGUE', and on three beautifully lettered slabs let into the drystone walls inside are the words FOLDING ... THE LAST ... SHEEP. It is an ingenious construction, rich in meanings, and the primary meaning is a shaft of sadness – where is the last sheep when the sheepfold is (and always will be) empty? The pastoral poems of Virgil and the golden world were long ago and are faded from memory, even as Erwin Panofsky's mid-twentieth-century reading of Virgil's pastorals (his perceptions of regret, of evening settling over the world) is fading from memory. Later the thought comes that perhaps the folded sheep are to be

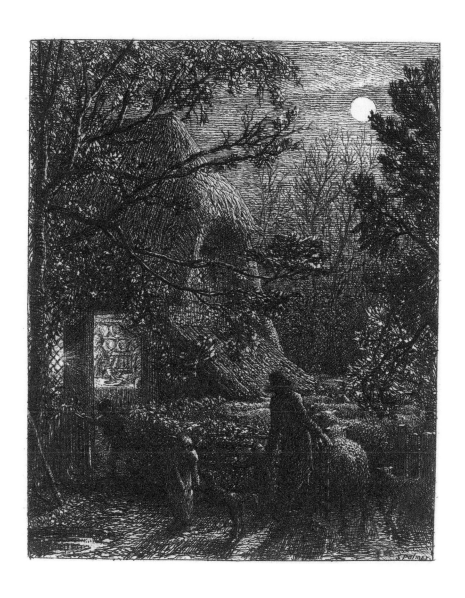

Cottage lamplight spilling into frosty moonlight. Samuel Palmer, *Christmas, or Folding the Last Sheep*, 1850.

imagined in the fall of moonlight on the lichen-softened stones? When Finlay was alive, perhaps, and the garden was closed, and when he and assistants were the only people there on moony nights. Or is the whole structure an almost-abstract evocation of pastoral, in the intensified context of this last, most introspective landscape garden, a designed landscape set amongst the moorland tops of the sheep-grazing Borders, a garden which aims to be a summary of much of what Europe has thought and felt about landscape, and grass and water, and the far past.

Perhaps the monument, the inscribed stone enclosure, simply offers one more beautiful reminder of what has gone, as the stone urns by little streams evoke the innocent sentimentality of the turn of the nineteenth century? Does the little sheepfold simply invite the garden visitor to withdraw into its shelter under the thin summer rain, and conjure up their own vision of homecoming and firelight and lamplight folded under the moorlands? Like the whole of this last section of Finlay's garden, it invites a poised leave-taking from a past ever-receding, rendered beautiful by the distant afterglow of the ancients.

★

It is evening now and I should walk home soon. But I am still thinking of that echoing garden, of candlelight and firelight spilling out from the cottage in Palmer's etching, of Berryman's firefly flame in the latticed window with all the vastness of America to landward behind it under the night. And of its visual rhyme, George Ault's street light at the lonely crossroads, light in the darkness of wartime, a pinpoint distillation of the summer stars. Of the squire's widow in Hardy's poem dancing in the lamplit window of the manor house, of the young athlete in his white singlet, glimpsed across Alan Hollinghurst's imagination of Peckwater Quad in wartime. How distant a window, a light, a burial, a life.

It is dark now; September nightfall has surprised me as I write, and my desk lamp is the only light. There are no voices or footfalls in the narrow street under the bulwark of the city wall outside, deep in the quiet vacation. It is time to stop writing now, to tidy up and

walk home. I look round my pleasant, slightly subterranean office. My grandfather's desk by the window, armchair by the fireplace, old plasterwork on the beams, Regency sofa. I switch off the desk lamp and go out and through the garden door with its smart 1930s' panel of diamond-point-engraved glass. The sky above the garden shows dry, thinning cloud and filtered moonlight with many, many stars – a fair late-summer evening, a wonderfully fair evening.

I go out by the back gate into Rose Place, closing it firmly behind me, listening for the click of the automatic latch. Sweet, mild air with just a filament of wind, relief after a disordered summer spoiled by airless droughts, uncontrolled downpours. A stone wall lit by a tall lamp post, the crack of an invisible squash ball striking the other side of the wall. A first-floor window in the student house on the right projecting four panes of slanted yellow light onto the gable opposite. On along the lane, walking on tarmac laid over the culverted 'hidden stream', along the well-trodden path between Campion Hall and the Catholic Chaplaincy, whose leaded windows shine at the end of the dark lane, a lit ship at anchor at the end of a pier.

The cafe on the ground floor is dark except for the blue ghost-light of the refrigerated display, but the Tudor windows of the Old Palace above are bright, and the deep-cut plaster ceiling of the big room on the first floor is as crisp and fantastical as when it was new, four centuries ago. There are flowering plants on the windowsills, trails of climbing jasmine silhouetted against the lattices. The big lamp beside the desk is on, and the far corner of the room is warm with yellow light. I can't see him but my friend the chaplain must be sitting where Monsignor Knox once sat writing apologetics and detective stories in the between-time of the 1920s and 1930s. Time passes: the summer hurries on to its end, then the turning leaves and Michaelmas Term, then another dark, too-mild winter. Our own slice of time is only ever betwixt and between.

I cross St Aldate's towards the great trees in Christ Church grounds and turn south past the Faculty of Music. Dry pine cones crunch underfoot. I walk between the Police Station and the deserted bus

stop, and then into the broadening street, indifferent modern houses immediately onto the pavement to the left – one open window and the delicate and beautiful scents of turmeric, fenugreek and cinnamon quills roasting together float for a few seconds on the mild air.

The weighty, cast-iron railings of the Head of the River are to my left: the ground floor is illuminated, darkness upstairs. There are few people sitting out on the terraces so late in the day, so late in the summer. In August the tables would be thronged, with laughter and music, and the punts and rowing boats coming and going to their little quay between the pub and the back-door footbridge to the Meadows.

I am on Folly Bridge now and looking down river towards the boathouses. Stars flicker in the great trees drowsing by the water. Their lights sinking in the branches, glimmering in the river, mingling with the lit ripples from the windows of the pub, from a bicycle lamp far away on the towpath. It is perfect in its own kind – the trees overhanging their green reflections, the lights in the rooms of the Victorian boathouse, in the attic windows, in the oriels overhanging the stream, all trailing their threads of light into the mirroring, folding, unstill darkness below them. The moon rides clear of the cloud wisps and trees, and the Thames glimmers on both sides of the bridge.

> The moving Moon went up the sky,
> And nowhere did abide:
> Softly she was going up
> And a star or two beside –

I cross over towards the Gothick grotto tower on Folly Island with its brick crenellations and fireback-flat statues in shallow niches. There's nobody about, so I linger on the little bouncing footbridge over the pool by the gimcrack tower, with the stars and the lights from the Folly and the riverbank all reflected in the still water by the bridge: a full sky of late-summer stars doubled in the black-blue, softly moving water of the pool. How beautiful all this is and how it draws things together.

Lights in the water like the 'drowned towns off England' at the end of *Homage to Mistress Bradstreet*: their lights sunk below the river-drift of

the old world. I am thinking back four decades to unforgotten lights seen across a dark river. Of my lodgings in Wentworth House, of my attic window overlooking the Cam and the water-reflected lights of the cul-de-sac pub and its little beer garden on the other bank. These were the only lights that I could see, shining between the dark warehouses and the sparse street lamps on the common. The beer garden was almost always empty, and the one time I went there for a drink it was dull and ordinary, but it seemed a kind of paradise garden seen across the river, and it seems so still in memory.

Light seen across water at night so often evokes longing for a paradise just out of reach. Reflected moonlight and starlight intensify it by bringing the sky down into the estranging river. Coleridge's famous gloss on the *Rime of the Ancient Mariner* hides the image of a great house lit for a festival within its expression of grief in isolation, in separation from the sky and its starry lords:

> he yearneth towards the journeying Moon, and the stars that still sojourn, yet still move onward; and everywhere the blue sky belongs to them, and is their appointed rest, and their native country and their own natural homes, which they enter unannounced, as lords that are certainly expected and yet there is a silent joy at their arrival.[24]

This has a response in Gerard Manley Hopkins's 'The Starlight Night', which positions the gazer at the lighted windows of the night sky – 'the bright boroughs, the circle-citadels' – as one who is watchful for the smallest showings-forth of the glories of paradise in glimmering light in dew, in the flickering of leaves or pollen, the glistening of feathers. By the end of the intricate sonnet, the starry sky has become a barn filled with the sheaves of God's harvest and the stars themselves are the brilliant rents through which the glory of the court of heaven shines on the attentive watcher on earth:

> This piece-bright paling shuts the spouse
> Christ home, Christ and his mother and all his hallows.[25]

Like Seamus Heaney's walker halted by the hawthorn hedge, who is scrutinized by the lantern-eyes of the berries and is not found wanting by its 'small light for small people', its 'lantern seeking one just man',[26] Hopkins's gazer on the sky is blessed with the sight of the triumphal homecoming of the court of heaven, 'which they enter unannounced, as lords that are certainly expected'. And the stars burn on in the water below me, and the lamp in the tower window has its double in the river.

An extraordinary visual rhyme for all of this is found in Goya's small nocturne showing the Bohemian Saint John of Nepomuk, martyred by an unjust king, and his corpse thrown into the Vltava river flowing through Prague. The first impression of the picture is inevitably of sheer depth of colour: the moonlit sky is rendered in profound azure and ultramarine. High moonlight falls on the humble, almost melancholy figure of the saint, blanching the white linen of his vestments, and the tassel on his biretta. The young man is cradling a crucifix in his arms, and the fall of the moonlight animates the carved figure, on which the saint gazes to the exclusion of everything else, stillness and devotion without duration. He is standing in an imagined place, on an imagined moonlit night, but he is not standing in time. On the far bank of the shadowy river is a great round tower – two minute flicks of yellow pigment articulating a lit window and a brazier on the ramparts. All worldly power is there and the saint is outside in the moonlight, alone with the crucifix. The moonlight plays round the edges of distant trees, catches a bright cloud on the horizon. But there is a stranger light in the picture, light from the grey-blue waters of the river itself where the saint's body floats downstream in a coracle of miraculous stars. And the unearthly light in the water obliterates the reflection of the tower window, outlasts earthly power, outshines the moonlight and blends the sky with the earth.

I walk on along the path by the river. The moon has flooded the sky above me and I can hear the water murmur as it divides its flow at the island. Two hundred paces from our house. It will all come out right in the end: the stars go home and so do we.

Sacred nocturne, with both natural and miraculous lights. Goya, *St John Nepomuck.*

OVERLEAF View northwards from the Sutors of Cromarty, seen at nightfall in December.

NOTES

OXFORD AT NIGHTFALL

1. Cyril Connolly to Noel Blakiston, 22 December 1924, in Cyril Connolly, *Romantic Friendship: Letters of Cyril Connolly to Noel Blakiston* (London: Constable, 1975), pp. 28–9.
2. Joseph Leo Koerner, *Caspar David Friedrich and the Subject of Landscape* (London: Reaktion, 2009).
3. E.g. Thomas West SJ, *Guide to the Lakes in Cumberland, Westmoreland and Lancashire* (Kendal, 1778).
4. Alan Hollinghurst, *The Sparsholt Affair* (London: Cape, 2017), p. 5.
5. Ibid., p. 7
6. Ibid., p. 9
7. Ibid., p. 198.
8. Ibid., p. 338.
9. Ibid., p. 93.
10. Ibid., p. 94.
11. Ibid., p. 94.
12. *Cymbeline*, 2.4.89–90 (*The Oxford Shakespeare: The Complete Works*, 2nd edn, Oxford: Clarendon Press, 2005, p. 1197).

WINTER CITIES

1. Gerard Reve, *The Evenings*, trans. Sam Garrett (London: Pushkin Press, 2016) p. 288.
2. M.R. James, *Collected Ghost Stories* (Ware: Wordsworth, 1992), p. 83.
3. https://imslp.org/wiki/Des_Fischers_Liebesgl%C3%BCck,_D.933_(Schubert,_Franz); accessed 14 July 2020.
4. Text at www.hyperion-records.co.uk/dw.asp?dc=W2088_GBAJY9301813; accessed 8 May 2020.
5. Graham Johnson, 1993 notes on the song, ibid.
6. Ibid.
7. Carl Gustav Carus, *Haus Carus in Pillnitz*, Museum of Dresden Romanticism, Kügelgenhaus, Dresden.
8. Dresden Neue Meister Collection. See the classic discussion of it in Joseph Leo Koerner's *Caspar David Friedrich and the Subject of Landscape* (London: Reaktion, 2009).
9. Augustus Welby Pugin, *Contrasts: A Parallel between the Noble Edifices of the Fourteenth and Fifteenth Centuries and Similar Buildings of the Present Day* (London: Printed for

the author, 1836). The prolonged sneer at the degeneracy of the present is already expressed by the deliberately emotive title.

10. https://marcel-proust.com/marcelproust/293; accessed 30 September 2019.
11. Marcel Proust, *À la recherche du temps perdu*, Volume II: *Le Côté de Guermantes* (Paris: NRF, 1954), p. 95. (À côté de l'hôtel, les anciens palais nationaux et l'orangerie de Louis XVI dans lesquels se trouvaient maintenant la Caisse d'épargne et le corps d'armée étaient éclairés du dedans par les ampoules pales et dorées du gaz déjà allumé qui, dans le jour encore clair, seyait à ces hautes et vastes fenêtres du XVIIIe siècle où n'était pas encore effacé le dernier reflet du couchant … et me persuadait d'aller retrouver mon feu et ma lampe qui, seule dans la façade de l'hôtel que j'habitais, luttait contre le crépuscule…)
12. Ibid., p. 96. (La vie que menaient les habitants de ce monde inconnu me semblait devoir être merveilleuse, et souvent les vitres éclairées de quelque demeure me retenaient longtemps immobile dans la nuit en mettant sous mes yeux les scènes véridiques et mystérieuses d'existences où je ne pénétrais pas. Ici le génie de feu me montrait en un tableau empourpré la taverne d'un marchand de marrons où deux sous-officiers, leurs ceinturons posés sur des chaises, jouaient aux cartes sans se douter qu'un magicien les faisait surgir de la nuit, comme dans un apparition de théâtre…)
13. Ibid., p. 97. (Dans un petit magasin de bric-à-brac, une bougie à demi consumée, en projetant sa lueur rouge sur une gravure, la transformait en sanguine, pendant que, luttant contre l'ombre, la clarté de la grosse lampe basanait un morceau de cuir, niellait un poignard de paillettes étincelantes, sue les tableaux qui n'étaient que des mauvaises copies déposant une dorure précieuse comme la patine du passé ou le vernis d'un maître, et faisant enfin de ce taudis où il n'y avait que du toc et des croutes, un inestimable Rembrandt.)
14. Ibid. (Parfois je levais les yeux jusqu'à quelque vaste appartement ancien dont les volets n'étaient pas fermés et où des hommes et des femmes amphibies, se réadaptant chaque soir à vivre dans un autre élément que le jour, nageaient lentement dans la grasse liqueur qui, à la tombée de la nuit, sourd incessamment du réservoir des lampes pour remplir les chambres jusqu'au bord de leurs parois de pierre et de verre, et au sein de laquelle ils propageaient, en déplaçant leurs corps, des remous onctueux et dorés.)
15. Philippe Delerm, *Paris l'instant* (Paris: Fayard, 2002), pp. 126–9.
16. Ibid., p. 126. (C'est au-dessus que la lumière appelle. Dans les appartements ambrés, croisillons des fenêtres et plafonds hauts. Une silhouette passe, au second, indifférente au regard de la rue. Indifférente? Dans le naturel de ses gestes passe une imperceptible affectation, la conscience d'appartenir aux lampes basses, au safran du sofa, au blanc crémeux de la bibliothèque.)
17. Julian Green, *Paris* (London, Marion Boyars, 1993), p. 108. (Ce soir, une légère brume couvrait Paris et les marronniers, éclairés par le dedans par les réverbères semblaient d'énormes lanternes japonaises.)
18. Ibid., p. 130. (si Paris, celui que j'ai imagine, devenait le vrai, si le passage du Caire était désert, qu'il fasse sombre, que la pluie crépite sure les verrières opaques? Les vitrines luisent sinistrement. … Ne vais-je pas entendre les pas tranquilles s'approcher de la voix qui donnait à mon héros le pouvoir d'émigrer de corps en corps prononcer insidieusement le sésame: 'si j'étais vous…')
19. W.H. Auden, 'Brussels in Winter' (December 1938), in *Collected Poems*, ed. Edward Mendelson (London: Faber, 1991), p. 178.
20. Helen Tookey, 'Aftermaths', in *City of Departures* (Manchester: Carcanet, 2019), p. 44.

1. www.toutelapoesie.com/poemes/apollinaire/la_chanson_du_mal.htm; accessed 10 July 2020.
2. Ibid.
3. Ibid.
4. Ibid.
5. Ibid.
6. Patrick Keiller, 'Popular Science', in *The View from the Train: Cities and Other Landscapes* (London: Verso, 2014), p. 67.
7. J.M. Richards and Eric Ravilious, *High Street* (London: Country Life, 1938); Alan Powers and James Russell, *Eric Ravilious: The Story of High Street* (Norwich: Mainstone Press, 2008); Alan Powers, *Eric Ravilious* (London: Lund Humphries, 2015).
8. W.H. Auden, *Collected Poems*, ed. Edward Mendelson (London: Faber, 1991) p. 67.
9. G.K. Chesterton, 'The Invisible Man', in *The Penguin Complete Father Brown* (Harmondsworth: Penguin, 1981) p. 64.
10. G.K. Chesterton, 'A Defence of Detective Stories', in *The Defendant* (London: R. Brimley Johnson, 1901), pp. 118–23; available at www.chesterton.org; cited in Peter Davidson, *The Last of the Light* (London: Reaktion, 2015), p. 136.
11. G.K. Chesterton, 'The Head of Cesar', in *The Defendant*, p. 232.
12. Arthur Conan Doyle, *The Penguin Complete Sherlock Holmes* (London: Penguin, 2009), p. 161.
13. Ibid., p. 269.
14. Ibid., p. 270.
15. Ibid., p. 492.
16. Ibid.
17. Michael Steinman, ed., *The Element of Lavishness: Letters of Sylvia Townsend Warner and William Maxwell* (Washington DC: Counterpoint, 2001), p. 50.
18. Letter to Paul Nordoff, 16 March 1940, in *The Letters of Sylvia Townsend Warner* (New York: Viking, 1983), p. 61.
19. Sabine Rewald, *Rooms with a View: The Open Window in the Nineteenth Century* (New Haven CT and London: Yale University Press, 2011), pp. 22–3, 86–7, 90.
20. Charles Baudelaire, 'Paysage' from *Tableaux Parisiens*, in *Les fleurs du mal* (Paris: NRF/Gallimard, 1972), p. 114.
21. Charles Dickens, *Hard Times* (Cambridge: Riverside Press, 1869), p. 88.
22. A particularly fine example is James Paterson's *The Last Turning, Moniaive*, in the Glasgow Art Galleries and Museums at Kelvingrove.
23. Virginia Woolf, 'Street Haunting', in *Collected Essays*, vol. 4 (London: Hogarth, 1967), p. 156.
24. Ibid., pp. 156–7.
25. Ibid., pp. 157.
26. Ibid., p. 165.
27. Virginia Woolf, *Night and Day*, ed. Suzanne Raitt (Oxford: Oxford University Press, 2000), pp. 439 *et seq.*
28. Ibid., p. 462.
29. Ibid., p. 463.
30. Ibid., pp. 528–9.
31. Ibid., p. 533.
32. Ibid.
33. Ibid., p. 535.
34. Ibid.
35. Virginia Woolf, *Mrs Dalloway* (London: Panther, 1984), p. 143.

36. Ibid., p. 145.
37. Ibid., p. 151.
38. Ibid., p. 165.
39. Osbert Sitwell, *Noble Essences* (London: Macmillan, 1950), p. 281.
40. Cf. Nikolaus Pevsner and Bridget Cherry, *The Buildings of England, London 4: North* (New Haven CT and London: Yale University Press, 1998), p. 20.

WINDOWS IN THE LANDSCAPE

1. Derek Mahon, *The Hudson Letter* (Winston-Salem NC: Wake Forest University Press, 1995), p. 75.
2. John Milton, *A Mask (Comus)*, lines 337–341, in *Poetical Works*, ed. Douglas Bush (London: Oxford University Press, 1966), p. 122.
3. William Wordsworth, 'When slow from pensive twilight's latest gleam', in *Poems*, ed. John O. Hayden (Harmondsworth: Penguin, 1977), p. 88.
4. Gerard Manley Hopkins, 'The Candle Indoors', lines 2–5, in *Poems*, ed. Robert Bridges (London: Oxford University Press, 1930), p. 46.
5. Thomas Hardy, *The Woodlanders* (London: Macmillan, 1939), pp. 5–6.
6. Samuel Palmer, *Dark Trees through which a Bright Light Breaks*, Indian ink wash landscape sketch, 1824–35, Victoria and Albert Museum, E.643–1920.
7. (*Yoru no Shinkawa*), from the series *Twelve Scenes of Tōkyō* (*Tōkyō jūnidai*), woodblock print,1925, Boston Museum of Fine Arts, accession number 49.680.
8. Kenneth Grahame, *The Wind in the Willows* (Oxford: Oxford University Press, 2010), p. 48.
9. Ibid., pp. 48–9.
10. Ibid., p. 49.
11. 'John Clare's walk to Northamptonshire, 1841', dawnpiper.wordpress.com/john-clares-walk-1841; accessed 3 June 2020.
12. John Cowper Powys, *Wolf Solent* (Harmondsworth: Penguin, 1964), pp. 180–81.
13. Thomas Hardy, *Collected Poems* (London: Macmillan, 1960), p. 370.
14. This device is first used in *The Return of the Native* when Wildeve signals in this way to Eustachia Vye, but it finds its fullest expression in this poem, first published in 1914.
15. Hardy, *Collected Poems*, p. 369.
16. Ibid., p. 134.
17. John Milton, *Il Penseroso,* in *Poetical Works* (Oxford: Oxford University Press, 1966), p. 94, lines 85–87.
18. 1879, a reimagining of his gouache painting of 1868, replacing the foreground lovers and moon behind cloud of the earlier version with two shepherds and a visible crescent moon on the horizon. Yeats hints at the importance of this etching to him in his 1937 'A General Introduction for My Work', where he lists 'that tower Palmer drew' among the images that enabled him to 'commit [his] emotion' to words. I am grateful to Dr Adam Hanna for this and many other references to Irish literature.
19. W.B. Yeats, *Collected Poems* (London: Macmillan, 1977), p. 180.
20. Ibid., p. 227.
21. Ibid., p. 351.
22. W.B. Yeats, *Collected Plays* (London: Macmillan, 1966), pp. 681–9.
23. Alan Garner, *The Moon of Gomrath* (London: HarperCollins, 1972), p. 123.
24. Ibid., p. 152.
25. Ibid., p. 158
26. Ibid., p. 165.
27. John Milton, *Il Penseroso*, lines 81–84.

28. www.wagneroperas.com/indexmeistersingerlibretto.html; accessed 12 April 2020.
29. www.luminarium.org/sevenlit/herrick/bellman.htm; accessed 12 April 2020.
30. Sylvia Plath, 'Wuthering Heights', in *Collected Poems* (London: Faber, 1981), p. 167.
31. Emily Brontë, *Wuthering Heights*, ed. Ian Jack (Oxford: Oxford University Press, 1976), p. 46.
32. http://gutenberg.org/files/4349/4349–h/4349–h.htm.
33. Marcel Proust, *À la recherche du temps perdu*, Volume I: *Du côté de chez Swann*, ed. Pierre Clarac and André Ferré (Paris: NRF, 1968), pp. 3–4. (j'entendais le sifflement des trains, plus ou moins éloigné, comme le chant d'un oiseau dans une forêt, relevant les distances, me décrivait l'étendue de la campagne déserte où le voyageur se hâte vers la station prochaine; et le petit chemin qu'il suit va être gravé dans son souvenir par l'excitacion qu'il doit à des lieux nouveaux, à des actes inaccoutumés, à la causerie récente et aux adieux sous la lampe étrangère qui le suivent encore dans le silence de la nuit, à la douceur prochaine du retour.)
34. John Meade Falkner, *The Nebuly Coat* (London: Steve Savage, 2006), pp. 160–61.
35. Proust, *À la recherche du temps perdu*, vol. I, p. 152. (Quelquefois le temps était tout à fait gâté, il fallait rentrer et rester enfermé dans la maison. Çà et là au loin dans la campagne que l'obscurité et l'humidité faisaient ressembler à la mer, des maisons isolées, accrochées au flanc d'une colline plongée dans la nuit et dans l'eau, brillaient comme des petits bateaux qui ont replié leurs voiles et sont immobiles au large pour toute la nuit.)

NORTHERN TOWNSCAPE, WESTERN SUBURBS

1. There is no space in this chapter to give any representative account of the night as a subject for North American artists: it is a major theme of American photography and painting, admirably set forth in Joachim Hoffmann et al., *Night Vision: Nocturnes in American Art 1860–1960* (New York: DelMonico Books/Prestel and Bowdoin College Museum of Art, 2015)
2. www.lindenfrederick.com/quotes.html; accessed 8 June 2020.
3. www.toddhido.com/outskirts.html; accessed 8 June 2020. His two books of photographs of suburban houses at night are *House Hunting* (Paso Robles CA: Nazreli Press, 2001) and *Outskirts* (Paso Robles CA: Nazreli Press, 2002).
4. www.toddhido.com/outskirts.html.
5. Derek Walcott, *The Poetry of Derek Walcott*, selected by Glyn Maxwell (London: Faber & Faber, 2014), p. 399.
6. Altair Benadon-Salmon Esq., Stanford University, personal communication.
7. Alexander Nemerov, *To Make a World: George Ault and 1940s America* (New Haven CT: Yale University Press, 2011), p. 12.
8. Ibid., p. 69.
9. Ibid., p. 121.
10. www.poetryfoundation.org/poems/48266/homage-to-mistress-bradstreet.

SUMMER NIGHT ILLUMINATIONS

1. William Shakespeare, *The Merchant of Venice*, 5.1.89–92 (*The Oxford Shakespeare: The Complete Works*, 2nd edn, Oxford: Clarendon Press, 2005, p. 477).
2. William Shakespeare, *Romeo and Juliet*, 2.1.46 (*The Oxford Shakespeare*, p. 379).
3. Shakespeare, *Merchant of Venice*, 5.1.109–110 *The Oxford Shakespeare*, p. 477).
4. 'Illuminierte Lackier- und Ausschneidebilder'; see Barbara Maria Stafford and Frences Terpak, *Devices of Wonder: From the World in a Box to Images on a Screen*, exhib. cat. (Los Angeles: Getty Publications, 2001), pp. 336–9.

5. The pioneering study is the excellent *Lichtspiele* by Birgit Verwiebe (Stuttgart: Füsslin Verlag, 1997); and wide coverage and incisive commentary are found in the catalogue *Devices of Wonder* by Stafford and Terpak.

6. I am greatly indebted to Prof. Dr Winfried Löffler of the University of Innsbruck, and to the present curator of the Tyrol Folk Museum, Innsbruck, Dr Karl Berger, who have gone out of their way to help me to learn about this fascinating continuing baroque tradition.

7. Archives of the Congregation of Nobles, Rome, 1683, quoted and translated by Andrew Horn in '*Teatri Sacri*: Andrea Pozzo and the *Quarant'Ore* at the Gesú', in Linda Wolk-Simon, ed., *The Holy Name: Art of the Gesú* (Philadelphia PA: St Joseph's University Press, 2018), p. 359 *et seq.*

8. Reinhard Rampold, *Heilige Gräber in Tirol* (Vienna: Tyrolia-Verlag, 2009).

9. Ibid., pp. 20–21.

10. Ibid., pp. 250–52. The magnificent Easter Sepulchre, which is no longer exhibited, at the monastery church of St Laurence in Wilten outside Innsbruck, dating from 1708, by Johann Martin Gumpp and Johan Ferdinand Schorr (ibid., pp. 122–4), with its foreground fictive staircase, and its backlit monstrance, is perhaps the most complete and direct imitation of Pozzo in this genre, being clearly derived from Pozzo's *macchina di quarant'ore* for 1685, as published in his (much used) *Perspetiva Pictorum et Architectorum* (Rome, 1693).

11. Ibid., pp. 203–5.

12. Ernestine Hutter, 'Schöffleit-Krippen', *Das Kunstwerk des Monats: Salzburger Museum Carolino Augusteum*, vol. 9, no. 104, cited in Stafford and Terpak, *Devices of Wonder*, pp. 334–5.

13. Ibid., p. 331.

14. Frances Terpak, 'Free Time, Free Spirit: Popular Entertainments in Gainsborough's Era', *Huntington Library Quarterly*, vol. 70, no. 2, June 2007, pp. 209–28. This article also traces many aspects of glass painting and peep shows Europe-wide.

15. Kircher's magic lantern in its developed form was certainly in his museum in the Collegio Romano by the 1670s, as were his mirrored show-boxes. Giorgio de Sept describes them as being on show there by the 1670s in his *Musaeum Celeberrimum* (Amsterdam, 1678). There is a more primitive projection device illustrated in his *Ars Magna Lucis et Umbrae* (Rome: Ludovico Grignani, 1646). Huygens would seem to have sketched his device in the late 1650s, and Kircher only included a convincing illustration of a magic lantern in the 1671 edition of *Ars Magna*, for all that the *Musaeum Celeberrimum* claims it as his own invention.

16. Christopher Baugh, 'Philippe de Loutherbourg: Technology Driven Entertainment and Spectacle in the Late Eighteenth Century', *Huntington Library Quarterly*, vol. 70, no. 2, June 2007, pp. 251–68, quoting William Pyne, *Walnuts and Wine* (London: Longmans Green, 1823), pp. 296–7.

17. Birgit Verweibe, *Lichtspiel* (Stuttgart: Füsslin Verlag, 1997) p. 15.

18. Ibid., pp. 16–17.

19. Ibid., p. 58.

20. Ibid., pp. 60–61.

21. Alan Hollinghurst, *The Sparsholt Affair* (London: Picador, 2017), p. 5.

22. Peter Scupham, 'Alert', in *Collected Poems* (Manchester: Carcanet, 2002), p. 25.

23. Peter Scupham, 'Talismans: Christmas Lantern', in *Collected Poems*, p. 75.

24. Samuel Taylor Coleridge, *Sibylline Leaves* (London: Rest Fenner, 1817), p. 19.

25. Gerard Manley Hopkins, *Poems*, ed. Robert Bridges and Charles Williams (London: Oxford University Press, 1930), p. 27.

26. Seamus Heaney, *The Haw Lantern* (London: Faber, 1987), p. 7.

FURTHER READING

Apollinaire, Guillaume, *Alcools*, Paris: Belin-Gallimard, 2020.

Arnold, Matthew, *The Poems of Matthew Arnold, 1840–1867*, intro. A.T. Quiller-Couch, London: Oxford University Press, 1909.

Auden, W.H., *Collected Poems*, ed. Edward Mendelson, London: Faber & Faber, 1991.

Baudelaire, Charles, *Les fleurs du mal*, Paris: NRF/Gallimard, 1972.

Berryman, John, *Homage to Mistress Bradstreet*, in *Poems*, London: Faber & Faber, 2004.

Brontë, Emily, *Wuthering Heights*, Oxford: Oxford University Press, 1978.

Chesterton, G.K., 'A Defence of Detective Stories', *The Defendant*, London, 1901.

Chesterton, G.K., *The Penguin Complete Father Brown*, Harmondsworth: Penguin Books, 1981.

Clare, John, *Journey out of Essex*, in *Major Works,* ed. Eric Robinson and David Powell, Oxford: Oxford University Press, 2004.

Coleridge, Samuel Taylor, *The Complete Poetical Works*, Oxford: Clarendon Press, 1912.

Delerm, Phillipe, *Paris l'instant*, Paris: Fayard, 2002.

Dickens, Charles, *Hard Times*, London: Oxford University Press, 1959.

Doyle, Arthur Conan, *The Penguin Complete Sherlock Holmes*, London: Penguin, 2009.

Falkner, John Meade, *The Nebuly Coat*, London: Oxford University Press, 1959.

Garner, Alan, *The Moon of Gomrath*, London: William Collins, 1963.

Garner, Alan, *Elidor*, London: William Collins, 1965.

Grahame, Kenneth, *The Wind in the Willows*, London: Methuen, 1908.

Green, Julian, *Paris*, London: Marion Boyars, 1993.

Hardy, Thomas, *The Woodlanders*, London: Macmillan, 1887.

Hardy, Thomas, *Collected Poems*, London: Macmillan, 1930.

Heaney, Seamus, *The Haw Lantern*, London: Faber & Faber, 1987.

Hido, Todd, *House Hunting*, Paso Robles CA: Nazreli Press, 2001.

Hido, Todd, *Outskirts*, Paso Robles CA: Nazreli Press, 2002.

Hoffmann, E.T.A., *Tales of Hoffmann*, trans. R.J. Hollingdale, London: Penguin Books, 2004.

Hoffmann, Joachim, and others, *Night Vision: Nocturnes in American Art*, Delmonico Books/Prestel and Bowdoin College Museum of Art, 2015.

Hollinghurst, Alan, *The Swimming Pool Library*, Harmondsworth: Penguin, 1989.

Hollinghurst, Alan, *The Folding Star*, London: Chatto & Windus, 1994.

Hollinghurst, Alan, *The Sparsholt Affair*, London: Picador, 2017.

Hopkins, Gerard Manley, *Poems*, ed. Robert Bridges and Charles Williams, London: Oxford University Press, 1930.

James, M.R., *Ghost Stories of an Antiquary*, Harmondsworth: Penguin, 1974.

Keiller, Patrick, *The View from the Train: Cities and Other Landscapes*, London: Verso, 2014.

Kircher, Athanasius, *Ars Magna Lucis et Umbrae*, Rome: Ludovico Grignani, 1646.

Koerner, Joseph Leo, *Caspar David Friedrich and the Subject of Landscape*, London: Reaktion, 2009.

Mahon, Derek, *The Hudson Letter*, Dublin: Gallery Books, 1995.

Milton, John, *Poetical Works*, ed. Douglas Bush, London: Oxford University Press, 1966.

Nemerov, Alexander, *To Make a World: George Ault and 1940s America*, Washington DC: Smithsonian Institution, 2011.

Orme, Edward, *An Essay on Transparent Prints and on Transparencies in General*, London: 1807.

Plath, Sylvia, *Collected Poems*, London: Faber & Faber, 1990.

Powers, Alan, and James Russell, *The Story of High Street*, Norwich: Mainstone Press, 2008.

Powers, Alan, *Eric Ravilious*, London: Lund Humphries, 2015.

Powys, John Cowper, *Wolf Solent*, Harmondsworth: Penguin, 1964.

Praz, Mario, *The House of Life*, trans. Angus Davidson, London: Methuen, 1964.

Proust, Marcel, *À la recherche du temps perdu*, Paris: Gallimard, 1954.

Rampold, Reinhard, *Heilige Gräber in Tirol*, Innsbruck and Vienna: Tyrolia-Verlag, 2009.

Ravilious, Eric, and J.M. Richards, *High Street*, London: Country Life, 1938.

Reve, Gerard, *The Evenings* [*Die Avonden*], trans. Sam Garrett, London: Pushkin Press, 2016 [1946].

Rewald, Sabine, *Rooms with a View: The Open Window in the Nineteenth Century*, New Haven CT and London, Yale University Press, 2011.

Rodenbach, Jules, *Bruges-la-Morte*, Paris: Flammarion, 1910.

Scupham, Peter, *Collected Poems*, Manchester: Carcanet, 2002.

Severs, Denis, *18 Folgate Street: The Tale of a House in Spitalfields*, London: Chatto & Windus, 2001.

Sitwell, Osbert, *Noble Essences*, London: Macmillan, 1950.

Stafford, Barbara Maria, and Frances Terpak, *Devices of Wonder: From the World in a Box to Images on a Screen*, Los Angeles: Getty Publications, 2001.

Terpak, Frances, 'Free Time, Free Spirit: Popular Entertainments in Gainsborough's Era', *Huntington Library Quarterly*, vol. 70, no. 2, June 2007, pp. 209–28.

Tookey, Helen, *City of Departures*, Manchester: Carcanet, 2019.

Townsend Warner, Sylvia, *The Letters of Sylvia Townsend Warner*, ed. William Maxwell and Susanna Pinney, New York: Viking, 1983.

Townsend Warner, Sylvia, *The Element of Lavishness: Letters of Sylvia Townsend Warner and William Maxwell*, ed. Michael Steinman, Washington DC: Counterpoint, 2001.

Verweibe, Birgit, *Lichtspiel*, Stuttgart: Füsslin Verlag, 1997.

Walcott, Derek, *Collected Poems 1948–84*, London: Faber & Faber, 1992.

Woolf, Virginia, *Collected Essays*, London: Chatto & Windus, 1969.

Woolf, Virginia, *Mrs Dalloway*, London: Panther, 1984.

Woolf, Virginia, *Night and Day*, Oxford: Oxford University Press, 2000.

Wordsworth, William, *The Poems*, Penguin: Harmondsworth, 1990.

Yeats, William Butler, *Collected Plays*, London: Macmillan, 1966.

Yeats, William Butler, *The Poems*, New York: Macmillan, 1990.

PICTURE CREDITS

81 Manchester Art Gallery/Bridgeman Images
82 Image courtesy of The Scottish Gallery/© Estate of Joan Eardley
 All Rights Reserved, DACS 2020
85 Manchester Art Gallery/Bridgeman Images
89 Leeds Museums and Art Galleries/Bridgeman Images
97 Artmedia/Alamy Stock Photo
99 Photo Peter Davidson
100 © Victoria and Albert Museum, London
107 © Victoria and Albert Museum, London
109 Photograph © 2021 Museum of Fine Arts, Boston, Gift of L. Aaron Lebowich,
 49.680
111 Photo Ashmolean Museum, University of Oxford WA1972.23/© Crafts Study
 Centre, University for the Creative Arts
112 © James Lynch/Bridgeman Images
119 Yale Center for British Art, Paul Mellon Collection, B1977.14.147
125 © Ashmolean Museum, University of Oxford, WA1954.117
127 Sanders of Oxford, Antique Prints & Maps
130 Bridgeman Images
132 © The Trustees of the British Museum, 1981,1021,0.3
134 Private Collection, photographer: John McKenzie
139 © CSG CIC Glasgow Museums Collection/Bridgeman Images
142 © Ashmolean Museum, University of Oxford, EA2016.4
147 Nationalmuseum, Stockholm
149 Nationalmuseum, Stockholm
150 Art Museum, Gothenburg, GKM 0311
153 © Linden Frederick. All Rights Reserved
156 Copyright © Todd Hido
158 © Gregory Crewdson. Courtesy Gagosian
161 Yale University Art Gallery, Gift of Stephen Carlton Clark B.A. 1903, 1961.18.30.
 © Heirs of Josephine Hopper/Licensed by Artists Rights Society (ARS) New
 York/DACS, London 2020
162 Museum of Modern Art, New York. Photo © Fine Art Images/Bridgeman
 Images. © Heirs of Josephine Hopper/Licensed by Artists Rights Society (ARS)
 New York/DACS, London 2020
165 Smithsonian American Art Museum, Gift of Mr and Mrs Sidney Lawrence,
 1976.121
166 © Ashmolean Museum, University of Oxford, WA1949.350
171 Oxford, Bodleian Library, Vet. E4 e.45
172 Oxford, Bodleian Library, Johnson c.185
175 © Anton Prock
176 The J. Paul Getty Museum, Los Angeles. Digital image courtesy of the Getty's
 Open Content Program
179 © Victoria and Albert Museum, London, P.33-1955
183 © Museumslandschaft Hessen Kassel/Arno Hensmanns/Bridgeman Images
185 Courtesy of Alan Powers
186 Private collection/Margaret and Peter Scupham/© Mark Hearld
189 Private collection/Margaret and Peter Scupham, photo Peter Davidson
191 © Ashmolean Museum, University of Oxford, WA1964.75. 1309
197 Photo Peter Davidson
198 Photo Peter Davidson

ACKNOWLEDGEMENTS

This book has been a considerable time in gestation and has incurred a number of debts. Its first iteration was as a short book (or, possibly, exhibition) devised in collaboration with my former doctoral student Dr Sophie Dietrich. I would like to take the chance here to thank Sophie for having acted as a peerless research assistant on this rather different version of the project, and to compliment her on the fine discussion of distant lights in her own, original and beautiful, doctoral dissertation on 'Season and Climate in the Landscape Painting of Northern Europe'. Working with her has changed the way in which I see places and seasons.

I am profoundly in the debt of those friends who corresponded with me about the first ideas for this book, who offered me suggestions and ideas, for reading, places, paintings: Alexandra Harris, Robert Macfarlane, Fiona Stafford, Ed Behrens, Andrew Biswell, Robert Douglas-Fairhurst and Anne Laurence. I am most grateful to the following libraries, museums, galleries and their curators: the Bodleian Libraries, the Ashmolean Museum, the Tyrol Folk Museum, the Salzburg Museum, (with particular thanks to Ulrike Roider), the Scottish Gallery, Edinburgh. At the Tyrol Folk Museum, director Dr Karl Berger went far out of his way to help me on the subject of the extraordinary surviving baroque sacred theatres of the Tyrol, as did my friend and colleague at the University of Innsbruck, Prof.

Dr Winfried Löffler. I am grateful, too, to the proprietors of those domestic wonders discussed and illustrated in this book: Susanna and Alan Powers; Margaret and Peter Scupham.

I am grateful also to two friends whose exceptional work is discussed in this book: Helen Tookey and Victoria Crowe.

A part of this work in progress was read to the Oxford University Environmental Humanities Seminar in Michaelmas 2019, and I have profited from discussion and response there, from Fiona Stafford, Dan Grimley and Henry Weikel, and from a wonderful conversation on the walk back to Campion Hall with my friend Fr Mark Aloysius SJ, who has contributed more to this book than I can readily say.

I have been fortunate since 2015 to hold a Senior Research Fellowship at Campion Hall in Oxford and would like to thank every single member of the Hall community (as well as its past and present masters) for their friendship, intellectual companionship and endless daily kindness. While my gratitude is due to all, and especially to those named in the course of this book, I have also incurred particular debts to Vijay D'Souza SJ, Joseph Simmons SJ and Matthew Dunch SJ. I also hold a lectureship at Jesus College, Oxford, where I have constantly enjoyed, and profited from, conversations with all of my students and colleagues, but most especially Paulina Kewes.

I am conscious of debts to a wider circle of friends: Edward Coulson, Judith Curthoys, Melanie Marshall and Mark Edwards, Andrew Biswell and Wil Dixon, Janet Graffius, Gerard Kilroy, Patricia Hanley, Daniel Höhr, Charity Charity and James Stourton, Jonathan Key, Mark Williams, Miranda Seymour, Dora Thornton and Jeremy Warren, Tessa Murdoch, and John Martin Robinson, Susan Owens and Stephen Calloway. Catriona Wellesley has been the most loyal of friends and neighbours, and wonderful company on an evening walk.

I am much in the debt of those who have read and commented on sections of this work: Fiona Stafford, James Stourton, Andrew Biswell, Jelena Todorovic, Dora Thornton, Patricia Hanley and Daniel Höhr, who has taken all the sections on the Germany of the early nineteenth century to his heart and greatly improved them. Robert Macfarlane,

as is his wonderful habit, offered the idea which wrenched this book back on course when things were drifting.

Acknowledgements are very much due to friends who offered me wonderful moments, pictures or ideas which somehow failed, through my lack of ingenuity or because of the strange times in which the book was finished, to find a place in it: Bruce Kinsey, Patricia Hanley, Ed Behrens, Alexandra Harris. I thank Dora Thornton profoundly for the walk through Clerkenwell at nightfall in October which we will take one day; and Janet Graffius and Michael Hurley for their peerless company on a haunting earliest spring evening – Hesperus rising over Pendle Hill, and the lights from the great house shining down the Avenue at Stonyhurst – which really needs a whole book to itself.

My friend and former student Altair Brandon-Salmon, now of Stanford University, has offered continual encouragement and has kindly introduced me to Alexander Nemerov, whose own exceptional writings on the motif of light in the dark set a standard very hard to match.

My cousins, whom I adore, were the most wonderful company on a winter visit to Cádiz and Jerez and led me (via *flor*-smelling *bodegas* as good as a *madeleine* any day) to the extraordinary Goya with which this book ends. Jane Stevenson was the ideal companion on that and every other journey.

I am simply and hugely grateful to everyone at Bodleian Library Publishing: Samuel Fanous, Janet Phillips and Leanda Shrimpton, and to Lucy Morton and Robin Gable for production. Thanks to Kate Allan for providing a splendid index.

As the dedication reflects, Alan Powers and Mark Gibson have, with infinite patience and kindness over many years of friendship, taught me to see so many of the things which appear in this book.

INDEX